MEANING AND TRUTH
IN THE ARTS

MEANING AND TRUTH IN THE ARTS

BY

JOHN HOSPERS

The University of North Carolina Press

Chapel Hill

© 1946, 1974 by The University of North Carolina Press
All rights reserved
Manufactured in the United States of America
ISBN 0-8078-4008-4
Library of Congress Catalog Card Number 47-2307
First printing, January 1967
Second printing, May 1970
Third printing, February 1976
Fourth printing, October 1979

Introduction

To have experiences is one thing; to talk about them is another. It is possible to have intense and valuable experiences in response to works of art without attempting to make claims for them or to characterize the works to which they are responses. As a rule, however, this is just what we try to do; and here endless confusion begins. We ask, "What is the meaning of this piece of music?" without stopping to ask ourselves what it is that we are asking, precisely what sense of "meaning" is being used here, or what it means for a work of art to have meaning. We assert that art reveals reality, or expresses truth, without inquiring into the precise meanings of crucial words like "reality," "truth," "expression," which are so constantly employed in discussions of this kind. Moreover, in discussions about art, as in morals, there is a great temptation to let our feelings run away with us and consequently use language with a chiefly emotive intent—which means an end of rational discussion. Terms which are vague at best rapidly lose whatever modicum of meaning they may once have had by being used in this motivational manner. One, at least, of the important functions of the philosophy of art is to attempt to analyze and clarify the central concepts which are employed in dealing with the arts; such an analysis cannot help but make us more careful in using the terms which express them.

But the purpose of this study is not entirely negative. It is positively to investigate certain questions which are of great import to those who are interested in the arts, and especially in esthetic

theory, questions revolving about the allied concepts of meaning and truth as applied to the arts. Do works of art have meaning in any sense? If so, how does artistic meaning differ from the meaning of a word or of a proposition? And how does meaning differ from expression and representation? Similarly, in what sense can works of art be said to contain truth? We often use the word "true" in characterizing a novel or a portrait; yet how are we to analyze such a usage? Is a work of art true as a statement is true? Do these general terms such as "meaning," "reality," "truth," have any definite meaning at all when applied to the arts, and if so, is it the same meaning these terms have in logic or metaphysics? Most students of the arts will agree that such questions are greatly in need of clarification. And to go some distance at least toward achieving this clarification will be the primary aim of this book.

In the preparation of this volume I have many debts to acknowledge. The principal one is to my former teacher and friend Dr. Irwin Edman, at whose suggestion this work was begun and whose constant help and advice were invaluable in guiding it through to completion. Thanks are due also to helpful suggestions from Professors H. W. Schneider, Virgil C. Aldrich, Meyer Schapiro, Lionel Trilling, Katherine E. Gilbert, and Helmut Kuhn, as well as to frequent discussion of the issues with my good friend Mr. Martin Lean.

<div align="right">JOHN HOSPERS</div>

Acknowledgments

I wish to acknowledge my gratitude to the following persons and publishing companies who kindly gave me permission to quote excerpts from their publications as follows: Dr. Albert C. Barnes, *The Art in Painting;* Mrs. A. P. Diamand, *Transformations* and *Vision and Design* by Roger Fry; Allen & Unwin, *Scepticism and Poetry* by D. G. James; *British Journal of Psychology,* "Psychical Distance" by Edward Bullough; Chatto & Windus, *Art* and *Landmarks in Nineteenth-Century Painting* by Clive Bell; F. S. Crofts and Company, *Understanding Fiction* by C. Brooks and R. P. Warren; Harcourt, Brace and Company, *Enjoying Pictures* and *Landmarks in Nineteenth-Century Painting* by Clive Bell, *Communication* by Karl Britton, *Speculations* by T.E. Hulme, *Principles of Literary Criticism* by I. A. Richards, and *The Meaning of Meaning* by I. A. Richards and C. K. Ogden; Harvard University Press, *Philosophy in a New Key* by S. K. Langer; The Hogarth Press, *Esthetics and Psychology* by Charles Mauron; Henry Holt and Company, *A Modern Book of Esthetics* by M. M. Rader; Alfred A. Knopf, *Beethoven: His Spiritual Development* by J. W. N. Sullivan; The Macmillan Company, *Aristotle's Theory of Poetry and Fine Art* by S. H. Butcher, *A Study in Esthetics* by L. A. Reid, and *The Theory of Beauty* by E. F. Carritt; McGraw-Hill, *The Meaning of Music* by C. C. Pratt; Novello and Company, *The Beautiful in Music* by E. Hanslick; Partisan Review, "An Interview with Marc Chagall" by J. J. Sweeney; Princeton University Press, *The Arts and the Art of Criticism* by

T. M. Greene; G. P. Putnam's Sons, *The Gentle Art of Making Enemies* by J. M. Whistler, and *Art as Experience* by John Dewey; Charles Scribner's Sons, *The Literary Mind* by Max Eastman, with the permission of Charles Scribner's Sons, copyright, 1931, by Charles Scribner's Sons, *Reason in Art* by George Santayana, with the permission of Charles Scribner's Sons, copyright, 1905, 1933, by George Santayana, *The Sense of Beauty,* by George Santayana, with the permission of Charles Scribner's Sons, copyright, 1896, 1923, by George Santayana, and *The Realm of Truth* by George Santayana; with the permission of Charles Scribner's Sons, copyright, 1937, 1938, by George Santayana; M. Secker and Company, *The Theory of Poetry* by L. Abercrombie; University of North Carolina Press, *Modern Poetry and the Tradition* by C. Brooks, and *Literary Scholarship* by N. Foerster (ed.); The Viking Press, *The Story of Modern Art* and *A World History of Art* by S. Cheney; The Warburg Institute, "Allegory in Baroque Music" by M. Bukofzer, from *Journal of the Warburg and Courtauld Institutes;* and selections reprinted from *The Philosophy of Art* by C. J. Ducasse by permission of The Dial Press, Inc., copyright, 1929, by Dial Press, Inc.

Contents

Part I:
Meaning in the Arts

1

Preliminary Distinctions

THE STARTING POINT of all philosophy of art is the fact of esthetic experience. Without this, there would be no fine art, no speculation about beauty, no discussion of the issues which will concern us in the following pages. And the first point it is necessary to make about esthetic experience is that there is such a thing: that is to say, that there is a kind of experience which, though not completely isolated from the rest of our experience, is sufficiently distinct from it to deserve a special name, "esthetic." What precisely is it that characterizes this kind of experience? In what respects, if any, is it different from other kinds? I shall try to deal with this question only insofar as is necessary to develop the main argument of this book. It will be necessary to make a brief general characterization of esthetic experience before making certain distinctions within that experience which will underlie much of the discussion of subsequent chapters.

It may be presumed that the word "esthetic" arose, like most words, to satisfy the felt need for a distinction—in this case a distinction between a kind of experience possessing a certain common property (or group of properties) and all experience not thus characterized. But again like most words, it is not rendered precise by common usage: where the speech of everyday life can get by without exactness, the word does not possess exactness; and accordingly, if one wishes to employ the word with more than ordinary precision, he must refine or clarify its more or less indefinite usual meaning; and this refinement is partly an arbitrary matter. There are experiences which some would call esthetic and others would

not, and whether they are or are not esthetic depends upon a more or less arbitrary stipulation of one's usage of the word which ordinary discourse does not supply. But is there any kind of experience which falls so clearly within the bounds of what has commonly been called "esthetic" that to refuse to apply the word to it would be to deprive the term of any distinctive meaning whatever?

The esthetic attitude has been variously defined in terms of empathy, of repose, of detachment or isolation, "synaesthesis," feeling of unreality, or simply pleasure. These conceptions are not necessarily incompatible with one another; each of them seizes upon some aspect or element of a kind of experience which we have—for example in art-appreciation—and defines the esthetic experience in terms of it alone. And the kind of experience we have in contemplating works of art is indeed sufficiently complex and variegated to render such a situation natural and almost inevitable. It is not my purpose here to discuss and compare these conceptions, or to decide among them. It must suffice to say that there is one kind of *attitude* which is fundamental to all of the experiences described, and without which the use of the term "esthetic" to apply to anything distinctive in our experience must quite disappear. This fundamental attitude consists in the separation of the esthetic experience from the needs and desires of everyday life and from the responses which we customarily make to our environment as practical human beings. Ordinarily we perceive a chair simply as something to sit on, a murky sky as a forecast of rain, the sound of a bell as the signal for "dinner" or "guests" or "time to get up." But the esthetic attitude can occur only when this practical response to our environment is held in suspension. We may take pleasure in regarding the sky as a mass of shifting forms and shades of color, and not merely as an indicator of weather changes; we may contemplate with a peculiar delight entirely divorced from practical considerations the spectacle of a building burning at night, the flames rising into the dark sky and illuminating the faces of the awed spectators. On these occasions we are perceiving something "not for the sake of action, but for the sake of perceiving." "As a rule, experiences constantly

turn the same side toward us, namely, that which has the strongest practical force of appeal. We are not ordinarily aware of those aspects of things which do not touch us immediately and practically."[1] This attitude, of course, cannot be our usual and normal one. Nevertheless, we do sometimes view things in this manner even in situations of personal danger when the practical attitude would seem to be almost inevitable. A fog at sea, for example, is normally an experience of great unpleasantness and even danger.

. . . Apart from the physical annoyance and remoter forms of discomfort such as delays, it is apt to produce feelings of peculiar anxiety, fears of invisible dangers, strains of watching and listening for distance and unlocalized signals. . . .

Nevertheless, a fog at sea can be a source of intense relish and enjoyment. Abstract from the experience of the sea fog, for the moment, its danger and practical unpleasantness, just as every one in the enjoyment of a mountain-climb disregards its physical labor and its danger (though, it is not denied, these may incidentally enter into the enjoyment and enhance it); direct the attention to the features "objectively" constituting the phenomenon—the veil surrounding you with an opaqueness as of transparent milk, blurring the outline of things and distorting their shapes into weird grotesqueness; observe the carrying-power of the air, producing the impression as if you could touch some far-off siren by merely putting out your hand and letting it lose itself behind that white wall; note the curious creamy smoothness of the water, hypocritically denying as it were any suggestion of danger; and, above all, the strange solitude and remoteness from the world, as it can be found only on the highest mountain tops; and the experience may acquire, in its uncanny mingling of repose and terror, a flavor of such concentrated poignancy and delight as to contrast sharply with the blind and distempered anxiety of its other aspects. This contrast, often emerging with startling suddenness, is like a momentary switching on of some new current, or the passing ray of a brighter light, illuminating the outlook upon perhaps the most ordinary and familiar physical objects—an impression which we experience sometimes in instants of direct extremity, when our practical interest snaps like a wire from sheer over-tension, and we watch the consummation of some impending catastrophe with the marveling unconcern of a mere spectator.[2]

1. Edward Bullough, "Psychical Distance," *British Journal of Psychology*, V, 89.
2. *Ibid.*, pp. 88-89.

The painter who, in viewing an expanse of pasture land, observes the gentle curve of the hills, the gradations of light and shade on the grass, the limbs of the trees silhouetted in intricate patterns against the sky, may be said to be viewing the scene esthetically; but not the surveyor who is interested merely in measuring its extent, or the real-estate man whose attentions are confined to estimating its value. The man who seeks a painting because it is rare or expensive, and the woman who prizes a vase because it is antique or because it belonged to her great-grandmother, are not viewing these objects esthetically any more than the person who becomes so obsessed with the nudity of a statue that he fails to regard it as a work of art.[3]

Whatever else may characterize the esthetic attitude, if the term "esthetic" is to retain any distinctive meaning, it must at least refer to the kind of thing just described. If this is denied, the most obvious and fundamental ground for distinguishing the esthetic from the non-esthetic is taken away. Many writers on esthetics, however, asserting that such a characterization of the esthetic attitude does not go far enough, have tried to limit it or render it more precise in various ways. Some have declared that the sensations of smell and taste, as well as organic sensations, are somehow beneath the level of the esthetic, thus limiting the application of the term to visual and auditory experiences. Others have held that esthetic contemplation must be of a concrete sensuous percept and cannot be of anything abstract such as a moral character or a mathematical proof. Still others have used the presence or absence of empathy, or some kind of physiological effect such as "equilibrium," as the criterion for dividing the esthetic from the non-esthetic. And certain extremists such as Clive Bell have limited the "esthetic emotion" to a relatively small class of experiences which occur in the contemplation of abstract formal relations in works of art. I disagree with most of these suggested restrictions and refinements; but it is not necessary to my purpose to argue

3. The esthetic attitude is particularly well characterized in Langfeld, *The Esthetic Attitude*, especially the first three chapters; Charles Mauron, *Esthetics and Psychology*, pp. 31 ff.; C. J. Ducasse, *The Philosophy of Art*, Chapter 9; T. E. Hulme, *Speculations*, the chapter on "Bergson's Theory of Art"; and the article by Bullough cited above.

them here. One may define the esthetic attitude as one wishes, but common usage of the term "esthetic" would indicate that it means *at least* what I have described, and that whatever else is added is a more or less arbitrary addition, not in accord with the way people generally use the term. The esthetic attitude is, to be sure, "a matter of degree"; a given attitude may be more esthetic or less esthetic than another, and the esthetic and the non-esthetic gradually shade into each other; there is a penumbra or twilight-zone in which it would be unsafe to draw definite boundary-lines. Thus I have taken as examples attitudes which we may call typically esthetic—which would be admitted to be esthetic by any normal usage, and contrasted them with other examples which would not be called esthetic on any conceivable criterion, omitting the mention of doubtful states in between. And these examples indicate, in as precise a way as common usage warrants, what constitutes the esthetic attitude.

I have not defined the esthetic attitude. I do not think it is possible to define it in other words. Like all expressions which refer to experiences or states of feeling, one must have had the experience to know what it is like. It is impossible to define the taste of a persimmon; one can give a general idea by comparing it with the taste of a mango or a lime (assuming that the person in question has tasted these), but no words can convey exactly *how* it tastes. In the same way, one cannot define the esthetic attitude so as to convey its nature to anyone who has not experienced it. The best we can do is to call his attention to certain experiences we trust he has had—such as the experience of the fog or the green field—and contrast the attitude he remembers on those occasions with his attitude toward other things or toward the same thing in other situations, hoping that the difference between the two kinds of examples will make clear to him the distinction which we have in mind.

Much confusion results from the failure to remember that "the esthetic" refers to a kind of *attitude* rather than the *objects* toward which that attitude is taken. For example, it may often be more difficult to take the esthetic attitude toward the objects of taste and smell than toward those of sight and hearing (owing largely to

their closer connection with practical bodily needs, and the consequent difficulty of "distancing" them), although it can hardly be disputed that we do sometimes adopt this attitude toward them; I see no theoretical limit to the number of objects toward which it is possible to take the esthetic attitude. Confusion enters when we ask whether the smells and tastes, or the objects smelled and tasted, are *in themselves* esthetic; actually what is esthetic is our attitude toward them—and this can be esthetic on some occasions and not on others.

It is important to remember also that the esthetic attitude may be co-present with other attitudes, and only occasionally is present exclusively. Rarely does the experience reach such a peak of intensity as to exclude all else from the field of consciousness. And at the other extreme, it is quite likely that the esthetic attitude seldom disappears *entirely,* except in moments of terror or crisis: if the color-scheme of a room in which we are sitting does not please us, we have a vague sense of uneasiness, even though this feeling may never come to the foreground of consciousness. There is probably an *element* of the esthetic in all the attitudes we take in waking experience. The buyer of lands who looks out upon the field may be esthetically affected to some extent even when he is evaluating it as a piece of real estate, although not as intensely, to be sure, as the artist.

Within the field I have described, however, there are still distinctions to be drawn. When the painter views from a distance the New York skyline as an interplay of lines and spaces, colors and volumes, he would generally be said to be contemplating it esthetically; but what of his attitude when he contemplates it as a center of seething humanity with all manner of conflicting purposes and ideals, or as small bits of animated matter darting about, crowded together in an area infinitesimally small when compared with the vast reaches of the universe? What of the artist who observes the green field not in terms of arrangement of balancing masses or shifting color-patterns but as an expression of the life of simple people, or of what we may roughly call "pastoral quality"? All but the most sophisticated "purists," I think, would agree that both are esthetic; but there is certainly a difference between these last-

mentioned examples and the others. And it is this distinction which I want to explore throughout the remainder of the present chapter.

2

The first level, or dimension, of esthetic experience that I want to set forth is one which is sometimes called esthetic *surface*.[4] When we are having an experience of esthetic surface in nature or a work of art, we are enjoying simply the look, the sound, the taste, the sensation, without making distinctions and without considering meanings or interpretations or significances—simply enjoying the "feel" of the sensuous presentation, "on the very surface of experience directly had." The smell of a rose, the taste of a wine, the sheen and texture of a piece of cloth, the vivid blue of the sky, the sensuous richness of a Strauss tone-poem or a Swinburne stanza, the sheer sound of Mallarmé, the exquisite colorations of Tanguy—all these are examples of "sensuous surface." Colors or sounds taken singly are better examples than in combination, for when they occur together we are apt to center some of our attention on their relationships to each other, in which case we have already passed into the second dimension, that of form— although it is quite possible to contemplate a work of great formal complexity or rich and varied meaning from the point of view of esthetic surface by confining one's attention to that aspect of it.

The meaning of esthetic surface stands out more clearly by contrast with the second dimension, which we may call "esthetic *form.*" It too can be best presented through examples: All of us, I daresay, require a certain degree of balance and symmetry in the arrangement of objects in space; the pictures on the piano must not all be on the right side, nor must they be arranged "mechanically," nor must they be so numerous as to clutter, nor so few as to seem bare; there must be symmetry, yet perfect geometrical symmetry would be monotonous.

In most scenes in nature, and certainly in works of art, there are certain requirements of form which must be satisfied, though it is

4. I borrow this term from D. W. Prall, whose analysis of it occurs in *Esthetic Judgment,* especially Chapters 3, 4, 5, and 10.

very difficult to state just what they are. Some response to form is quite universally agreed on as essential to our experience of a work of art. For example, we require not only balance of the sort just described, but unity, and not the unity which reveals no distinctions within itself—a blank wall has unity—but a unity which consists in the synthesis of a variety of elements, but not a variety so great as to be bewildering or so as not to be subordinated to some dominant arrangement or idea. "Organic unity" is generally set forth as a *sine qua non* of all works of art. Each element is necessary to all the rest, and together they form a whole so unified that no part could be removed without damaging the remaining parts. A work the effect of which is "split in two," without the parts being connected, is a simple example of the lack of organic unity. Closely bound up with this is the principle of "theme and variation": there is some central or preëminent shape or color or melodic pattern or meaning, which, however, cannot be simply repeated, or it will become monotonous, nor can entirely different material be continually introduced, since then there would be no unity but only a bewildering succession of differences; repetition must be repetition with a difference. Bare recurrence is monotonous; bare difference chaotic. Or again, there are the principles of rhythm and development: tension and release, conflict and resolution, which, however, do not simply alternate, but grow and develop and (in the temporal arts at any rate) reach a climax. There must be development toward some goal and not mere sequence or juxtaposition. The rhythm must be dynamic and not static—not like the beat of a drum, which simply repeats itself, but changing, yet changing in accordance with some principle of development or order—recurrence with a difference.[5]

These principles are perhaps the most important part of what might be called the formal aspect of our esthetic experience. When our experience of a work of art lacks some of these elements, it is impaired; and whether we are aware of it or not, they play a very

5. The best accounts I know of these "formal criteria" for works of art are to be found in De Witt Parker's *The Analysis of Art*, Chapter 2; John Dewey, *Art as Experience*, Chapters 7-10; Kenneth Burke, "The Psychology of Form" in *Counterstatement;* and Stephen Pepper, *Esthetic Quality.*

large role in our enjoyment of works of art—and to a lesser extent, of nature—regardless of what the content of the particular work may be. The list just presented, I fear, has been somewhat arbitrary. Different writers classify the principles of form in somewhat different ways. And some writers who insist on the supreme importance of form, notably Clive Bell, assert that all attempts at description of esthetic form must fail and that no criteria for its presence can even be indicated. In any event, precisely what principles of form, if any, can be laid down do not really matter for our purposes; I have suggested a few simply in order to give the notion of "form" some fairly concrete meaning, without which any future use of the word in these pages would be rather pointless. And that form is an important aspect of our esthetic experience cannot, I think, be easily denied.[6]

3

It must be evident, however, that only a small part of the story has been told. Only a small part, that is to say, of our enjoyment of the arts, or even of nature, consists in enjoyment of esthetic surface or esthetic form simply in themselves. Indeed, our appreciation of works of art does not usually consist primarily of these at all. We often employ the words "beautiful" and "great" to works which, viewed from the standpoint of form and surface, are far less impressive than many which we value less highly—a portrait presenting a powerful characterization, for example, even one which in a certain way is repulsive, such as Rembrandt's "Old Woman Paring Her Nails." The sensuous surface in *King Lear*

6. A few further distinctions might be made here: (1) Esthetic form and esthetic surface are not the same as form and surface. Any sensory presentation, no matter how revolting, has *some* form and surface. "Esthetic form" and "esthetic surface" are normative concepts, not merely descriptive; not all forms and surfaces are esthetic. Which ones are, and to what extent the term can apply to forms as such rather than to our experience of them, is of course another question. The point at present is that not all forms can be described as esthetic. (2) Some writers, such as Professor T. M. Greene in *The Arts and the Art of Criticism* (pp. 123-25), distinguish between *esthetic* form and *artistic* form. Esthetic form is found to some degree in nature as well as in art; but artistic form, on this analysis, is peculiar to art, because it is form conditioned by the intentions of the artist. We may make this distinction if we wish; it does not change the fact that the formal criteria remain—it merely indicates that other factors must be considered as well.

and Goya's *Disasters of War* and Beethoven's late quartets is, to say the least, certainly not predominant; and if the form is, it is employed chiefly as a vehicle for something beyond itself—something conveyed through the form, and upon the esthetic surface. This something comes from life, from the world of experience outside art—and for lack of a better term I shall call what is thus conveyed *life-values*.

> The arts, especially the fine arts, have sometimes a surface more esthetically rich and satisfying, even if sometimes less vivid and arresting, than any mere separate sense elements but this surface is not the central life and significance of the arts any more than it is the life and meaning of nature. And no esthetic theory is even plausible that fails to notice that the arts themselves are directed human activities, operations and processes of creating, not mere esthetic surface. . . . The fine arts are first of all . . . arts, and only secondarily fine.[7]

In this respect the fine arts differ from the arts of pure design, such as arabesque, in which life-values are often of little or no importance.

It is this taking-up-into-art of material from life which makes art more than esthetic surface and esthetic form, and constitutes our third dimension. It is by virtue of this third dimension that we can employ the language of life in speaking of art; we can recognize human characters and situations in a drama, melancholy or sprightliness in a piece of music. Even when we call a marble column "graceful," we are employing a life-value. Life-values play an important part in the artistic appreciation of most persons— rightly or wrongly, they figure more largely than the formal or surface values.[8]

The same principle holds in esthetic experiences outside the realm of the fine arts. When we contemplate a starry night or a mountain lake we see it not merely as an arrangment of pleasing colors, shapes, and volumes, but as expressive of many things in life, drenched with the fused association of many scenes and

7. D. W. Prall, *Esthetic Judgment*, pp. 181-84. Prall uses "esthetic surface" as a general term opposed to "expressive beauty," or what I have called "life-values."

8. The tripartite division into surface, form, and life-values is described in a general way in L. A. Reid, *A Study in Esthetics*, Chapters 1-4, and finds a parallel in Santayana's material beauty, formal beauty, and expressive beauty in his book *The Sense of Beauty*.

emotions from memory and experience.[9] So too in the useful arts; we enjoy not merely the shining black and silver of the streamlined automobile, or the pleasing red brick of the fireplace, or the sharp curve of the Indian arrowheads, but rather these surfaces and forms as expressing certain life-values, and adapted to certain life-purposes. The design of the streamlined automobile seems to express speed, efficiency, ease, power (all of them values from life, dependent upon our knowledge from everyday experience of what an automobile is and does). The graceful curve of the arrowhead is not apprehended merely as a line, but as admirably designed for its purpose—the same form and the same surface would be inappropriate and not at all pleasing on another sort of object. The same red that pleases us in a sunset revolts us when seen in a boil on somebody's face. Seldom indeed is our enjoyment of objects purely one of esthetic surface and form, but rather of these things as suited to and expressive of their function in life.

4

At this point I want to suggest a distinction between two senses of the word "esthetic" which can now be made on the basis of the foregoing analysis and which, I think, may save us many confusions. Certain "purists"—who will be specifically mentioned and discussed in Chapter IV—have declared that strictly *esthetic* appreciation occurs only when we are concerned with surface- and form-values, and that when we consider life-values we have left the realm of esthetics. Most works of art, on this view, do not contain exclusively, or even primarily, esthetic values. Now this sense of "esthetic," which excludes much of what is generally included in that term, I should like to call the *thin* sense of the word. (No deprecation is implied in this usage.) But this is not the only possible sense of "esthetic." When we contemplate a painting as something more than a set of relationships of lines and colors, when we enjoy the mood it conveys or the light-values presented in it, or the "sadness" of a piece of music, or the character-study in a novel, or the love-emotion in a poem, I suggest that this kind of experience, depending on previous experience of life, to which the

9. Cf. Prall's excellent example of the garden, *op. cit.,* pp. 180-81.

"purists" would deny the title "esthetic" at all, be called the *thick* sense of "esthetic."[10]

Some works of art are noteworthy primarily because they are esthetic in one sense, and some because they are esthetic in the other. Botticelli and Matisse, for example, are certainly esthetic primarily in the thin sense, while Rembrandt and Van Gogh are as certainly esthetic on the thick side. To explore the relationship between these two, and their importance to each other, will occupy us at length in analyzing the nature of artistic meaning, where the arts of music, painting, and literature will be dealt with separately.

During the course of our discussion an interesting question may have presented itself to the reader. We began by discussing the esthetic experience, but we seem to have come round to discussing objects such as works of art as if they were in themselves esthetic—for example, in saying that most works of art can be esthetic in the thick sense. Yet we do constantly speak in this way: instead of saying that we have certain experiences which we may denominate "form-experiences," we say that a work of art itself contains certain form-values; instead of saying that a given piece of music gives us an impression of melancholy, we say that the piece of music is itself melancholy, etc. The question thus arises, what can we mean by saying that a work of music itself contains or embodies these qualities? Can we mean any more than that it produces on us, or on a majority of listeners, or a certain selected group of listeners, the impression or experience of melancholy? When we say that a work of art has esthetic form, how can this statement be analyzed except in terms of certain experiences (actual or potential) of observers of the work? We normally speak of these things as objective constituents of the work as much as its size or color, and our linguistic habits in referring to admittedly objective qualities make the extension to these other cases quite natural; moreover we can find no adequate linguistic equipment for these cases—thus inevitably we speak the object-language rather than experience-language.

10. This usage bears a rough analogy to Prall's two senses of "beauty"—surface beauty and expressive beauty—which he introduces in *Esthetic Judgment*, pp. 219 ff., but never develops. But the word "beauty" introduces complications which I would prefer to avoid at this point.

But *can* a work of art itself be defined in any other way than as a set of actual or possible experiences? This is a huge question, and if we entered into it here we would have to be embroiled in it for the rest of this volume. Throughout subsequent discussions we shall employ the convenient object-language and will often speak, for example, of the melancholy as if it were a property of the music, without analyzing just what it means to say, "This music is melancholy." In the discussion that follows, dealing with the vexed distinction between form and matter, we shall employ this usage—speaking of form and matter, that is, as objective entities without inquiring into what a correct analysis of these in terms of experience (the question of "the ontological status of a work of art") would be.

5

Often in discussing the arts we distinguish between the "form" and the "matter" of a work of art, generally on the ground that "matter" refers to "what is said" while "form" denotes "how it is said." Both of these are admittedly in some way distinguishable, but the distinction is an extremely misleading one.

The central confusion lies in the term "matter," which is ambiguous and may refer either to something that is in the work of art or to something that is outside it. This confusion is pointed out by A. C. Bradley in the opening chapter of *Oxford Lectures on Poetry* and may be described as follows: Many persons realize that bad poems can be made on worth-while subjects and good poems made out of trivial subjects, and so they are led to say that what really counts is not the subject which the poet selects, but how he treats it—which they express by saying that it is not the matter that counts but the form. Then the layman connoisseur of poetry is shocked and says, "What! only the form important! All that matters in a poem in the *way* the poet expresses what he has to say, not *what* is expressed! Absurd! The way he expresses it depends on what it is that he wants to express; the manner is only a means to an end, which is the expression. Not the window, but the landscape which we see through the window, is what is important. Art is not for art's sake; art is for life's sake; and unless a work of

art has some significant content it is failing of its purpose, no matter what its form may be!"

Now the layman is quite right, I think, in maintaining that the attempt to reduce a poem such as *Hamlet* to an exercise in style and versification and sound-values, rather than to a "pre-occupation with man and his fate" (Bradley's term), is indeed mistaking the means for the end, and that the critic who says, "It doesn't matter what the poet says, just so he says it well; the *what* is poetically indifferent, . . ." does indeed put art into an ivory tower. But I do not think that the esthetic critic wishes, actually, to take this position; he rather thinks he is forced to it by the fact that significant subject-matter does not insure a good poem, and vice versa. The critic is put into the embarrassing dilemma of asserting on the one hand that the form alone is important and on the other hand that art is related to and revelatory of life. And he would take the position on the side of form rather than to admit for a moment that the merit of the poem has anything to do with its subject-matter.

But this dilemma is only a supposed one, based upon an ambiguity in the word "matter." The distinction between form and matter may hold in other branches of philosophy, but in esthetics it is a terribly misleading one. "Matter" in art can refer on the one hand to the materials or the subject-matter from life, outside the poem, or to "what is expressed" inside the poem—what we shall call content or substance. It is true that the subject-matter, which is outside the poem, is quite irrelevant to the merit of the poem—a poet may do well or ill with any given subject-matter; on the other hand, the content *is* important, since it is in the poem and refers to what the poet has actually expressed. Many poems have been written on the theme of love, and all of them have had the same subject, but in each case the content was different. As Bradley says, "The extreme formalist lays his whole weight on form because he thinks its opposite is mere subject. The general reader is angry, but makes the same mistake and gives to the subject praises that belong to the substance."[11]

It is often said that "in art the treatment is everything"—what

11. A. C. Bradley, *Oxford Lectures on Poetry*, p. 13.

the artist does with his subject-matter, and not the subject-matter itself, is what counts. "The expressed content of a picture is determined not by subject-matter as such but by the way in which it is handled."[12] And this, we can now see, can be true without entailing that it is the form only which is of importance. For the content also is within the work of art, and it is a product of the artist's genius; it represents what he does with the subject-matter, as opposed to what that subject-matter itself is. The critic of a painting depicting the Crucifixion, if he is a critic of painting and not of history or theology, certainly does not concern himself with criticism of the Crucifixion as a historical event; but he is not thereby limited to remarks about form (rhythm, balancing of color-masses, etc.); he may also criticize what the artist has expressed, the feeling-tone of the work, the spirit the artist has achieved in his work, and whether or not the artist has given us, for example, a fine sensuous surface but has had "nothing significant to say." And to do this he must have not only esthetic sensibility and a knowledge of the art-form but also a knowledge of the aspects of life which the work touches upon, and a feeling for the subject-matter which the artist is dealing with, so that he can better evaluate what the artist has done with that subject-matter. A critic who is quite insensitive to religious feeling would scarcely be the person to evaluate Giotto. It does not follow from the fact that a certain critic is not a pure formalist that he concerns himself with things which are esthetically irrelevant. "Confusion of values arises only when the spectator is moved, not by what the artist shows him, but by what he does *not* show him—the historical event. The interest in *that* is wholly adventitious, and if allowed to play a part in determining judgment of the picture it can produce nothing but distraction.[13] And if the painting has

12. T. M. Greene, *The Arts and the Art of Criticism*, p. 292.

13. A. C. Barnes, *The Art in Painting*, p. 25. It might be objected here that subject-matter *is* relevant; for example, Cézanne's still-lifes picture dishes, fruit, and small household articles—intimate objects of common life, easily manipulable and movable and possessing little internal life of their own; for this reason Cézanne used these objects rather than others. Now it may well be true that certain effects can best be achieved by means of certain subject-matters; nevertheless it is not the subject-matter as such that is important, but its handling by the artist. Not all still-lifes of tables with dishes of fruit on them are works of art. The difference between those that are and those that are not does not lie with the subject-matter.

no value of its own (of surface, form, or life-values) but merely derives its interest from our human interest in the historical subject-matter, the historical event depicted in it, then it is illustrational painting and not art at all. The response of most persons to painting is probably this illustrational one; they respond to the subject-matter, particularly if it is familiar or reminiscent of childhood memories, and not to what the artist has done with the subject-matter.

The notion of form has been discussed in a previous section,[14] and that of content is equivalent to what I have already called "life-values." A more complex and ambiguous concept is that of *subject-matter*. And I want first of all to distinguish the subject-matter of a work of art from its *materials*.

I should like to define the materials of a work of art as all the

14. Every object, whether a work of art or not, has *some* form—even a patch of blue sky and the sound of a tuning-fork (in a single tone) have some form, the form of unity. One must distinguish form from *esthetic* form; certain requirements for esthetic form have been described earlier in this chapter. (I call it "esthetic form" rather than "artistic form" because the forms described occur in nature, to a limited extent at least, as well as in works of art.)

This usage of the term is somewhat different from Dewey's in *Art as Experience,* where he calls the "matter or substance" "the poem itself," while form "marks a way of envisaging, of feeling, and of presenting experienced matter so that it most readily and effectively becomes material for the construction of adequate experience on the part of those less gifted than the original creator. . . . The work itself is matter formed into esthetic substance" (p. 110). This usage is confusing; apparently the form is something outside the poem, something the poet did to the original material in order to transform it into the poem. Ordinarily we do speak of form as present in the work. And when we speak of the "content of the poem," we do not mean the poem itself, for we speak of "the content of the poem" and would never take this to mean "the poem of the poem."

Form must be distinguished from technique. "Technique" is an extremely ambiguous and evasive word. In one sense it can refer to the *means* or devices by which the artist achieved a certain set of effects—something which may be apparent on viewing the work but is not "a part of" the work itself. When we study how the artist mixed his paints to get the colors this way, or what devices he used to create the illusion of three-dimensional space, or how he contrasted colors to accentuate light-values, we are studying technique. In another but related sense, to say that an artist has "technique" is to say that he is at home in the artistic medium he employs—he takes to the art-form easily, as Renoir did to painting and Mozart to music. Or again, "technique" may become a term of dispraise, signifying that the artist can handle his medium, knows how to put colors on canvas, but can express nothing significant through that medium, in either the thick or the thin dimension. A painter may be facile in employing his artistic medium without employing it to any good advantage; then we call him a "mere technician." Technique in itself is not artistry; mediumistic virtues are not artistic virtues; doubtless they are a *necessary condition* for them. An artist must first of all be at home in his chosen medium, but this does not alone make him an artist.

experiences the artist had which are relevant to the production of the work of art, and, through these experiences, whatever objects and events in the world, that stimulated or inspired the artist to create his work. Certainly it cannot be denied that all the arts have material in this sense—in all the arts there are experiences of the artist which are relevant to and leading to the artistic creation, and without which he would not have created the finished work as he did. What the materials are, in any individual case, is a biographical and not an artistic question, and hence is more important to the historian than to the critic.

Dewey emphasizes the notion that the materials of the artist are the world itself—the world of common human experience, of objective things and events, and that the work of art is a product of the mutual interaction between the artist and his materials, that is to say, between the artist and his environment. All this is true enough, but it is "materials" in one sense further removed from the sense in which I have defined it above; for in any case, "materials" for art are not simply the world or objects in it as such, but the artist's experience which has been moulded by these materials and out of which he creates his work; the things and events in the world, which moulded and shaped his experience (which is the immediate material from which his work is drawn), are materials but in a more remote sense.

We may note in passing that no distinction between representational and non-representational arts can be drawn on the basis of their materials, for all the arts equally have materials in this sense. If Shelley's political cogitations are part of the material for *Prometheus Unbound,* it is at least as well founded that part of Brahms' material for his second piano concerto was the vivid blue of the Italian skies. Both may equally be causally relevant to production of the work of art.

I want now to distinguish the materials of works of art from their subject-matter. Subject-matter is, artistically, a more important and more ambiguous concept. In one sense in which I think the term is used, "subject-matter" refers to the model or object of imitation—whatever is imitated in the work of art. If, for example, a painter sees a certain hillside in Burgundy and tries to transcribe

it photographically onto the canvas, or if the novelist attempts to depict with perfect accuracy some historical situation, then they may be said to be imitating (in the literal sense) that scene or that situation, and the hillside or the historical situation is their respective subject-matters in the strictest possible sense. Now, it goes without saying that no artist actually does this—nature is always transformed, interpreted, "distorted" in art (this topic will be discussed in Part II); but to the extent that there *is* this "distortion," nature is not accurately imitated: to this extent, that is, the artist is using the historical event or scene in nature not as his *subject-matter,* but merely as *material,* stimulus, source of inspiration from which he may draw, or on the basis of which he may conceive imaginatively.

It seems to me that works of literary or pictorial art which do have as their basis some certain scene or person or historical plot or situation constantly gravitate between using it as subject-matter (in this sense) and using it as material, and it is sometimes hard to know which they partake of more. When the painter draws a picture, having in mind a certain landscape he has seen, at what point in his "transformation of the photographic reality" is one able to say that the painting ceases to be a painting of *that* particular hillside in Burgundy (with distortions to accentuate certain effects) and becomes instead a painting only of a landscape in the artist's mind, one which had this particular Burgundy hillside as a stimulus, a taking-off point, as *material?* The two fuse into each other; and the point at which it ceases to be a painting *of* the Burgundy hillside and starts to be "a hillside of the artist's imagination with the actual Burgundy hillside as material" is one which it is for most purposes not necessary to try to decide. Similarly in a portrait, when it ceases to be a portrait of *this* man (this particular historical person) and becomes "a portrait drawn from the artist's imagination," though using this man as material (stimulus), would be a matter of some difficulty to decide; and I think no distinct boundary line need be set. The same would hold true of the literary work which depicted a set of historical events; as the "distortion" or "free play of the imagination" on the historical incidents became greater and greater, we would be less and less

entitled to say that the historical series of events was the subject-matter of the work, and more and more that it was merely material.

It might be contended here that the non-representational arts (such as music) differ from the representational arts (such as painting) in this sense of subject-matter, since painting can, at least theoretically, imitate some actual scene from nature. But what can music imitate? I would reply that if painting can imitate sights in nature, music can imitate sounds in nature. It is, of course, quite true (as we shall see in the next chapter) that the extent of life-sounds that music can imitate is far smaller than that of life-scenes which painting can imitate; but this is a difference in degree, not in kind. It is not on this basis either that we can draw a distinction between representational and non-representational arts.

It is important to notice here that some works of art have a subject-matter (in the sense we have discussed) outside the work and some do not. Thus far we have been discussing only those that do. But many do not: for example, there is, so far as is known, no historical counterpart to the character of Odysseus; Odysseus and his experiences exist only within the *Odyssey*. In this Odysseus is opposed to Agamemnon, who does (or did) have an existence outside Aeschylus' drama—likewise Henry IV (in Shakespeare's play) and Rembrandt (in any of his Self-Portraits). In these latter cases the subject-matter existed outside the work of art and was there before the work of art was. Now I think it would be quite generally agreed that whether or not a work of art has a subject-matter outside of it in life or history is not artistically important; the greatness of the *Odyssey* would not be affected one way or another if the character of Odysseus should turn out to be historical. It is enough to point out that there is sometimes a subject-matter outside the work (which the artist may imitate more or less accurately —the more accurately, the more the historical object or event is subject-matter rather than material), while sometimes there is not (in which case no question of subject-matter in the above sense arises).

Since whether or not there is a subject-matter outside the work is, as we have seen, artistically irrelevant, I think I had best pass on

to a second sense of subject-matter which does not depend upon this distinction: the sense, namely, in which we say that the subject-matter of the *Odyssey* is the adventures of Odysseus, or that the subject-matter of Manet's *Olympia* is a woman lying on her bed with a black cat. The subject-matter in this sense is certainly in the work of art itself; for as we have seen, there is no historical Odysseus—Odysseus is a character within the poem only. Subject-matter in this sense refers to whatever persons, objects, scenes, or events are depicted or represented in the work of art, irrespective of whether they have any historical counterparts. I think that this is the sense of "subject-matter" we ordinarily employ when we ask for the subject-matter of a work of art. "What is the subject-matter of the *Odyssey?*" "The adventures of a character called Odysseus. . . ." We are asking, that is, for that which is represented, set before us, *in* the work of art.

What is the relation between this sense of subject-matter and the plot, in the case of a novel or drama or narrative poem? It seems to me that the only difference is that the plot is the subject-matter in greater detail; when asked for the subject-matter of a novel we state who the main characters are and what happened to them, and if we are asked to give the plot we merely set forth these characters and events in greater detail. And if we have done this in some detail we say we have given an account of the plot. Both plot and subject-matter (in this sense) are in the work, though as we have seen, the events depicted may have subject-matter in the first sense as well, namely, a historical counterpart to the events depicted in the work.

We may note here that what the events depicted in the novel are is not important; what the artist does with them is what is important. Yet they are of some importance since we do criticize a novel or drama by saying that it has a weak plot; and this is criticism not of anything outside the drama or novel but of something presented in it to which nothing outside may correspond at all.

We have seen that some works of art (such as historical dramas) have subject-matter outside the work, and that some (such as the *Odyssey*) do not. It now remains to ask, "Do all works of art have

subject-matter in this second sense, that is, subject-matter *in* the work? Do they all have representational content?" To this I think we may certainly reply in the negative. And here at last we come upon the distinction between the representational and non-representational arts. The representational and non-representational arts are to be distinguished, not on the basis of anything outside them, but on the basis of something within the works themselves, namely, whether or not there are characters, scenes, or events depicted in the works. And it will be clear at once that in the case of novels, dramas, narrative poems, and representational paintings there are characters and scenes and events represented in the works; while in the sense of abstract paintings and music there are none of these in the work at all. And here we find the difference between representational and non-representational arts, a difference which will be pursued in Chapter II in the discussion of representation.

(Whether or not there are characters or events or scenes in the work—subject-matter in sense two—is sometimes a matter of degree. In semi-abstract paintings such as some of Picasso's "Violins," where we have lines and fragments here and there suggestive of violins, common usage is not so precise as to require us to say definitely that violins are represented or that they are not, just as common usage does not require us to decide whether certain borderline experiences are or are not esthetic.)

In discussing subject-matter thus far, I have used two distinguishable senses of the term: subject-matter may refer to (1) scenes, characters, or events in life which act as models for artistic imitation; this subject-matter is a matter of degree, and when present at all, is more or less present, according to the degree of fidelity of the imitation. Subject-matter in this sense is definitely outside the work of art. It may also refer to (2) scenes, characters, and events depicted in the work; for example, subject-matter of the *Odyssey* is the wanderings of Odysseus. Listed in greater detail, subject-matter in this sense becomes plot. And in this second sense, subject-matter is in the work of art; it might be called "representational content."

But I believe there is still a further sense in which the word

"subject-matter" is used. When we ask, "What is the subject-matter of *Paradise Lost?*" we may not be asking at all for the characters and events depicted in the poem or for anything outside the poem to which these characters and events correspond, but for the central, underlying *idea* of the poem—its *theme*. When asked what the theme of the poem is, we will probably make some such reply as: "The moral truth that man free to exercise his will is better than man in his sinless state," or: "The eternal lesson of human fallibility," or something of the sort. Our answer will not be in terms of representational content at all.[15]

I grant that there is a usage of the word "theme" in which the word refers to subject-matter in the second sense; if we ask "what is the theme of the *Odyssey?*" we may be satisfied with the reply, "Odysseus and his adventures constitute the theme of the *Odyssey.*" But I think we would be more satisfied with an answer like this than we would be with regard to other works; for example: "The theme of *Pilgrim's Progress* is the adventures of an imaginary character called Christian against many obstacles," and: "The theme of *Paradise Lost* is the interactions of Satan and man before and after the Fall." For in these latter cases we are asking for theme in the sense mentioned in the preceding paragraph, that is, the underlying *idea* of the work. And the only reason why we are more willing to accept "Odysseus and his adventures" as the theme of the *Odyssey* is that in this case it is so difficult to say what (if any) the theme really is. Shall we say it is "the essence of adventure (or wandering humanity?) everywhere," or "Man is always beset with misfortunes"? These seem unsatisfactory, and perhaps there is no theme to the *Odyssey* in the same sense in which some moral truth about man might be said to be the theme of *Paradise Lost,* and the temptations of man on the road to salvation is the theme of *Pilgrim's Progress.* Perhaps the *Odyssey* is just a story. In any event, it is very difficult with many works of art to say just what the theme of each is; and in many cases there doubtless is

15. If we reply, "The Fall of Man," that reply is ambiguous; for if by this we mean the Fall of Man as a historical event, we are referring to the subject-matter in the first sense; if we mean the characters and events constituting the Fall of Man in the poem, we are referring to it in the second sense; and if we mean the Fall of Man as an idea or concept, we are referring to subject-matter in the third sense, i.e., theme.

none, or the ascribing of one to the work seems very arbitrary. But when there *is* definitely a theme in the sense of "underlying idea" (subject-matter in the third sense), then we shall not be satisfied with answers about representational content (subject-matter in the second sense) when we ask for the theme of a work of art.

Just to what degree the theme is in and a part of the work of art is a matter of some question. The "representational content" is *there;* it can be referred to and pointed to, and no one doubts that it is part of the work in a sense in which our emotional reaction to the work is not; but what the theme is may well be a matter for disagreement. The theme must often be read into, or "inferred out of" the work; and a whole era in human history may take the theme of some poem to be one thing, while the next generation finds an entirely different interpretation. (How many persons think that the theme of *Crime and Punishment* is that the sinner will inevitably be led to repentance by the pangs of his conscience!) In some cases the theme is very obvious (as in *Pilgrim's Progress*), while in other cases it is extremely obscure and dubious (as in Blake's prophetic writings or Shaw's *Major Barbara,* where everything that is said seems to cut two ways).

6

One further distinction remains to be made, and this can best be brought out by means of a concrete example. What is the material of music? Is it notes, or is it human experiences and feelings? Both of these answers seem to be true, and yet how can both these things constitute material? This points to a distinction to which Professor Greene assigns the names "primary" and "secondary."[16]

A composer may write a symphony partly as a result of experiences (particularly affective experiences) which he has had, which were in turn occasioned by objects and events in the world; these are his materials, in the sense of stimulus or source of inspiration, causally relevant to his composition.[17] I have already discussed

16. Greene, *The Arts and the Art of Criticism*, p. 39.

17. Professor Greene employs the distinction between raw material and medium (there being a primary and secondary of each), the medium being only a further stage in the development of the material in the artist's experience: specifically, the material after it is esthetically "conditioned" by the artist. In the present context I do not find this distinction useful.

this sense of "material"—it is what I shall call *secondary* material.[18] But his *primary* materials are sounds—or, to be more precise, the notes in the Western semitone scale; it is out of these that he builds his composition. The two constitute material of two different orders or dimensions. In the same way, the world of experience— or more specifically the author's experience—is the secondary material of literature, and words and sentences are the primary material. Forms drawn on canvas with paints and brushes are the primary material of the painter. The distinction, once pointed out, is, I think, obvious.

The notion of "primary" does not seem to apply to subject-matter. The subject-matter of *Paradise Lost* has been described in its three senses in the previous section: as a representation of an alleged historical event, as its plot, and as its theme. All these are "secondary." The subject-matter of a work, in any of the above senses, is what the work is *about;* and no work is *about* its primary materials, nor anything strictly "mediumistic" such as the word "primary" refers to. What "primary subject-matter" could be I cannot even imagine. More important, however, the notion of subject-matter does not apply even in the "secondary" sense to music, except on those rare occasions when the music imitates some sounds from life and the music might be said to be about those sounds. (The degree to which music can do this will be discussed in the next chapter.) Music has no "representational con-

18. At this point I would take issue with Professor Greene's analysis. He asserts that the secondary material of music is "emotive-conative states." Why does he not say that the material of a musical composition is the entire range of relevant experience on the part of the composer, as he does in the case of painting and literature? Because he holds to a particular theory about the relation of primary to secondary material, namely that the latter is *transformed* or *translated* into the former: "emotive-conative states," according to Professor Greene (*op. cit.,* p. 60), "are translated into expressive musical patterns." Now I am not sure just what this transformation or translation consists of. Certainly the composition is causally related to certain experiences which the composer had (his secondary material), and the range of these could have included almost anything (Brahms' "blue Italian skies" for his second piano concerto) and not just "emotive-conative states." But Professor Greene apparently means that these states can, while objects and our perceptions of them cannot, be transformed or translated into a pattern of notes and rests, and it is because of this that he limits the materials of music to "emotive-conative states." And with this I should disagree. What would such translation be? Does not translation involve the carrying over of something from one medium to another, and transformation the changing of some entity from one state to another? But are "emotive-conative states" *translated* or *transformed* into sounds? Certainly this is, to say the least, a stretching of the normal meaning of a word.

tent" (no persons or objects or events appear in it as in painting and literature), nor has it a theme in the way that a poem or drama can have a theme. We do speak of a "musical theme," but here the word "theme" is ambiguous: the themes in music are not the Fall of Man or the exploits of Odysseus; they are *musical* themes, occurring entirely within the musical medium. The difference is important. When we ask for the theme of a poem we are interested not in a set of words but in the ideas for which those words stand; but when we ask for the theme of a piece of music we ask for a succession of notes, constituting the principal melody. This is also what we have in mind when we speak of a musical *subject*.[19] Again we are referring to something "mediumistic." Music is sometimes said to have emotions as its subject-matter. But is music "about" emotions in the way that *Paradise Lost* is about the Fall of Man? What would it mean to say that a musical composition is *about* emotions, and how would such an assertion be established? Is it not enough to say that the composer wrote his composition as a result of certain experiences (including emotions) and that the composition when heard also evokes certain experiences?

In the case of painting there is a narrower gap between the primary and secondary materials than there is in the case of music. For the principal (secondary) materials of painting are intuitions of visual objects (whatever else, in other sense-modalities, may be evoked by the sight of those objects), and visual objects are colored and extended; and the primary materials of painting are colored and extended shapes as they appear on canvas. Thus, in the case of painting, the two orders of "material" occur in the same sense-modality. The principal stimulus to painting comes from what the painter, in imagination, *sees;* but the principal stimulus to music does not come from any sounds that the composer *hears,* for the chief stimulus to music lies in internal states, not in auditory ones.

19. Except in rare cases in which we say that the theme (or, sometimes, the subject-matter) of Beethoven's Fifth Symphony is Fate, in the same way in which the theme of *Paradise Lost* is the Fall of Man. But in what sense could this be said to be the theme, and how could such a contention be established? In program music this phenomenon is most frequent. It is said, for example, that Strauss' *Don Quixote* has Cervantes' hero as its theme or as its subject-matter. But in what sense program music can be said to have subject-matter in this sense of the word, that is, to represent objects or events in the world, we shall try to see in Chapter II.

In this respect literature is like music and not like painting; experiences are not like words any more than emotions are like notes.

With these considerations in mind, we may undertake our first principal task, an investigation of the concept of artistic meaning.

2

Representation

When we ask, What does a word mean? we usually mean to ask, What does it stand for? What is it a symbol for? We also ask the question, What does this work of art mean? And we must discover whether our meaning of "meaning" in this question is the same as in the question about the meaning of a word. That is, is there any one thing or group of things that a work of art or any part of it refers to or stands for in the same way that the word "chair" refers to the kind of object that I am now sitting on?

And if there is nothing in art that stands for anything else in this way, does symbolization occur in any other way? What, precisely, is the extent to which in the arts one thing stands for another? This will be the first step in our investigation of artistic meaning.

I

Whenever one item in our experience stands for another, the first item is said to *represent* the other, or to be a *symbol* of the other, while the thing symbolized or represented is called the *referent* of the symbol. We shall use the word "symbol" here to apply to any situation in which there is something that stands for something else—the broadest possible use of the term.

Perhaps the most common type of symbol is that which is generally called a *conventional* or *arbitrary* symbol, which stands for its referent only by a common convention resulting from an explicit stipulation of the meaning to be attached to it. Thus a nod of the head means yes; a shake of the head, no. A red flag means danger; a white flag signifies the desire for a truce. Someone not acquainted with the convention does not know what the symbol

means; he must simply learn that this thing has been agreed to stand for that. It is in this way that words are symbols. The creatures we know as cats could equally well have been referred to by other names, as indeed they are in other languages—for example, "chat," "felix," "Katze," etc. But English-speaking people, for their own mutual convenience, have agreed to designate that kind of object by the word "cat." (There are, of course, the onomatopoetic words which actually sound somewhat like the thing they stand for—for example, "splash," "crack," "bang," "buzz," "whir," etc. But even in these cases the resemblance is generally apparent only after the meaning is already known. Those not knowing the meanings of the symbols in advance would not be likely to have guessed them.)

As opposed to conventional symbols there are the so-called *natural* symbols, in which there is some non-conventional or natural relation (usually either of resemblance or causal connection) between the symbol and the thing symbolized. A photograph of the United States Capitol stands for the object of which it is a photograph, in a natural relation of resemblance; the symbolism need not be learned (except simple conventions like the representation of three-dimensional objects on two-dimensional surfaces), and a photograph of something else would not have sufficed in its stead. A map of the United States also stands for the United States, and the relation is a natural one with respect to the spatial proportions of the two (not with respect to color or to topography, unless it is a relief map). Nimbus clouds stand for or signify rain, not by virtue of resemblance, but by virtue of an observed causal sequence: the one has preceded the other so often in experience that it has come to be taken as a fairly reliable sign of the other. Here again the symbolism is a natural one: there is no man-made convention by which one object has been agreed upon to stand for another; and no other phenomenon in nature would have done equally well in its place.

The difference between natural and conventional symbols can be well illustrated by Professor Pollock's example of the traffic signs:[1] If a man driving an automobile sees a red traffic light at

1. T. C. Pollock, *The Nature of Literature* . . . , pp. 30-31.

an intersection, he puts his foot on the brakes; but there is no "natural" relationship between the red light and the stopping. A green light might have been agreed on just as well;[2] and indeed sometimes a signpost bearing the word "Stop" is used to stand for the same thing. But if the driver sees, instead of a traffic signal, another car coming straight toward him, he makes the same move to stop the car, and here the signal to stop (the approach of the other car) is a natural one.[3] Another symbol chosen at random, such as a glass of water or a toothpick, would not have sufficed in its place. The term "natural" here does not imply "without experience"; the man would not have stepped on the brakes (on seeing the other car) the day he was born; he had first to become acquainted, through experience of the world, with the properties of heavy moving objects, that is, that they possess great momentum and are quite capable of wrecking anything they collide with. The point is that there was no stipulation or convention about it, no code to learn; a natural symbol presupposes some experience, but no convention.

There are many symbols which cannot be classed purely as conventional or as natural—symbols in which there is *some* natural relation between symbol and thing symbolized, but not enough to make the relation obvious without convention; and in most cases another symbol could easily have been substituted. In these cases there is generally some convention or stipulation, but the fact that one convention was selected rather than another is "not an accident" but the result of some (however far-fetched) natural relation. The onomatopoetic words already mentioned are examples of this. A curve in analytic geometry stands for a certain equation; there is here no physical resemblance at all, but there is nevertheless a non-conventional relation—not just any curve could represent the relationship expressed by the equation. That this or that means of graphing the relationship should have been adopted

2. Though, of course, there may have been reasons of appropriateness and suitability in choosing red, for example, that it is brighter and more easily seen from a distance. But this does not keep the symbol from being arbitrary, or agreed on by convention.

3. Strictly speaking, of course, the two do not stand for exactly the same thing. The one says in effect, "The law requires you to stop here"; the other says, "Stop if you don't want to have a collision."

(for example, ordinate and abscissa) is conventional; but once this conventional notation is agreed upon, *only* this curve symbolizes the relationship. Again, a fever-curve is not a likeness of the increase and decrease of heat in the human body, but there is a non-conventional element in the relationship between the temperature and the curve, though different means might have been used to represent it.

> It is important to realize that representation encompasses the extremes of, on the one hand, this inexorable relation and, on the other, the shifting relation of the conventional sign to its term, which it denotes according to a purely arbitrary agreement. Between these poles there is the wide expanse of partly determined representations.[4]

To illustrate this point Bernheimer uses the following example: One function of the representation of the eagle that appears on the American twenty-five-cent piece is purely conventional; it indicates that the coin is valid currency of the United States. It is the result of a convention (which could be altered) of the government with its people that pieces of silver bearing a certain inscription and picture are to be recognized as representing a value of twenty-five cents. The eagle on the coin is a natural symbol, however, in its function of representing a certain kind of bird. There are conventions involved even here (the structure of the bird is only roughly indicated; it does not appear in its true color, etc.), but in general the proportions of the figure on the coin resemble those of the actual bird to such a degree that we can recognize the likeness and identify the bird without being told what the figure stands for. And in a third function, the eagle stands for the strength, freedom, and nobility of the American government. "There are supposed to be in the eagle certain qualities which render it fit to replace by analogy the corresponding qualities in the institution for which it stands."[5] The relationship here is by no means so "inevitable" as in the case of the previous function—a lion, for example, might have been selected to stand for the same set of qualities; and yet these qualities could not appropriately be rep-

resented or symbolized by a snake or a mosquito. This kind of symbol we may call "semi-conventional."[6]

Before we apply this analysis to the arts, a word about terminology is needed. I have used the term "symbol" to denote any relationship of representation, or "standing-for"; but usages differ widely on this point. Carritt uses "symbol" to stand for "conventional symbol" only,[7] while Bernheimer uses, for the three functions of the eagle just summarized, the terms "conventional sign," "image-likeness," and "symbol," respectively. Mrs. Langer, again, distinguishes between a sign and a symbol on the basis of whether the relation is triadic (subject-sign-object) or tetradic (subject-symbol-conception-object).[8] Both signs and symbols are sometimes distinguished from signals, and also from types and tokens. For our purposes here I do not think it is necessary to make these refinements. I think it is most convenient to apply the term "symbol" to all cases of "standing-for," of one thing (not necessarily a material thing, of course) in some sense representing another, and to make the necessary distinctions *within* this general category of symbols: conventional or arbitrary, natural, and semi-conventional symbols.

2

Words are conventional symbols; and inasmuch as one of the major arts—literature—depends for its very existence on the use of words, we have here one example of conventional symbols in the arts. To what extent the use of words simply as symbols is relevant to literature *as an art* is an issue which will be discussed in Chapter IV.

What of our other sample arts, music and painting? Do musical notes, or groups of them, or whole movements or compositions, or similar elements (such as colors and shapes) in the visual arts, stand for or symbolize anything in the way that words symbolize objects and relations? Suppose that someone claims that they do. We could ask at once, "How do you know?" In the case of words

6. Manfred Bukofzer in his article "Allegory in Baroque Music," *Journal of the Warburg and Courtauld Institutes,* III, 1939-40, 2-3.

7. E. F. Carritt, *What Is Beauty?,* p. 91.

8. Susanne K. Langer, *Philosophy in a New Key,* p. 64.

the reply would be "By convention: English-speaking people have agreed to use this word to refer to . . ." etc. But how could we give such a reply in the other cases? What does middle C refer to? What are the referents of the Beethoven C minor sonata? Such questions, it seems to me, are as foolish as they sound. Musical notes have no assigned referents. Neither (in this sense) do the elements in the visual arts.

It might be alleged that "Musical notes (or larger units) refer to whatever their composers decreed that they should—just as, when I invent a word, e.g., 'pirots,' and say that I shall in the future use it to stand for all buildings more than ten stories high, then the word 'pirots' *does* stand for all buildings more than ten stories high, i.e., the word—to myself and to those who adopt my usage—conventionally denotes such buildings." But the two cases are quite different: a word is given meaning by fiat and by subsequent usage. But in music we question such matters of fiat; we might say "I don't think that *La Mer* successfully represents the sea," or, "Debussy intended *La Mer* to symbolize the sea, but *I don't think it does.*"

There are, of course, certain musical phrases which have come to have a conventional meaning; for example, the first four notes of Beethoven's Fifth Symphony have come to symbolize Victory (or in pre-war times, "fate knocking at the door"); but here there is, at the basis of the convention, a natural relationship: the notes easily remind one of knocks at the door, and the structural resemblance between the letter V in the Morse code and the first four notes of the symphony is well known. In Wagner's *Ring des Nibelungen* cycle, each of the principal characters, some of the emotions, and even some of the objects which occur in the operas are symbolized by a "motif" or brief set of notes. The notes are played upon the entrance of the person in question, or even the thought of him, and in the case of the emotions and objects, on each of the important occasions when these are seen or felt or thought of. (Sometimes this method is even used to convey to the listener information which the character in the opera is unfamiliar with, as when the Valhalla motif is played while Siegmund is professing ignorance of his parentage. From this we infer that

Wotan was his father even though Siegmund does not know this himself.) But still, we do not treat these symbols simply as conventions; we say, "What's the connection between *that* set of sounds and Siegfried? Wouldn't another have done better? I don't see any *connection* between them. Why is this motif more appropriate than that?" We look for resemblances between symbol and referent here which we do not in the case of most words. In music (as in analogous instances in painting which we might present), we do not accept the simple fiat of the composer, but we require some non-arbitrary relation between the symbol and the thing symbolized. This kind of relation must now be discussed.

<div align="center">3</div>

Before proceeding to the purely "natural" symbols in the arts, I want to discuss what have been described above as "semi-conventional" symbols, whose importance and prevalence in the arts have not always been fully realized. Again I rely upon music for most of my examples.

In music, which of all the arts might seem to be the one in which symbolism of this sort is least likely to occur, there is abundant illustration of semi-conventional symbols. Manfred Bukofzer in a remarkable article on "Allegory in Baroque Music" cites many interesting examples which he calls "allegory" to distinguish them from purely conventional symbols which he calls simply "symbols."

We find in the music of the sixteenth century on almost every occasion when the text reads "descendit de coelis" a descending melody, and when the text reads "ascendit in coelum" a rising melody. . . . The descent, which is directly expressed in the word "descendit" and which therefore requires no further figurative transformation, is embodied in the descent of the melody.

It should be noted that the descending melody is not an emotional expression of the textual phrase "descendit de coelis"; for these musical figures have nothing expressive about them. They express no emotion or feeling, since the shape of the melody is not defined and may equally well be a descending third, a descending scale, or simply a few descending notes. As far as the allegory is concerned, this is immaterial, as is, for example, the shape of the scales in an allegory of justice; the point is that there must be a pair of scales.[9]

9. Bukofzer, *op. cit.,* p. 4.

To symbolize distance, "when the text reads 'so far,' Bach writes an interval in which the tones are widely spaced . . . Here Bach writes an augmented or diminished ninth. Similarly with the words 'wandered far and wide.' "[10] "Night and darkness" is symbolized by downward intervals, "deepest abysses" in the basses. On other occasions Bach uses the diminished ninth to symbolize, not distance, but anger and horror, on account of its harmonic sharpness. ("It sounds as horrible as the horror he wishes to allegorize.") What precisely is symbolized in each case can be determined only by the context (and in this case, the text accompanying the words).

Sometimes what is symbolized is not anything that could be discovered from *hearing* the music at all, but depends on the written musical notation:

In the cantata "Hercules am Scheidwege" the words "for the snakes which tried to seize me with their lullaby" are represented by winding figures in the bass. To be sure, one hears this rise and fall, but the allegory of winding appears in its clearest shape *only in the musical notation*. The bass is of course not an emotional expression of the snakes, but indicates them by its reference to their convolutions. The melody, however, also indicates the word "wiegend" by constantly representing the stereotyped figure of a lullaby. Here we have two meanings superimposed: the snake in the bass and the lullaby in the vocal line.[11]

Finally, there are examples of one allegory superimposed on another within the same composition. In Bach's cantata "And Thou Shalt Love the Lord Thy God," Mr. Bukofzer traces five allegories proceeding simultaneously. (1) The commandment "Thou shalt love thy Lord" is allegorized by means of a fugue. "All passages of the Bible which are of dogmatic importance and contain a general commandment are set by Bach almost without exception in fugue or canon form. . . . The fugue and canon are evidently an allegory of law, since the fugue and the canon are the most rigid forms of musical composition."[12] (2) To the words of the first Commandment the trumpet plays the chorale "These Are the Holy Ten Commandments," the text of which is taken

10. *Ibid.*, p. 7.
11. *Ibid.*, pp. 12-13. Italics mine.
12. *Ibid.*, p. 14.

for granted as commonly known, to point to the Commandment itself. (3) The melody of the trumpet is taken up by the bass, in a special form known as canon in augmentation. "All the values are doubled, and thereby the Ten Commandments are made the basis of the whole, just as they are the basis of human life."[13] (4) All the while the trumpet is used, as it always is by Bach, as an allegory of the majesty of God (often to the point of representing the voice of God himself). (5) The chorale melody occurs ten times, as a mystical allegory of the number ten.

The musical value of these devices has sometimes been questioned. For Mr. Bukofzer they add rather than detract: "When we recognize the fivefold complexity of meaning and hear it as a simultaneous musical unity, we experience a feeling of immense richness. As we listen, it is as though we were perpetually leaping from one meaning to another. This multiplicity in unity, this combination of spiritual and purely esthetic pleasure, appears to me unique in its intensity."[14] But there is room for argument on this point. In any case, the important point for our discussion is this: Here we have examples of symbolization of a kind which is not simply conventional—there is a natural relation in every one of the above examples, though it may sometimes seem far-fetched and even pointless—nor is it simply "natural" after the manner of the examples listed above under that heading. The convention, though as we saw it has some natural basis, must be known independently of hearing the music, and the recognition of the symbolism is an intellectual one, not something felt, as is generally supposed to be the case in program music (which will be discussed below).

In the baroque period music is a language of signs, in which every sign has one or more meanings; but these can only reproduce things which are more or less known in advance. . . . Baroque music is not, like modern music, a language of feeling, which expresses its objects directly, but a sort of indirect iconology of sound. For this reason it lacks all psychology in the modern sense. The rigidity of baroque music, especially from the rhythmic point of view, has long since been remarked upon. But this is not a weakness of such music; on the con-

13. *Ibid.*, p. 15.
14. *Ibid.*, p. 18.

trary, it is its very strength. The humanization of music by means of a dynamic emotional conception of its nature appears only during the first half of the eighteenth century, when baroque ceremonial—the pigeon-holing of the stereotyped emotions—gave way before the so-called *natural feelings*. To the rising middle-class age the formality of baroque music appeared unnatural, even inhuman. The two styles are based on two different conceptions of music.[15]

If this kind of symbolism—iconology, as Bukofzer calls it— occurs in music, it does so much more in the other arts, which are better adapted to it, and in which the phenomenon is much more familiar. Paintings, especially in religious traditions, are full of iconographic significance. The sheep is a symbol of Christian discipleship; the flat gilt background is a symbol of eternity as opposed to our world of space and time; white symbolizes purity; the halo symbolizes the holiness of a divine being. Acquaintance with these symbols is presupposed, and without them one cannot go far in understanding the work. (In some symbols, such as the halo, the symbolism is almost entirely conventional; in every case it must be learned. Certain specific symbolisms must be known before an appreciation of the work is possible.) Moreover, acquaintance with the Bible narratives is presupposed by all the painters in the Christian tradition. One unacquainted with this tradition may appreciate a work like the famous *Pieta* of the School of Avignon as a pleasing interplay of forms and colors and as a moving human document, but he will miss its peculiarly Christian significance, and he will be puzzled by many things in the painting, such as the compositional arrangement of certain figures and the contrast of the realistic three-dimensional figures with the flat gold background.[16] In my opinion, acquaintance with the conventional and semi-conventional symbols in painting is much more necessary in regarding certain kinds of painting than in listening even to baroque music.

In literature, particularly in poetry, such symbolism is fairly common. A poem such as *Paradise Lost* is full of it, as every reader knows. Sometimes the symbolism permeates a whole poetic tradi-

15. *Ibid.,* p. 21.
16. Cf. Greene, *The Arts and the Art of Criticism,* pp. 285-88.

tion, as is the case with pastoral poems from Vergil to Shelley; again it is characteristic of one age in particular, as of seventeenth-century English poets but not of the Romantics; sometimes it is peculiar to one poet or even to one of his works, as, for example, the system of images in *Othello* as contrasted with that of *King Lear* (discussed in essays by Caroline Spurgeon and G. Wilson Knight). Sometimes the symbols approach the point of being purely conventional, but generally there is enough of a natural relation between symbol and thing symbolized to justify their classification as "allegory" (as Bukofzer defines it). (In some cases the symbolism more nearly approaches the conventional than in others, and the distinction between conventional and semi-conventional symbols is not a sharp one but proceeds by degrees, so that in certain instances it would be hard to say in which classification a particular symbol falls.) As in the case of iconographic painting, it is impossible to appreciate fully a poem such as Milton's *Lycidas* without a fairly thorough acquaintance with the conventional and semi-conventional symbols of pastoral poetry. Most readers feel about it as Bukofzer does about baroque music, that the experience of the work of art is enhanced and deepened by this symbolism, and that the reading of *Lycidas* would not be nearly so rich a poetic experience as it is if it were not overlaid with this symbolism (though it goes without saying that the presence of the symbolism often inhibits enjoyment at the start). In every case the symbolism must be learned.

This is not the place in which to give an exhaustive account of particular symbols that occur in the various arts; my concern here is to point out their existence, distinguish their various types, and eliminate certain confusions current in discussions of them. The conceptual framework, not the individual examples of things falling within that framework, is the business of this study.

4

We come now to "natural" symbols. What do works of art "naturally" symbolize? There are several obvious respects in which works of art, or (more commonly) various elements within them, stand for other things in some sort of natural relation, and

I shall mention these first. (In this particular context the word "represent" is more common than "symbolize," though I see no real difference between them.)

And the first sense in which works of art, or parts of them, represent other things is that in which a painting may represent a person or a landscape, or a novel a situation from life. This requires some amplification.

In discussing material and subject-matter in Chapter I we saw that all the arts have life as their material; their production is caused by, and would not have taken place without, certain life-experiences. But I think that no one would say that on this account the work *represents* those experiences. (If someone did, then for him all the arts would be equally representational.[17])

We may accordingly dismiss this as an example of the kind of representation we are discussing. However, the sense in which a painting represents Napoleon cannot be thus dismissed. The sense I am speaking of here is the first sense of "subject-matter" mentioned in Chapter II: in this sense, if a work of art has a given thing as its subject-matter, it is said to imitate or represent that thing, and hence to symbolize it (and the symbolism is of the natural type because there is a close natural relation, namely, likeness or resemblance, between symbol and thing symbolized, object representing and object represented). No art, as we have already seen, imitates anything photographically; but some "realistic" art approaches this point as a limit, and the more nearly it approaches it the more nearly we have "pure imitation" of the original, or literal representation. Paintings, as we saw in Chapter I, may imitate, more or less, actual existing persons or scenes, and literature (especially novels) may imitate with greater or less fidelity the actual sequence of historical events. (Just how closely this ideal of "pure realism" can be achieved will be discussed in Part II.) Whether they do so is, generally speaking, artistically irrelevant: to learn that there was a historical character Odysseus whose adventures the *Odyssey* "imitates" in every detail would not make the

17. I use the term "representational" instead of the more often used term "representative" in order to avoid confusion of language. The term "representative" has other connotations, such as "typical," which has no relation to the concept in which I am interested here.

Odyssey a better or worse work of art. But it would make the *Odyssey* representational of something outside itself which now it is not.

Imitation—to repeat the remarks about subject-matter in Chapter I—is a matter of degree; in no case does it reach 100 per cent. (Even a photograph which we may consider a perfect likeness appears in two dimensions only, whereas its original appeared in three.) And as the degree of imitation becomes less and less, that which is imitated becomes less and less the "model" which is copied and more and more simply a stimulus to the artist or foundation from which the rest was built through his creative imagination—it becomes, that is to say, his (secondary) material rather than his explicit subject-matter (in the first sense of that term).[18]

The case is clear enough in the so-called representational arts of painting and literature, but what of music? Can music represent (in this sense of "literally imitate") anything? Painting can imitate, to a very close approximation, visual scenes from life; literature may imitate (not directly through a sensuous medium as painting does, but indirectly through the symbolic medium of words[19]) any kind of situation; but the position of music in this scheme may well be questioned. It seems clear that just as painting can directly imitate or reproduce (when it does so at all) the *sights* of life—only what can be sensed through the visual sense-modality can be directly represented on canvas—so music, if it reproduces anything from life, can reproduce only its *sounds,* that is, only what can be sensed through the auditory sense-modality. And it

18. If it be held that the sense in which I have been using the word "imitation" is an unduly narrow one, and that one thing can imitate another even if it is not an *exact* imitation, I can only point out the distinction already made, that to the extent that it is less exact, it becomes more and more merely the *material* of the work of art. To continue to use the term "imitation" as the departure from exactness increases is misleading and dangerous. Suppose, for example, that someone says that the artist *always* imitates something, namely an ideal in his own mind; but if we use "imitation" in this sense, the word becomes quite unmeaning through the very fact of its being applicable to everything and hence distinctive of nothing. Every work of art represents in this sense of representing (imitating, copying) some idea or conception or image in the mind of the artist. Moreover, I do not think that this is a customary way of employing the word: most persons, when they speak of a work of art as imitating something, do not mean anything in the artist's mind but something in the world, something external to both the artist and the work of art in question.

19. On this double medium of literature, see Greene, *op. cit.,* pp. 350-53.

should be equally clear that among sounds, music can represent (in the present sense of reproduce, imitate) only a very small number, since music is composed only of sounds which are reducible to a musical scale, and in nature we find almost no sounds at all which are thus reducible. As Hanslick says:

The systematic succession of measurable tones which we shall call *melody* is not to be met with in Nature, even in its most rudimentary form. Sound-phenomena in unassisted Nature present no intelligible proportions, nor can they be reduced to our scale. . . . Just as little as melody, do we find in Nature . . . *harmony* in a musical sense, the simultaneous occurrence of certain notes. Has anybody ever heard a triad, a chord of the sixth or seventh in Nature? Harmony like melody is an achievement of man, only belonging to a much later period.[20]

It is true that the third factor in music, rhythm (harmony and melody being the first and second), is to be found in nature.

In the galloping of the horse, the clack of the mill, the singing of the blackbird and the quail, there is an element of periodically recurring motion in the successive beats which, when looked at in the aggregate, blend into an intelligible whole. . . . But the point in which natural rhythm differs from human music is obvious: in *music* there is no independent rhythm; it occurs only in connection with melody and harmony expressed in a rhythmical order. Rhythm in nature, on the other hand, is associated neither with melody nor harmony, but is perceptible only in aerial vibrations, that cannot be reduced to a definite entity.[21]

Such sounds as the murmuring of a brook, the roar of the ocean, the howling of the wind, are not music, but noise—"an irregular succession of sonorous pulses," a mixture of sounds of many different frequencies. "Very seldom, and even then only in an isolated manner, does Nature bring forth a *musical idea* of definite measurable pitch. But a musical note is the foundation of all music."[22]

Seldom or never, then, can the imitation in a musical composition of a sound in nature be exact. However, there are works of music which do purport to represent sounds in nature—for example, Debussy's *La Mer,* Stravinsky's *Le Sacre du Printemps,*

20. Edouard Hanslick, *The Beautiful in Music,* pp. 144-45.
21. *Ibid.,* pp. 145-46.
22. *Ibid.,* pp. 149-50.

Delius' *Brigg Fair,* to mention a few at random. But it should be evident that such works do not literally imitate sounds in nature—they only resemble them to some degree, usually to such a small degree that we must know the title of the work before we can be quite sure what it is that the music is supposed to represent. Without the title, we might not associate *La Mer* with the sea at all. But once the title is given to us, it is helpful in our enjoyment of the music. (In many other cases, however, it is quite adventitious, and we could enjoy the music just as much if we associated it with something quite different. Some composers write an entire composition before they decide what to call it: "Now that the piece is finished, does it sound more like a savage dance or a powerhouse?" they ask themselves, and the result is often a toss-up.)

Sometimes a musical composition is designed to imitate other than auditory phenomena, in fact whole scenes from nature or life. Mussorgsky's *Pictures at an Exhibition* and Debussy's *Reflets dans l'eau* and *Nuages* are examples of this. We have already seen that musical compositions cannot strictly imitate anything but sounds; but it is true that certain combinations of notes can, by sundry conscious or unconscious associations, serve to *remind* us of, or evoke in us the *impression* of, certain scenes or objects or events in nature and life, including sounds. And I think most persons would agree at least in the case of the first two compositions mentioned (*La Mer* and *Le Sacre du Printemps,* which, incidentally, are intended to represent visual and organic sensations as much as auditory ones), that they are successful in evoking in us the feeling and images of the things indicated by their titles. The question of *how* music, being composed of auditory stimuli, can evoke in us the impression or feeling of scenes in nature, particularly of non-auditory presentations, is a complex psychological problem which it is not the purpose of this book to investigate. If we are not sure of the explanation, however, we are very sure of the fact; and the fact is the cornerstone of all program music, without which it could not exist.

The following objection may be raised at this point: "But if program music generally doesn't resemble or imitate its program enough for us to know what the program is without being told,

then doesn't it belong in the class of semi-conventional symbols along with Bukofzer's musical allegory?" Now, the sense in which program music can be said to consist of natural symbols will be discussed shortly; but even at this point program music can be distinguished from allegory. The possibilities are the following:

1. Imitation so exact that we would mistake the imitation for the thing imitated. This never occurs in music, as the quotations from Hanslick abundantly show. It does not occur in painting, nor even in sculpture, where, for example, the uniform coloration and the obvious "stoniness" of the statue of Lincoln (among other things) prevent us from mistaking the statue for Lincoln himself.

2. Imitation which one would not mistake for the original, but close enough to the original so that we would be able to guess it without being told. This occurs often enough in painting, but seldom in music, though it may in such instances as the representation of bells and thunderstorms, cuckoo calls and fanfares. (In cases where certain sounds in the orchestra have come to signify certain other things by *convention,* the identification of course is easy; but these would not be cases of "natural" imitation.)

3. Imitation which is sufficiently unlike its original so that we must usually be supplied with some indication of its nature (such as hearing the title or learning the intentions of the composer) other than simply hearing the music. This is true of most program music, although once the program is known, and the listener's response is thus channelized, the enjoyment is generally enhanced (if the program really "fits the music") through the association of the emotions and images produced by the music with those produced by the program. The relationship felt between the music and its program is close enough so that no convention is required, other than the initial one indicated by the title (which actually serves as a means of directing the listener's feeling, "setting his responses going"). If some alleged program were obviously unsuited to the music, the program would simply be ignored.

4. Representation which possesses so little in common with its original that it can scarcely be called imitation at all. To illustrate: when the chorale theme is introduced ten times in order to symbolize the mystical number ten, the *natural* relationship is so feeble

that its effect on the *feelings* of the listener is apt to be of little importance. As Bukofzer himself says, the allegory is something grasped by the intellect, not felt and responded to in the way that program music is: "Allegories are fundamentally unpsychological; they are intellectual."[23]

The difference between program music and "pure" music is, I think, one of degree. Program music may be defined as music which evokes in most listeners the impression of specific objects or situations (some might prefer to say, music that was *designed* to do so). Strauss' tone-poems, I daresay, do this for most of us, while a Mozart concerto or a Haydn quartet probably does not do it for any of us. Between the two there exists what we might call "descriptive music" of all degrees; just at what point a given composition ceases to be "program music" is not always easy to determine, and depends on how inclusive we choose to make this class by definition. For example, compositions such as Shostakovitch's Symphony No. 1, Smetana's quartet *Aus Mein Leben*,[24] Dvorak's *American* quartet, and Brahms' *Academic Festival Overture* are not quite "pure" music, as Haydn's is, but on the other hand they are not quite program music either; this intermediate music does not remind us of concrete persons or scenes or situations, but simply evokes in us some dominant mood akin to what we feel outside music and to which we assign some definite name. Thus we might classify the transitions to program music as follows (I am not taking into account here such mixed forms as opera and song):

1. Program music: evokes the impression of some definite object, event (*Soviet Iron Foundry, The Swan of Tuonela*—to give an example from each extreme of this class) or series of events, that is, a story (*The Sorcerer's Apprentice, Till Eulenspiegel, Ein Heldenleben*).

2. Semi-program or descriptive music: evokes some definite mood-effect connected with a place or object or situation but does not attempt to imitate that object or tell a story; for example,

23. Bukofzer, *op. cit.*, p. 18.

24. Smetana said of this quartet, "I wanted to paint in sounds the true course of my life." But certainly the quartet does not and cannot do this, except in the weak sense of evoking in the listener experiences which may be similar to (or at least serve to remind us of) experiences in life such as we, together with the composer, may have had.

Dvorak is "Bohemian"; Mussorgsky is "Russian"; the *Coriolanus* Overture gives the impression of the pomp, pride, and suffering which marked the career of the Roman monarch, although it is not a story of his career in the way that *The Sorcerer's Apprentice* tells the story of the tale for which it is named.

3. Pure or abstract music: almost any instrumental piece by Haydn, Bach, Mozart. It evokes emotions but is unattached to definite life-situations.

The shading between (1) and (2) is gradual. For example, we might call most of Mussorgsky's music "Russian" (*why* it evokes this impression in most listeners is not an easy question to answer— I am convinced that our conception of what is "Russian" in music is shaped as much by hearing Mussorgsky's music and knowing certain facts about him as our judgment of Mussorgsky's music is shaped by a previous conception of Russian music; but that is another question). But if this impression became definitely specified enough to become "Russian landscapes in winter," then I think we would have no hesitation in calling it out-and-out program music—though still not quite so much as we would if the program were narrowed down to "this particular monastery in Russia in winter."

From (2) to (3) the transition is also gradual. Beethoven's music (with certain exceptions) does not have any program, nor is it "descriptive music"; but yet it is not quite so "abstract" as that of Haydn or Mozart. It evokes too definitely certain dominant moods, such as exultancy, pride, triumph, struggle, "noble grief," etc., although none of these is associated with a specific life-situation as in the case of the *Coriolanus* Overture.

It is perhaps needless to add here that the merit of program music does not depend on its value as representation. As Ernest Newman says, "The only esthetic fact we can be sure of is this, that no piece of representation will be tolerated unless it is at the same time *music*."[25] Some persons, indeed, prefer to define program music as music which *depends* for its effect upon knowledge of what the program is (the extent of the dependence is not made clear), and cannot be enjoyed without this knowledge; if we can

25. Ernest Newman, *Musical Studies*, p. 186.

enjoy it (how much?) without knowing the program, then, on this definition, it is not really program music. For example, the third movement of Beethoven's *Pastoral* Symphony has a program, but to enjoy the movement we need not be aware of one. There is musical value without knowledge of the program: even the thunder and lightning are taken up into the texture of the music as soon as they appear. But I think that this would be a highly prejudicial definition of program music. For on this definition, all program music would be "bad" music. And there is certainly a great deal of music which on any ordinary definition of program music would be called by that name (e.g., Debussy's *Reflets dans l'eau*) but which does not depend on the program for its success; that is, it is enjoyable as such even without knowing the program (even if Debussy had never supplied it with a title), although it may well be more enjoyable when we do know the program.

Now in what sense, if any, can a work such as *La Mer,* which calls up various images of the sea, be said to represent or symbolize the sea?[26] I suppose it must be admitted that a locution such as "*La Mer* represents the sea" is justified by common usage; but we must see at once how this case of "representation" or "symbolization" is different from others mentioned above and to be mentioned later. For by saying that *La Mer* represents the sea we cannot justifiably say any more than that it evokes the impression or image or feeling of the sea in certain persons; and when we say that there are other works of music which represent reflections in water and pictures at an exhibition we can mean no more than that this evocation occurs. And it must be seen at once that such "representation" is a subjective matter; to some persons parts of *La Mer* sound like a railroad train rushing through a tunnel, the frenzied dances of goblins, etc.; they declare that for them it bears no resemblance to the sea at all, and evokes no impression of it ("It doesn't represent the sea to *me!*"). "Represent" in this sense is always "to you" or "to me," never just "represent." I doubt whether

26. The qualifications of this type of "representation" to the title "natural symbolism" will be discussed in the next section along with all other theories which hold that music "naturally symbolizes" some evoked effect (of which this type of music as a natural symbolism would simply be an instance).

most persons, if they were aware of this, would dogmatically assert that a certain piece of program music simply *represents* this or that; they would probably decline to attach this title to it if they realized how subjective this appellation (when used in this sense) really is. But in what other sense could *La Mer* possibly be said to represent the sea?[27]

A further limitation must be mentioned here. The word "represent," even in this limited sense, would not, I think, be used to refer to *all* kinds of evocation by music. Beethoven's music evokes definite moods and impressions, but we would scarcely say that it *represents* them; we would be more likely to say that it *expresses* these moods (the next chapter will be devoted to the concept of expression). A composition evoking joy, for example, would not ordinarily be said to represent that emotion. Yet we do say that *La Mer* represents the sea. Why apply the word in the one case and not in the other? I think the criterion is this: the usage of "represent" here is such that it applies to the impression of concrete events or objects or situations, such as we have in program music, and not to abstractions like moods or emotions. But we must remember that even in the case of program music, where the word "represent" is commonly used because it does refer to concrete objects and events, it can refer only to evocation of the subjective kind I have mentioned, and cannot be used in the stronger senses in which it is applied to the other arts.

Other arts than music, of course, "represent" in this (second) sense of the term, inasmuch as they evoke in us the impressions of all sorts of different things. But I do not think that we would ever say that works of art in the visual or verbal media "represent" whatever objects they remind us of or whose image they create in us. We only say this in the case of music because in music there is nothing (no scenes or characters depicted) *in* the work of art, as there is in these other arts (as will be illustrated in the next section by the third sense of "represent"); so that if we want to say, as many people seem to, that music "represents" anything, then, being deprived of these more obvious cases of representation in

27. If someone objects at this point, "It represents the sea because Debussy intended it to," he is referred to p. 34 above, where representation by fiat is discussed with regard to music.

the other arts, we have to resort to this weak and strained sense of the word in which "to represent" means merely "to evoke the impression of."

Indeed, I believe that this weak usage of "represent" and "symbolize" deprives these words of an important part of their usual meaning. For is it not central to the meaning of these words that the state of standing for something else be a fairly uniform and stable one? When a word symbolizes a concept, the use of the symbol to mean just what it does is a convention among a considerable body of people—it does not symbolize the thing at one moment and cease to the next. Nor is it a matter of whim or caprice that a photograph (naturally) symbolizes or represents the object photographed. There are subjective overtones of meaning, but we generally refer to these differently: we say: "The word 'snake' means (symbolizes, represents) such-and-such a biological species, but to *me* it expresses (not symbolizes) everything that is horrible." However, I recognize that usage, here as elsewhere, is ambiguous; usages overlap—people do say, "This music to me *represents* the Russian spirit," for instance, where "express" would be more normally used. My point is simply that if "symbolize" is to retain any *distinctive* meaning, I think it should be restricted in such a way that it does not cover ground which is already covered by other words: The symbolic state must be independent of subjective fancy, either through a recognized convention or through some natural relation.

5

We have now considered two senses in which a work of art, or some part of a work of art, can be said "naturally"—not by convention—to represent, symbolize, stand for, something else. The first sense consisted simply in imitation of something outside; the painting and the novel represent some historical personage, for example (the painting directly through shapes on canvas, the novel indirectly through words describing the personage), and the musical composition can represent certain sounds in nature to an extremely limited extent. But many musical compositions do purport to represent something, often things which are not sounds at

all, and this fact led us at once to consider a second sense of "represent" in which "to represent" means merely "to evoke the impression of (in one person or another)." This, we saw, is a sense so weak that it is seldom or never applied in the visual and literary arts where representation (in the first sense, and another yet to be mentioned) of a much stronger and more obvious kind abundantly occurs; but music, almost entirely lacking representation in these senses, is sometimes said to possess it (particularly in program music where what is represented is usually concrete objects and events) in this weak sense which would deprive the term of its distinctive meaning.

To pass on now to a third (and last) sense in which works of art "naturally" represent or symbolize: One sense of "subject-matter," as we saw in Chapter I, refers to the "representational content" of the work—the men and trees and clouds shown in the painting, the characters and situations and events depicted in the drama. These things are clearly *represented* in the work, and it is important to see how this differs from other senses of the word. In this sense of "represent," the character is represented in the novel; the tree is represented in the painting. It is there—before us in the work itself; representation here does not consist in correspondence with (imitation of) some object outside the work; this would be representation in the first sense mentioned above. True, there *are* men and trees and clouds in nature outside the work of art, and it is in virtue of this fact that we do recognize these representations in the painting to be representations of these objects; but the fact remains that *this* man is on the canvas, not outside it (just as, in literature, there is no Odysseus outside Homer's epic). Colors and shapes are arranged in such a way as to represent a man, and the man exists in the painting regardless of whether he is the likeness of any particular existing man outside the painting or not.

In this sense, the sense in which the man is in the painting, there is no representation in music (either as heard or as read); nothing is or could possibly be represented in music in the sense in which the man is represented in the painting; in the succession of sounds we hear there is no object presented to us, nor could there ever be

one. And it is in this sense of representation, accordingly, that we can say that music is a non-representational art while painting is representational. Music, as we have seen, can evoke the impression of all sorts of things, but no object is in the music in the way that it is there on the canvas. In a somewhat less direct way, literature too can be representational: the characters and events depicted do not appear on the printed page as the figures in the painting do on the canvas—we must construct them out of the words and sentences; nevertheless, through this symbolic medium of words, Tom Jones and a whole series of his adventures can truly be said to be represented in Fielding's novel.[28]

A curious and interesting difference between literature and painting may be observed in this connection. Because of the linguistic medium of literature, which can name and describe in words, we can safely say that individual characters such as Tom Jones and Becky Sharp and Ernest Pontifex are represented in works of literature, even though they do not literally appear on the printed page. But particular persons with names are not represented *in* painting. Orestes is certainly represented in the drama *Elektra,* since the dramatist uses his name and this is a part of the play itself; while all that is represented in the painting *Orestes,* which Hanslick mentions, is a man of such-and-such a description, with this color of hair, that posture, in such surroundings, etc. The man of that description is represented in the painting; while the drama, working in the medium of language, clearly represents Orestes. That the painting is a painting of Orestes (judging by the title the painter has given it) is a fact outside the painting, for if the painter were to change the title, the painting would presumably become a painting of somebody else, *although nothing in the painting had been changed*—a clear indication that there is no Orestes *in* the painting; that is, Orestes is not represented in the painting in the (third) sense of "represent" now under discussion. In this sense the word refers to "representational content," namely, something *in* the painting. All that is represented

28. Tom Jones is not represented in the first sense, since there never was a character Tom Jones to represent. And the second sense is so weak that only in music, where no other is possible, would it ever occur to suggest it or to use the word.

is a man of such-and-such a description; *that* representation cannot be changed by a change of title or by any change whatever other than an alteration of the painting itself.

Before going further I want to forestall one possible criticism by giving a clearer statement of what may be said to be "outside" and "within" a work of art. Strictly speaking, nothing can be said to be *in* the work of art except the notes and rests in the music, the colors and shapes on the canvas, the words and sentences in the poem—what Professor Greene calls the "primary medium." For example, it is often said that there is much emotion in a work of music; but this, surely, is not strictly true, for I find the emotion in myself, as a result of hearing the music; and no matter how closely I may examine the music (either the score or the sounds I hear at a performance) I cannot find any emotion in *it*. All I can really assert to be in the music is the particular combination of notes and rests which is indicated by the score or played by the performers.[29]

If someone were to say that the only things *in* the painting were the particular configurations of colors present, and not the objects which those configurations were intended to represent, I would see no way to disprove him except to ask him whether (in the case of representational painting) he did not see the representations of men and objects before him on the canvas, and whether he would not say that these too were in the painting. If he denied that they were, I could ask him, "You mean that this configuration of colors and shapes here could be construed as representing something *other* than a man?" And in most cases it would be obviously absurd to interpret these colors and shapes as being anything else. He might still insist that the man is not in the painting in the way that the colors and shapes are but he would certainly have to admit that the man is a *construction out of* the painting, and moreover an *inevitable* construction out of it, so that

29. A deeper question (which I would rather discuss) is presupposed in all this, namely, the definition of a work of art itself. Must a work of art be defined in terms of the experiences of those who observe (hear, read) it? All I am doing here is to analyze the way I think "enlightened common sense" would deal with the question of what is in a work of art, for example, whether a human figure is in a painting or an emotion in music, leaving the more ultimate question (which would require a lengthy discussion) unanalyzed.

no one could take that combination of colors and shapes to refer to ("represent" in the third sense) anything else but the figure of a man. For there he is, before us on the canvas; and if he is not *in* the painting as the colors are, he is at any rate "representational content" in a way that nothing in music could ever be; and I think we would have to add that common usage would certainly justify us in saying that the man is in the painting, even though this might not be true in quite the strict sense in which the colors or the brushstrokes are in it.

At this point someone may object, "But if there's a man in the painting, there can be sadness in the painting; and yet you've just said that there can be no sadness *in* the music!" Now, to say that there is sadness in a painting may or may not be the same sort of thing as to say that there is sadness in a piece of music, depending on what is meant by the expression. If we mean that the painting evokes in us a certain feeling of sadness, then the emotion is certainly in us, exactly as in the case of music which we have just described; and in this sense we have no warrant for saying that the sadness is in the painting, although it may well be that the painting is of such a nature as to evoke in most observers a feeling roughly describable as "sadness." But if we mean that there is, for example, a woman in the painting whose face registers sadness, then, insofar as the sadness is recognized as a characteristic of her, the sadness is in the painting in the derived sense that it is a characteristic of the woman who is in the painting. Emotions occur only in sentient beings; but in music no sentient beings are represented, hence no emotions. You cannot have the smile without the Cheshire cat.

The same is true of lyric poetry and of all poetry in which no characters and events appear. And where they do appear, the emotions are "in" the poem only to the extent that they characterize persons who appear in the poem. The poem thus does not literally contain emotions, although it may well have emotions as its secondary material, and it may also evoke emotions in the listener or reader. Thus to say that a poem *evokes* certain emotions must be sharply distinguished from saying that it *represents* (in the third sense we have been discussing) these emotions. We might

be tempted to say that the poem *expresses* these emotions; but the notion of expression will be examined in Chapter III.

6

We have now discussed three respects in which works of art, or elements in them, can be said to be natural representations or natural symbols of something. It may seem, however, that some or all of them are of little artistic relevance; the fact that a man is represented on canvas, or that a novel reproduces point for point the details of some historical event, or that a piece of music has a program (the first, third, and second senses respectively), does not make it a work of art.

When one says that a work of art, or something in it, is a natural symbol, he may often mean that it is the *symbol for some evoked effect,* usually some complex of emotions. This means, presumably, that every time a certain combination of notes is sounded (and it may vary greatly with the context of surrounding notes), we are supposed "naturally" to have some unique emotional state (and since emotional states of any complexity are difficult if not impossible to describe in words, it is hard to see how one could be sure that any group of emotions was actually being felt in any given case); or that, as French symbolist poets taught, a poem is a natural symbol for—and should naturally evoke—a certain unique emotional state, which the poem alone is able to evoke. Some evocations, on this view, are natural while others are not, just as the other car in our example was a natural symbol while the red light was not. The poem is a natural symbol, that is, granted a certain sensitiveness perhaps, and *after* a certain amount of experience with poetry, just as the approaching car's function as a natural symbol presupposed some experience of the world.

If musical notes or certain combinations of lines and forms or juxtapositions of words or entire poems are natural symbols of certain evoked states (we need not insist that they be simply emotional states, though emotion doubtless predominates), what kind of natural symbols are they? There is no *resemblance* between notes heard or forms seen and the emotions they evoke, or between

the structure of any pattern of notes or words and the structure of the evoked effects which they are supposed to symbolize (indeed, what would the "structure of an emotion" be? do emotions have structures?). Nor does there seem to be any necessary or natural causal relationship between the musical notes heard by any given listener and the emotional effect evoked in him by those notes; why one reaction should be more natural than another I cannot imagine. Is it natural for us to feel solemn and religious in the presence of funeral marches? But surely this is largely dependent upon association; in Italy the gayest of airs from Verdi operas are sung in churches, shocking American visitors. Which is the "natural" response to Chinese music, Oriental enjoyment of it or American bewilderment? In general, horizontal lines give the effect of restfulness, jagged lines of conflict and turmoil, vertical lines of attention and unrest, some lines of voluptuousness, others of ease, etc. But there are endless exceptions to this, and in any case is it more than a statistical report? Would someone who did not receive these feelings from a given set of forms be having an "unnatural" response? How could such a theory be defended? Nimbus clouds are natural symbols of rain; they would not be such if rain did not actually follow the appearance of such clouds in some cause-and-effect relation. But would the defenders of the natural-symbol theory of music be willing to say that the emotional effects which are as a matter of fact usually evoked by a given piece of music (if indeed any single kind of effect is "usually" evoked at all) are the natural ones? On the contrary, they would probably say that certain evoked effects are the natural ones even if at a particular time musical taste were so degenerate that no one as a matter of fact experienced these "natural" effects. But then what would make them natural—and how would the defenders of the theory go about refuting anyone who declared that not this but another set of effects was the natural one? or that no set at all was natural? The theory breaks down because there is no discoverable *causal nexus* (Hanslick's phrase) [30] between any given

30. Cf. Hanslick, *op. cit.,* p. 25: "There is no *causal nexus* between a musical composition and the feelings it may excite, as the latter vary with our experience and impressibility. The present generation often wonder how their forefathers could imagine that just *this* arrangement of sounds adequately represented just *this* feeling."

combination of notes and any specific set of emotional effects, or of referents of any other sort.

How many compositions by Mozart were thought by his contemporaries to be the most perfect expression of passion, warmth, and vigor of which music was capable. The placidity and moral sunshine of Haydn's symphonies were placed in contrast with the violent bursts of passion, the internal strife, the bitter and acute grief embodied in Mozart's music. Twenty or thirty years later, precisely the same comparison was made between Beethoven and Mozart. Mozart, the emblem of supreme and transcendent passion, was replaced by Beethoven, while he himself was promoted to the Olympic classicalness of Haydn. The *musical* merit of the many compositions which at one time made so deep an impression, and the esthetic enjoyment which their originality and beauty still yield, are not altered in the least by this dissimilar effect on the feelings of different periods.[31]

Hanslick gives the following bit of advice to those who would say that music symbolizes[32] anything, particularly human feelings:

... Let them play the theme of a symphony by Mozart or Haydn, an adagio by Beethoven, a scherzo by Mendelssohn, one of Schumann's or Chopin's compositions for the piano, anything, in short, from the stock of our standard music; or again, the most popular themes from Overtures of Auber, Donizetti, and Flotow. Who would be bold enough to point out a definite feeling as the subject of any of these themes? One will say "love." He may be right. Another thinks it is "longing." Perhaps so. A third feels it to be "religious fervor." Who can contradict him? Now, how can we talk of a definite feeling being *represented,* when nobody really knows *what* is represented? Probably, all will agree about the beauty or beauties of the composition, whereas all will differ regarding its subject. . . .[33]

What, indeed, could be the criterion of whether a certain composition symbolizes state x or state y? How would disagreements

31. Hanslick, *op. cit.,* p. 25.

32. Hanslick uses the word "represent" instead, but it seems to be quite clear from the context that he is using the word in a way that does not mean "to imitate" or "to evoke" or "to contain as representational content"—the three senses of "represent" dealt with in the preceding sections—but rather "to be a natural symbol of some evoked effect." This at any rate is the most charitable interpretation; but his use of the word "subject" might lead one to suspect that he meant "subject-matter," something that the music was *about*— a conception I have tried to deal with in Chapter I. Or perhaps he has no clear meaning at all attached to the word.

33. Hanslick, *op. cit.,* pp. 43-44.

about this matter be settled? And who would determine the criteria? This line of argument seems to me to be a fairly powerful one. If it is impossible to say what is symbolized, or to offer any criterion for determining how we know what is symbolized, and if in a difference of opinion there seems to be no way of deciding among the disputants, what are we to conclude?

Professor C. C. Pratt has advanced a theory to the effect that some affective states, such as the sensations of rising, falling, soaring, springing, surging, trembling, and whispering, are properly *in* the music, not merely read into it. We have already noted the incorrectness of saying that any emotion or other evoked effect is *in* the music; but the point of his theory can just as well be rendered by saying that certain felt effects are naturally (some might say necessarily—though the meaning of that term in this context is far from clear) connected with certain combinations of notes, that is, naturally evoked by them. He tries to show, for example, that the "sense of finality" which we sometimes feel in hearing certain musical passages—presumably the feeling just before the end that "we can feel the end coming"—is really "in the music" or (in the more accurate locution) naturally felt as a result of the presentation of this or that particular combination of notes. He defines "sense of finality" strictly in terms of the notes themselves:

Finality is a function of four stimulus-variables: power of two, simplicity of ratio, falling inflection, and width of interval. If three of these factors are kept constant and the fourth varied, a generalization can always be stated in terms of each of the variables to the effect that of the two sequences of tones the more *final* one is that in which (1) the power of two occurs on the last note, (2) the last two notes sustain the simpler ratio, (3) the order of vibration-frequencies is from greater to smaller, and (4) the difference between the frequencies of the last two notes is smaller. In any one phrase more than one variable, of course, is at work. The more difficult problem is then to determine the *relative* influence of the four variables. In spite of troublesome complications this task has been accomplished by means of certain methods of mathematical weighting. For the present purposes it is enough to point out that ways may be devised for analyzing out the relation of musical character to stimulus-conditions. . . .[34]

34. Carroll C. Pratt, *The Meaning of Music*, p. 209.

Now such a study may be very useful for certain purposes, e.g., for enterprising young composers who want to achieve certain effects; but its value for our study is limited by the fact that when we talk about "sense of finality" in music, or for that matter of flying, tension, rushing, etc., we mean to speak, not of the objective physical pattern of sounds (or written notes), but of a certain state of feeling which may result from hearing these sounds. Suppose that a listener heard a passage of music fulfilling all of Professor Pratt's criteria for "sense of finality" but failed to have the experience of "finality" or "coming-to-a-close." One might reply that such a listener was not feeling what he ought to feel upon hearing the passage; but this would be dogmatism. It is always possible to define something out of existence by refusing to give a certain name to a phenomenon that has usually been designated by that name; and in this way Professor Pratt might say that this passage did have "sense of finality" because he had so defined it. But the fact remains that the usual usage of the term is psychological or experiential, and applies to one's feeling, not to the notes; and if the listener does not feel this "finality," no amount of analysis and arbitrary definition can make him do so. It may well be, and indeed is undoubtedly the case, that most listeners do feel a "sense of finality" when Professor Pratt's four conditions are fulfilled in any actual composition, and it is interesting to know at any rate that his subjects in the laboratory felt it; and this is doubtless the basis for his attempt to correlate a certain physical pattern of notes with a certain kind of feeling; but still, if sometime the correlation should fail to hold (that is, if a person did not "feel the finality" even after repeated trials, although the four physical conditions were fulfilled), there would be no alternative but to accept the feeling, since this is after all what is meant when "sense of finality" is referred to. Moreover, even if there were a perfect correlation between certain configurations of notes and certain specific kinds of feeling (supposing there were some way of determining that listeners meant the same kind of thing by the words referring to these complex emotional states), this would still not be equivalent to saying that the musical notes *symbolize* the feel-

ing, although we might have more reason for making such an assertion.

Thus, when it is asserted that "music is the language of the emotions," the truth of this statement depends on what it was intended to mean. If it means simply that music evokes certain effects that are unique and different from any which we would get elsewhere, then (as we shall see in some detail in Chapter IV) it is quite true. But if it means that musical notes or themes or compositions comprise a language much the same as words and statements do, then it is just as certainly not true, for musical sounds (like paints on a canvas) are not conventional symbols with definite referents as words are; and is this not essential to being a language? If something else is meant by the statement that music is a language—e.g., that it is a natural symbol of something—I can only object that to call music a language is an extremely loose and misleading use of the term "language." (If it may be said that music is a language because it "tells us something" about the world or about emotions, a consideration of this must be postponed until Part II.)

The most recent theory which has relevance to the theme of this chapter is that of Mrs. S. K. Langer in *Philosophy in a New Key*. Mrs. Langer argues that while music is not a language—notes have no assigned denotation in the way that words have, and she asserts (quite correctly) that this is the *sine qua non* of a language—it is nevertheless a system of symbols, but symbols of a peculiar kind. Musical notes, she says, are not symbols in the sense of representing something, but rather of presenting something—they are *presentational symbols*. Music, she says,

may be a presentational symbol, and present emotive experience through global forms that are indivisible as the elements of a chiaroscuro. This view has indeed been suggested. But it seems peculiarly hard for our literal minds to grasp the idea that anything can be *known* which cannot be *named*. Therefore philosophers and critics have repeatedly denied the musical symbolization of emotion on the ground that, as Paul Moos puts it, "Pure instrumental music is unable to render even the most ordinary feelings, such as love, loyalty, or anger, unambiguously and distinctly, by its own unaided powers. . . ."

But this is a fallacy, based on the assumption that the rubrics estab-
lished by language are absolute, so that any other semantic must make
the same distinctions as discursive thought, and individualize the same
"things," "aspects," "events" and "emotions." What is here criticized as
a weakness, is really the strength of musical expressiveness; that *music
articulates forms which language cannot set forth*. The classifications
which language makes automatically preclude many relations, and many
of those resting-points of thought which we call "terms." It is just be-
cause music has *not* the same terminology and pattern, that it lends
itself to the revelation of non-scientific concepts. To render "the most
ordinary feelings, such as love, loyalty, or anger, unambiguously or
distinctly," would be merely to duplicate what verbal appellations do
well enough.[35]

The main portion of Mrs. Langer's theory, which deals with
music as a form of knowledge, will become relevant to our purpose
only in the discussion of artistic truth in Part II. All that is of
interest at this point is her theory that musical notes are symbols.

First of all, what can be meant by a presentational symbol? I
should have thought that the very essence of anything's being a
symbol is that it is used to stand for (represent) something else.
Is not a symbol that merely presents, not represents, a contradic-
tion in terms? I can see no way out of this difficulty unless a
presentational symbol is defined in a way which is quite at variance
with the obvious implications of the term.

But sometimes Mrs. Langer seems to say that musical symbols
do represent something "beyond" themselves, only what they
represent is ineffable. Then there is considerable discussion of
how music does symbolize certain states of feeling, etc., but that
these cannot be put into language, and hence what music sym-
bolizes is incapable of statement in words. Now, it is certainly not
requisite to a symbol that its referent be statable in words—if the
alleged referents of the musical symbols cannot be stated in words,
this fact alone cannot constitute an objection to the theory, al-
though it is very unfortunate; what music symbolizes can be ever
so vague and unstatable so long as there *is* something beyond the
symbol which constitutes the referent of it, or that which is sym-
bolized by the symbol. But the objection arises here: no matter

35. Susanne K. Langer, *Philosophy in a New Key*, pp. 232-33.

what the things symbolized may be, be they emotional states or images or what have you, and no matter how varying-with-context and difficult of access they may be, still, as long as it is claimed that there *are* things symbolized, what basis is there for that claim and how could such a claim be defended in the face of conflicting ones? On this rock, it seems to me, all natural-symbol theories break.

. . . What is not clear from Mrs. Langer's account is the precise sense in which "presentational symbols" *are* symbols. It is undoubtedly the case that sense experience involves a selective and organizing activity, and thus involves the apprehension, if not the imposition, of certain sensory forms. What, however, is *symbolized* in this process? Mrs. Langer is quite definite on the point that in any situation of symbol-meaning, there must be a subject, a symbol, a conception, and an *object* (p. 64). What *object* is symbolized when, in ordering sense experience, sense forms are apprehended? . . . What, other than itself, does the sensory form "represent"? . . . The perplexed reader, remembering that symbols must have objects in order to be symbols, must conclude either that sensory forms are not symbols at all, or that they are "symbols" in a radically new and hitherto unspecified sense.[36]

If the concept of a natural symbol is to retain any distinctive meaning, it cannot be applied to the kind of cases we have just been discussing. In the absence of anything in the arts which would fulfill the criteria for natural symbols in the sense we have just been considering, it seems to me that further discussion of the point is both unnecessary and useless.

36. Ernest Nagel, in *Journal of Philosophy*, 1943, pp. 325-26.

3

Expression

Before turning to artistic meaning itself, we must pause over one more concept, that of expression. Most of us have probably never taken a stand on whether a piece of music represents or symbolizes anything, but we have doubtless all said at one time or another that a given composition *expresses* something. What precisely does such an assertion mean?

<div align="center">I</div>

"Express" is an extremely elusive and ambiguous word, and I am convinced that it is used to mean a tremendous number of different though related things. Some of these, such as most of those listed by Professor Reid in his subtle analysis of the concept,[1] are extremely useful for certain purposes but not of direct relevance to the theme of this chapter. I do not propose to analyze the *whole* field of expression, nor even all of the part that touches upon esthetics. These limitations will be made clear in the following paragraphs.

1. One main sense of "express" is that in which expression is a certain kind of conscious activity. A number of excellent accounts have been written about the nature of the *act* of expression, particularly those by John Dewey[2] and R. G. Collingwood.[3] Dewey distinguishes the act of expression from an act of mere release or discharge on the one hand (for example, a person may give vent to grief without expressing grief), and on the other hand from

1. L. A. Reid, *A Study in Esthetics*, Chapter 2.
2. Dewey, *Art as Experience*, especially Chapter 4.
3. R. G. Collingwood, *The Principles of Art*, especially Chapter 6.

an act of transcribing the result of an inspiration already complete before the act of externalization took place. Collingwood sets forth at some length the distinction between the true expression of some emotion (in which the expresser does not know just *what* it is he is expressing until the act of expression is completed) from an act of deliberate evocation of that emotion, classifying the products of the former as art and of the latter as "craft" (with "representation," "magic," and "amusement"—used in ways specifically defined by him—as subdivisions).[4]

2. But it is not with expression as an activity of the creative artist that we are concerned here, but rather with expression as something characterizing an experience which we derive from art or nature as observers. That is, we are concerned not with the sense in which one might say, "He expressed his inner conflict in his music," or, "He expressed himself in his work" (each of which exemplifies a subsense of the first main sense of the word, namely, expression as an act), but rather with the sense in which one might say, "This piece of music expresses deep conflict," or, "expresses the conflict of the composer's spirit," or, "expresses the spirit of his age."

Even here there is a distinction. (a) We may use "express" to mean something approximately equivalent to "reveal." This is most generally the case when we speak of an outer act or event revealing or expressing an inner state. For example, "His face expresses joy." This does not mean that seeing his face evokes in us a feeling of joy (this meaning will be discussed below), but rather that from seeing his face we infer that he is actually feeling joy. And if it should turn out that he is not actually feeling joy, then our inference was a mistaken one. That is, whether his face expresses joy or not depends (in part at least) *not* upon whether the sight of his face evokes in us joy or indeed any feeling at all, but on whether his facial expression actually gives an indication of, or does really reveal, a feeling which he has. If he does not have the feeling of joy, then his face cannot reveal or express it (although he may have it without revealing or expressing it). In short, whether A's face expresses joy or not in this sense of "express" is

4. *Ibid.*, Chapters 2-8.

determined not by what feeling is evoked in the observer but by what is actually the fact with regard to A's state of feeling.[5]

In the same way, when we say, "Smetana's quartet *Aus Mein Leben* expresses the composer's profound melancholy," we are making a statement about the composer, or more accurately, about the relation of the composer to his composition; we are asking whether it really does reveal something that the composer felt. I confess I do not know how the truth of such a statement about Smetana could be definitely decided one way or the other, since even if all the facts of the composer's life were known and agreed upon there might still be disagreement as to whether the quartet succeeded in expressing them (or any part of them). Nevertheless, facts about the composer's life would be relevant to the question; if we should learn, for example, that some composer never had a melancholy moment in his life, we could scarcely say that a melancholy which he did not have had been expressed by him in his music.

(b) In the other senses of "express" which we shall be concerned with here, expression is independent of such knowledge; expression will denote a certain state of the observer (the kind of state will be defined later), and what the artist's experiences were will not be relevant to it. For example, when we say, "This quartet expresses melancholy" (or "expresses it to me"), as opposed to "expresses the composer's melancholy," we do not mean to make any assertion about the composer, or anything that might be verified by knowing him personally; we might make the same statement about the music of a composer about whose life we had no knowledge whatever and no prospects of getting any. Nor would the statement be an inference or probable judgment about his life. What then, *would* be a correct analysis of the statement?

I do not believe that its meaning can be adequately rendered by substituting the terms "represent" or "symbolize" for "express." If in any particular case it can, then the matter has been dealt with

5. Determined partially, not wholly. Whether or not A's face expresses joy depends on (1) whether A actually is feeling joy and (2) whether his facial expression is such as to reveal it. (The criterion for determining whether this second requirement is met is a difficult one indeed to establish.) If either of these conditions is unfulfilled, there is no expression.

already in Chapter II. But to say in general that "x expresses y" is equivalent to "x symbolizes y," would be to reduce "symbolize" to the weak sense discussed in Chapter II and deprive the term of its distinctive meaning.

But what distinctive meaning has the word "express," when used in such a statement as "This composition expresses melancholy"? (We would ordinarily declare that it expressed something more subtle and complicated than this, but this example will suffice as well as any since the meaning of "express" is the same.)

First of all, when we say, "This composition expresses melancholy," I believe we are saying something about the effect of the composition on us. "Express" in this sense is always "to you" or "to me." What the composition expresses to you it may not express to me. Hearing the music may evoke one kind of state in you and another in me. So we say, "It expresses this to you, but that to me." To use "express" in this sense without saying to whom is to make an incomplete statement.[6]

There is another difference between the sense of "express" now under discussion and the previous ones: the difference between "express" and "seem to express" tends to disappear. In the sense of "reveal" just discussed, there is certainly a difference between expressing something and seeming to. A face may seem to reveal anger although the person may not be angry at all, and he cannot reveal, at any given moment, an anger which he does not have. Hence our criterion for settling this issue is an objective fact: *is* he angry or not? But in the sense of evoking a certain kind of mental state, would not to seem to evoke it be to evoke it? An analogous case would be: I may seem to see an oasis although I am not actually seeing one (it may be a mirage, with no oasis there to see), although to seem to feel a drowsiness is the same as to feel a drowsi-

6. It is true that when we say, "This composition expresses melancholy," we seem to be saying something about the composition itself regardless of any effects on us, as when we say, "This composition is for string orchestra." But to attribute such an objectivity here is to involve oneself in endless difficulties. What indeed could one mean by saying that the composition expresses melancholy, not to anyone in particular, just "expresses it"? The locution is admittedly misleading; but so is it in statements such as, "This house is strange" and "This drink is pleasing," although we would all grant that strangeness and pleasingness do not inhere in the house or the drink themselves but rather describe the effects (on one or more persons) of seeing the house or taking the drink.

ness; and the existence of a pain is constituted by the very fact of feeling it. We cannot see an object that isn't there—then we only seem to see it; but the feeling is there when we feel it—nothing else is required for its "being there."[7] We see here once again that "expression" in the sense now under consideration refers to a subjective state.

But we still have not indicated what kind of a subjective state. And in answer to this question, it seems to me that (i) in the broadest and loosest possible sense, when something (such as a piece of music), x, expresses something, y, to someone (usually y is something abstract or intangible such as an emotion, not an object such as the sea—hence we say as a rule that program music represents while "pure" music simply expresses), the most general thing we can say is that x evokes the impression y in that person. I think the word "express" has a much more precise meaning (which I shall mention shortly) than simply this broad sense of "evoke"; but, as in the case of "represent," we use words vaguely and loosely, in ways which rob them of individual meaning, but such usages must be recorded even though to a purist they will seem unfortunate. And in this case it does seem that the word is sometimes used in this way, which would make it synonymous with what will be discussed in the next chapter.

There is one distinction to be drawn even here between evocation and expression in the sense we are discussing. "Expression" is often used to refer to *definable* expression; when what is evoked is a state of feeling which at least approximately comes under the heading of one or another word referring to emotional states, we say that the work expresses that emotion: we say that the slow movement of the *Eroica* expresses grief, but we are less likely to say that a Mozart piano concerto expresses anything because the states evoked here, though often just as intensely esthetic, are less capable of being described in words. If this *linguistic* stricture is put on the use of "express," then we could say that the music *means* a great deal to us (evokes intense esthetic states—cf. Chapter IV)

7. There is only one consideration which would lead me to distinguish them at all. We may be aware that we feel something but may not know what to call it, that is to say, under what classification it falls; and so we say, "I *seem* to feel unrest," meaning, "I feel something but I'm not sure whether what it is I feel could correctly be called 'unrest'."

but does not *express* anything in particular (does not evoke any state of mind that we could *name*). *"Tristan* expresses to me many emotions, but a Haydn quartet expresses nothing in particular." This is a usage we sometimes employ. On the other hand, we sometimes employ a usage which does not involve this linguistic restriction, as when we say, "Haydn's music is just as expressive as Wagner's; only you can't put into words what it is that Haydn's expresses."

I believe, however, that the word "express" has a more specific meaning than the general one just mentioned. All evocation, that is to say, is not expression. When we say "x expresses y to me," we do not mean simply, "x evokes y in me." Most cases of evocation are not cases of expression at all; many times an object may evoke an intense effect in us even though we would never say that the object *expressed* it (the sight of a snake may evoke terror without expressing terror). Only *some* evocations can be denominated expressions.[8] Our question, then, remains, which ones? What is it precisely that distinguishes the sense of expression we are now considering?

It seems to me that the most satisfactory analysis that has been made of this sense of "expression" is Santayana's in *The Sense of Beauty* (ii). When objects express something to us, says Santayana, we

.... remain aware of their affinities to what is not at the time perceived; that is, we find in them a certain tendency and quality, not original to them, a meaning and a tone, which upon investigation we shall see to have been the proper characteristics of other objects and feelings, associated with them once in our experience. The hushed reverberations of these associated feelings continue in the brain, and by modifying our present reaction, color the image upon which our attention is fixed. The

8. It might seem that there are some cases of expression which are not cases of evocation at all—that "x evokes y in me" would not necessarily involve "x expresses y to me." But this, I think, results from the fact that we usually speak of *emotions* and *attitudes* as being evoked, forgetting that impressions and images and ideas can also be evoked. If x expresses y to me, *something* is evoked, although the evocatum need not be an emotion or attitude. While "This piece expresses to me a deep sadness" is not equivalent to "This piece evokes in me a deep sadness," still we would never say it expressed sadness if nothing at all were evoked; it might be an impression of sadness, or even an idea of sadness as appropriate to this kind of music, although we might not at the moment be having the emotion at all.

quality thus acquired by objects through association is what we call their expression . . . Expression may thus make beautiful by suggestion things in themselves indifferent, or it may come to heighten the beauty which they already possess.[9]

In all expression of this sort, there are two terms, that which expresses and that which is expressed: "The first is the object actually presented, the word, the image, the expressive thing; the second is the object suggested, the further thought, emotion, or image evoked, the thing expressed. These lie together in the mind, and their union constitutes expression. . . ."[10] For words to express to us thoughts, or for music to express joy, there must be both words and thoughts, music and joy, and the two members of each pair must "lie together in the mind."

However, Santayana continues, if expression is to be *esthetic* expression, a special requirement must be fulfilled: the one item must not merely *suggest* the other to the mind, it must seem to *embody* the other.

I may see the relations of an object, I may understand it perfectly, and may nevertheless regard it with entire indifference . . . I may receive a letter full of the most joyous news, but neither the paper, nor the writing, nor the style, need seem beautiful to me. Not until I confound the impressions, and suffuse the symbols themselves with the emotions they arouse, and find joy and sweetness in the very words I hear, will the expressiveness constitute a beauty. . . .[11]

For example:

We may so entirely pass to the suggested object, that our pleasure will be embodied in the memory of that, while the suggestive sensation will be overlooked, and the expressiveness of the present object will fail to make it beautiful. Thus the mementos of a lost friend do not become beautiful by virtue of the sentimental associations which may make them precious. The value is confined to the images of the memory; they are too clear to let any of that value escape and diffuse itself over the rest of our consciousness, and beautify the objects which we actually behold.

9. George Santayana, *The Sense of Beauty*, pp. 145-46. See also Katherine E. Gilbert, *Studies in Recent Esthetic*, Chapter 5.

10. Santayana, *op. cit.*, p. 147.

11. *Ibid.*, pp. 148-49.

We say explicitly: I value this trifle for its associations. And as long as this division continues, the worth of the thing is not for us esthetic.

But a little dimming of our memory will often make it so. Let the images of the past fade, let them remain simply as a halo and suggestion of happiness hanging about a scene; then this scene, however empty and uninteresting in itself, will have a deep and intimate charm. We shall not confess so readily that we value the place for its associations; we shall rather say: I am fond of this landscape; it has for me an ineffable charm. The treasures of the memory have been melted and dissolved, and are now gilding the object that supplants them; they are giving this object expression.[12]

For those who do not read Arabic the decorative inscriptions in Saracenic monuments are not expressive of what the inscriptions say (Santayana's own example); but even when there are two terms, the monuments and what they evoke, there may still be no expressiveness because the second term is not found *in* the first. The Saracenic monuments may have expression

by virtue of such thoughts as they might suggest, as, for instance, of the piety and oriental sententiousness of the builders and of the aloofness from us of all their world. And even these suggestions, being a wandering of our fancy rather than a study of the object, would fail to arouse a pleasure which would be incorporated in the present image. . . . The two terms would be too independent, and the intrinsic values of each would remain distinct from that of the other.[13]

Only when what is expressed is "incorporated in the present image," when "I find joy and sweetness in the very words I hear," does "the expressiveness constitute a beauty."

To the careful reader it will be evident that Santayana's terminology is ambiguous: on the one hand, as in the above quotation, he says that the Saracenic monuments may have expression by virtue of such thoughts as they might suggest, although this expression-by-suggestion would not be *esthetic* expression, since the one term only suggests the other and is not seen as a part of it. But in the same paragraph he says that this expression-by-suggestion is really not expression *at all*,[14] because this intimate union

12. *Ibid.*, pp. 146-47.
13. *Ibid.*, p. 148.
14. *Ibid.*, p. 148, line 8.

(previously listed as requisite for esthetic expression) is required for all expression. That is to say, Santayana seems to be saying on the one hand (1) that one thing may express another simply by suggesting that other to the mind, but that for esthetic expression to occur, the two must not only "lie together in the mind," but one must be felt *in* and as a quality *of* the other (not perceived as distinct entities in the way that the friend's memoirs are at first perceived as distinct from his memory). But on the other hand he seems to be saying (2) that in order for expression to occur at all there must be this latter relationship (whereby the joy is felt *in* the very music); if the one merely suggests the other without embodying it, there is no expression.

I would much prefer the second usage, since it does not involve the notion of "esthetic." Nor does it do violence to our usual notion of expression. For it seems to me that there are many cases in which one thing suggests another where we would never say it expressed the other: ice suggests coldness and many tactile and kinesthetic sensations without *expressing* them to us.[15] Santayana himself gives examples of the limitations of suggestion in this respect. Secondly, and more important, even when the conditions for expression (defined in (2) above) are fulfilled, there *need* not, it seems to me, be an *esthetic experience,* and hence it would be most misleading to characterize such expression as esthetic. There are esthetic experiences without expressiveness, as when I am moved by a group of forms or colors without any life-associations whatever. (Doubtless it is impossible to effect a complete separation, as Bell would have it. The sunset, even when I try to see it purely as a color-combination, expresses *some* life-value or other to me, but I am affected by the colors all out of proportion to their expressiveness to me.) And there are experiences of expressiveness which are not esthetic. The "whining adagios" that Hanslick mentions do express sadness to me but they do not affect me esthetically; I hear the sadness "in the very notes," but it is a kind of feeling which is either esthetically neutral or, more frequently, positively unpleas-

15. L. A. Reid, in "The Limits of Psychology in Esthetics," Symposium by L. A. Reid, Helen Knight, and C. E. M. Joad, *Proceedings of the Aristotelian Society,* Supplementary Vol. XI, 1932, p. 175.

ant. In short, an esthetic experience need not be expressive, and an experience involving expressiveness need not be esthetic.

2

Professor Reid offers a criticism of Santayana's theory of expression which is perhaps of more importance than the one just given. His contention is that Santayana uses the word "express" in too narrow a manner. "Mr. Santayana," he says, "uses the term 'expressive' to apply *only* to appeal through association. For Mr. Santayana, neither sense-data nor forms can be expressive, for expression is wholly a function of association. We get thus in his scheme three distinct *kinds* of beauty: material or sensuous beauty, formal beauty, *and* expressive (associative) beauty."[16] And then he quotes Santayana's passage, "We might commonly say that the circle has one expression and the oval another. But what does the circle express except circularity, and the oval except the nature of the ellipse? Such expression *expresses* nothing; it is really *im*pression."[17] But Professor Reid uses the term "express" in a more inclusive sense, "to assert, for example, that circles and ovals (as well as colors and sounds, tunes and harmonies) can in themselves appear as expressive, and that association is only *one* of two main processes which account for expression. If the implications of this be kept in mind, there will be no antithesis between 'formalism' and 'expressionism' as theories. For form as such will be 'expressive.' "[18] Colors and sounds and shapes, that is, can be expressive of other things not merely by association with them, but also because of their own intrinsic natures. Professor Reid's charge is that Santayana recognizes only the former, and that the latter also constitute expressiveness. And indeed Santayana does speak of expressiveness as if it occurred only through "fused association" (that is, of the friend with the memoirs, the joy with the music), without seeming to recognize a kind of expressiveness that Professor Reid insists upon:

We may associate pink with sentimental persons, with pink dresses and pink decorations and pink chocolate boxes. . . . The trumpet and the

16. Reid, *A Study in Esthetics*, p. 67.
17. Santayana, *op. cit.*, p. 65.
18. Reid, *op. cit.*, p. 67.

drum have martial associations. Yet, though in fact these associations always do come into play in our apprehension of colors and sounds, it is certain that there is a residue of non-associative meaning. It is indeed probable that in many cases the colors and sounds have come to possess the associations *through their intrinsic suggestiveness* rather than by the reverse process. Their effects cannot be entirely due to association. A certain kind of crude pink comes to have vulgar associations because *something in pinkness itself* jars upon us. . . . The trumpet and the drum come to have martial associations because their quality, as apprehended through our organisms, suggests in itself "martial" meaning.[19]

As examples of this "direct" expression, Professor Reid cites the following (this is only part of the list):

> Straight lines express the "values" of directness, unwaveringness, what can be called, in rather feeble language, rectilinear efficiency. Horizontal lines suggest—and not, I think, through association only—stability and balance; vertical straight lines in a picture or a landscape or a building suggest a different kind of stability. . . . Some curves suggest grace, or fluidity, or, again, vigor. Others suggest uncertainty and hesitation. . . .[20]

All these, he contends, are expressive not through association but partly at least because of their intrinsic natures.

Now I do not see how, *intrinsically,* a color can have expressiveness; the shade of pink referred to can no more "of its own nature" express vulgarity than can any other shade. I do not see how expression could occur *entirely* apart from association of any kind. Yet there is a distinction to be drawn between the kind of expressiveness which is felt in common by a large community of people, and has for its origin some (probably unconscious) association "way back when," and hence seems intrinsic to the expressive object, and the kind of expressiveness which is "an accident of one's biography," such as Santayana's example of the friend's memoirs. Of these two groups Santayana does seem to emphasize the latter; and to this extent Professor Reid's remarks seem justified.[21]

19. *Ibid.,* pp. 76-77; italics mine.
20. *Ibid.,* p. 83.
21. Cf. Professor Reid's own examples of the expressiveness of words, pp. 108-13. Those words he uses as examples of expressiveness, due to something intrinsic in the words themselves, seem to me, again, to be due to associations which are so fused together and so deeply embedded in one's affective background that one feels inclined to call them intrinsic in the thing itself.

In all this I have spoken of esthetic experiences and not of beauty; the precise relation (supposing that one can be established) between esthetic experiences and "the beautiful" would require many chapters of elucidation. (Speaking very roughly, not all esthetic experiences would generally be considered experiences of the beautiful, but nothing would be considered beautiful which had never given rise to an esthetic experience, although it might be considered beautiful without giving rise to an esthetic experience in some individual case.) But since I have touched on the relationship between esthetic experiences and experiences of expressiveness, I want to touch even more briefly on the kind of statement often made, that beauty and expression are synonymous, or at any rate necessary to each other.

Those who wish to identify beauty with expressiveness may do so in either of the following ways: (1) they may define beauty independently and say that *as a matter of fact* all things which are beautiful are also expressive (the meaning of the term "expressive" being left vague as long as it is supposed to characterize objects directly, and not, as we have discussed it, certain kinds of experiences); this would assert an empirical connection which, even if we grant (which I would not) that it has held hitherto, might well not hold in a future case; or (2) they may define beauty in such a way that unless an object is expressive (whatever this may mean) it cannot be beautiful, thus making the statement, "All beautiful things are expressive," a tautology. Now it is quite possible to define "beautiful" in such a way as to exclude all those things which are considered inexpressive; but this is surely to depart from any common meaning of the word: in any usual sense, it is at least logically possible (that is, would involve no contradiction) for something to be beautiful without being expressive. This leaves only the first alternative, and with regard to that I can only remark once more that to me (as to many others) there are many esthetically moving objects which do not live up to Professor Reid's criteria of either direct or indirect expression, and many objects which express a great deal to me but which I would never think of calling beautiful.

4

Meaning

When we state the meaning of a word or phrase, we are stating what the word refers to, what it has come by convention to stand for. This is doubtless the main sense in which the word "meaning" is used. There are other senses, however: for example, it can refer to causal consequences ("This means war"), logical entailment ("This means I have only $100 left"), general feeling of significance ("This old house means a great deal to me"), and intention ("I don't know what he means by acting that way"). Most of these meanings of "meaning" (Ogden and Richards list sixteen of them in *The Meaning of Meaning*) are fairly clear in actual usage from the contexts in which they occur. When we ask "What is the meaning of this word?" or "What is the meaning of his strange behavior?" or "You've found the footprints, but what do they mean?" people do not generally have trouble in understanding us, as is shown by the fact that that they give the right kind of answers, the sort of thing we had in mind in asking the question.

The case is different with "What is the meaning of a work of art?" When this question is asked, I am not sure what the inquirer is asking for. We have already seen that a work of art is not a conventional symbol (or set of such symbols) that has meaning in the way a word does. Nor does it seem to indicate implication, intention, or any of the other usual meanings. A person may state what the structure of a given work of art is, what effects it has on him, what effects it has on others, and even what he thinks its effects on others should be; but if he has stated these things and is still asked, "What does the work *mean?*" then one may well

74

wonder what the questioner is asking for, what he wants, what information he desires in answer to his question. Until this is known, there is no possibility of answering it. And, generally speaking, I suspect that most persons who ask this question have no clear idea what they are asking for. Perhaps the cardinal sin in philosophy is to demand answers (and be disappointed when none are forthcoming) when the whole fault is with the question—when the "question" is really no question at all but a set of words with a question mark at the end.

Under these circumstances it may not seem advisable at all to use the word "meaning" in speaking of works of art. And I am quite ready to agree with this sentiment; the term "meaning" when used in this context is vastly confusing. It derives its puzzling quality from the fact that it is meaningfully employed in other contexts and the person feels that it must mean something in this one, since "What is the meaning of this word?" and "What is the meaning of this composition?" *look* similar and seem like the same kind of question—not realizing that underneath the similarity of appearance, the meaning (reference) of the word "meaning" has changed, or vanished into nothing.

However, if one wants to retain the word in speaking of the arts, I suggest that it be defined somewhat as follows: a work of art means to us whatever effects (not necessarily emotions) it evokes in us; a work which has no effects on us means nothing to us, and whatever effects it does evoke constitute its meaning for us. As we become more acquainted with the work of art, the effects it evokes in us gradually change, but in that case its meaning for us (as I have defined it) gradually changes too. The work of art is one term in the relationship, the evoked reactions the other; and the gradual changing of the latter as we hear or see the work again constitutes a gradual change in its meaning for us. Its meaning may or may not be describable in words—in most cases it is not, since few if any states of mind (particularly affective states) are describable to the satisfaction of the person who experiences them.

This may seem to be an extremely arbitrary conception of artistic meaning. I grant that it is arbitrary, but I feel quite justi-

fied in making it so. My reason for this is simply the very elementary semantic principle that when a word has been given no meaning by convention when used in a certain context, one must (if he is to use it at all) arbitrarily confer a meaning upon it. This must be made clear beyond the slightest doubt:

No word has meaning (in the sense of reference) in itself; it has no meaning until it is *given* meaning by someone; lacking this, it is simply a row of marks on paper or uttered sounds. Most of the words in our language have been given meanings long ago, and this meaning has been agreed upon by the users of our language, so that the words have come by *convention* to stand for the things they now stand for, and all we have to do is learn them. Many words have several meanings (referents) and are called ambiguous words—in these cases we learn their multiple meanings; this is true of the word "meaning" along with thousands of other words. This word has a meaning when applied in such situations as "meaning of a word," "meaning of his behavior," etc. But just as words do not always have the same meaning in different contexts (as we have just seen in the case of the word "meaning" itself), there are contexts in which it has *no* meaning until it is *given* a meaning *for* that context. Thus, as we now use the word "on," the statement "The glass is on the table" has meaning but "The glass is on the universe" does not; the word "on" has been given meaning only within a certain physical context, and when it is not applied within that context it becomes simply a sound or mark on paper. The same is true for the word "meaning." It has a definite meaning (reference) in the ordinary situations referred to above, but when applied to a situation such as "What does this piece of music mean?" it does not, since the word "meaning" has been *given* no meaning in that context. At least it has no standard meaning (reference) in that context; different persons may mean (intend) different things by it, though for the most part I do not think they know what they really are after when they ask it. And in the absence of any standard meaning of the word "meaning" in this context, I have decided to give it one, i.e., arbitrarily to define the word when predicated of works of art. This would not be a justifiable procedure if the word (when used in this expression)

already referred to something—just as it would not be justifiable for me to use the word "cat" to refer to any university building because the word already has a standard usage which is well understood; such a procedure would cause endless confusion. But this is not the case in situations where the word *has* (i.e., has been given) as yet no meaning. Where there is a common usage of the word, even when it is quite ambiguous, one should perform an *analysis* of it to try to discover which of several things people mean by it when they use it; but when this is not the case, it is rather pointless to attempt this procedure. So it is in the present case.

To a certain extent this is true of words we have discussed already. "Represent" and "express" are, as we have seen, certainly ambiguous enough. But they do possess a sufficient modicum of standard reference, even when applied to esthetics, to render useful an attempt to track down these different senses and find out which of a number of things people (especially artists and philosophers) really do mean when they say that a work of art represents or expresses. This is what I have tried to do in the last two chapters. But when we come to "meaning" this is no longer the case. Here, when a person asserts that a work of art means so-and-so, I really do not know what he means (intends) to say. And so, since the word "meaning" has no conventional meaning (reference) in locutions such as "What is the meaning of this piece of music?" I must, if I want to use the word at all, *stipulate* how I think the word might be usefully used here. And I submit the one just presented as one of those least likely to be ambiguous and misunderstood.

Moreover, it leads directly into a most interesting problem. Much of the controversy that is generally associated with the phrase "the meaning of a work of art" is not concerned with trying to answer the pseudo-question "What does the work mean?" but rather with the question of the relation of the formal element in art to the expressive or content-element—what has been described in Chapter I as "life-values." The disagreement concerns how much of the non-formal element should be predominant in the appreciation of the observer (listener, reader)—that is, which element should be foremost in artistic meaning in the sense

I have defined. This is a most interesting controversy, and there are a number of clarifications that can be made in discussing it. It is this task which I shall now undertake, convinced that it is the most interesting and fruitful kind of issue that could be considered under the heading of "artistic meaning." I shall consider the arts of music, painting, and literature in turn.

IN MUSIC

I

In general, there are two schools of musical meaning, one consisting of the persons referred to above, who hold either that music "does not mean anything," "is meaningless," or that what it means is purely musical and not describable in non-musical terms; and the other consisting of those who hold that music does have meaning of a kind that possesses something in common with life outside music.

I do not know of any specific set of tenets which have been adhered to as a credo by either of the opposing schools; but I shall try nevertheless to summarize under a few definite headings the theses to which I think most authorities of each general inclination would subscribe. I shall take the "purist" school first.

Descriptions of music in "emotive" terms, or in any words whatever that are used to describe experiences in life, are extremely unsatisfactory. For example, Gurney quotes the following excerpt from a programme of a Philharmonic Concert, which purports to be an analysis of Schubert's Unfinished Symphony:

We begin with deep earnestness, out of which springs perturbation; after which almost painful anxieties are conjured up, till the dissolution draws the veil from an unexpected solace, which is soon infused with cheerfulness, to be however abruptly checked. After an instant of apprehension, we are startled by a threat of destruction to the very capability of rest, which in its turn subsides. From the terrible we pass to the joyful, and soon to playfulness and tenderness; a placid character which is quickly reversed by a tone of anger, continued till it leads up to a repetition of all that has gone before. Then comes the unfolding of a tale of passionate aspiration and depression, which works up to a cul-

mination; after which some more repetition of the already twice-heard perturbation and what follows it leads us to the final part, where, after being led in an unearthly way to abstract our thoughts from the present and its surroundings, we at last conclude in the strange mystery with which we set out, though just at the very end there is an effort to shut the mind against its incertitude.[1]

Such "analyses," says Gurney, are far beside the point. "In seeing what an uninteresting and inconsecutive jumble this really respectable piece of criticism looks," Gurney remarks, ". . . we see how impossible it would be for a musician deliberately to work it up, and in what total independence of it Schubert must have invented and developed the music. . . . As an interpretation or elucidation of what Schubert had in mind, (these remarks) would be meaningless; for they as little reveal or explain the essence of his utterance as a heap of loose garments on the floor reveals or explains the breathing beauty of face and form."[2] And then Gurney cites the testimony of the composer Schumann on the point:

Critics always wish to know what the composer himself cannot tell them; and critics sometimes hardly understand the tenth part of what they talk about. Good heavens! will the day ever come when people will cease to ask us what we mean by our divine compositions? Pick out the fifths, but leave us in peace. . . . Beethoven understood the danger he ran with in the Pastoral Symphony. How absurd it is in painters to make portraits of him sitting beside a brook, his head in his hands, listening to the bubbling water.[3]

And Mendelssohn:

What any music *I* like expresses for me is not *thoughts too indefinite* to clothe in words, but *too definite.*—If you asked me what I thought on the occasion in question, I say, the song itself precisely as it stands. And if, in this or that instance, I had in my mind a definite word or definite words, I would not utter them to a soul, because words do not mean for one person what they do for another; because the song alone can say to one, can awake in him, the same feelings it can in another— feelings, however, not to be expressed by the same words.[4]

1. Quoted in Edward Gurney, *The Power of Sound,* p. 353.
2. *Ibid.,* p. 353.
3. *Ibid.,* p. 357.
4. *Ibid.*

Even the use of descriptive adjectives like "sad" or "joyful" or "triumphant" is condemned by this group; they are, it is contended, quite irrelevant to the appreciation of the music. Moreover, the descriptive adjectives vary from age to age, while the judgments of musical value remain pretty much the same.

An intelligent musician will therefore get a much clearer notion of the character of a composition which he has not heard himself, by being told that it contains e.g. too many diminished sevenths, or too many tremolos, than by the most poetic description of the emotional crises through which the listener passed. . . . With the technically uninitiated "the feelings" play a predominant part, while, in the case of the trained musician, they are quite in the background. . . . If every shallow Requiem, every noisy funeral march, and every whining Adagio had the power to make us sad, who would care to prolong his existence in such a world?[5]

Again,

How is it that in every song slight alterations may be introduced, which, without in the least detracting from the accuracy of expression,[6] immediately destroy the beauty of the theme? This would be impossible, if the latter were inseparably connected with the former. How, again, is it, that many a song, though adequately expressing the drift of the poem, is nevertheless quite intolerable?[7]

Gurney in *The Power of Sound* illustrates this point at great length, reproducing the score of many admittedly great melodies, and just underneath them other tunes (often of his own invention) differing only very slightly in rhythm and tone-relationships,

5. Hanslick, *The Beautiful in Music,* pp. 77, 137.

6. I shall not take the time to question and examine the use of the terms "express" or "expression" every time the authors quoted use those terms. In some cases the word can be interpreted in the way analyzed in Chapter III, but in other cases I do not think it can, and I fear that in these cases the usage of the word is unclear. Sometimes one can simply substitute the word "evoke" in every occurrence (in these passages) of the word "express," and the arguments will still apply. However, when statements such as "Music expresses emotions" are made, the meaning is generally very hazy and requires interpretation, since as it stands it can mean any of an indefinite number of things, none of which are clearly specified. In such cases the presence of the author himself would be required to state his meaning specifically; but even if this were possible, I fear that in many cases he would not be able to state his meaning clearly.

7. Hanslick, *op. cit.,* p. 65. Hanslick illustrates this point in a very masterly fashion on pp. 56-63, particularly with regard to opera.

which, though the descriptive adjectives generally used to characterize them are or would be unchanged, are at once felt to be trivial and dull,[8] showing that the "expression" (evocation) of emotions can scarcely be the important thing. We may use as many descriptive adjectives as we like, but "all the while the essential magic seems to lie at an infinite distance behind them all."[9]

And if one forces himself to try to give a name to the character of the successive sentences or phases in a page of a sonata, though this one as compared with that may be more confident, or more relaxed, though we may find an energetic phrase here and a pleading phrase there, a capricious turn in close proximity to a piece of emphatic reiteration, etc., our interest seems to lie in something quite remote from such a description, and it is only by a sort of effort that we perceive whether or not the musical current has been colored by occasionally floating into the zone of describable expression.[10]

And yet,

In 99% of the current talk and writing about music and composers, it is implied (even where not definitely stated) that music is primarily an art of expression; that it is "the language of the emotions," i.e. of modes of feeling familiar in the life external to music (which for convenience I have called *extra-musical* modes of feeling); and that its great function, either with or without the association of some external words or subject-matter, consists in the evocation of these emotions. And this view is connected . . . with the idea that in mentioning the expressive aspects the problem of music's power has been solved. To many the question never occurs *why* mournfulness or exultation should be held as any more explanation or guarantee of overpowering beauty in a tune than in a face.[11]

Gurney arranges under five headings his arguments to show that the expression of extra-musical emotions is any part of the function of music. His arguments are so relevant and so convincing that I shall quote them, at least in part:

1. . . . In an immense amount of beautiful music the element of definable expression is absent; or present only in such vague and fragmen-

8. Gurney, *op. cit.*, pp. 152-55, 161-67.
9. *Ibid.*, p. 316.
10. *Ibid.*, pp. 336-37.
11. *Ibid.*, p. 338.

tary ways that, in describing the phenomena under that aspect, we seem to get about as near the reality as when we attempt descriptions of things in the vocabulary of some unfamiliar foreign language. . . . If I find twenty bits of music beautiful and indescribable, and one bit beautiful and pathetic, it is unreasonable to say I enjoy the last (which I don't enjoy at all more than the others) *because* it is pathetic.

2. The very features which may be often indisputably connected with definable expression are perpetually present in cases where, the music not being perceived as impressive or beautiful, they produce no effect on us. The essential conditions of musical beauty, of the satisfaction of the musical sense, must therefore be quite outside these special features of musical effect.

3. It is often found that music which wears a definable expression to one person, does not wear it or wears a different one to another, though the music may be equally enjoyed by both. For instance, the great "subject" of the first movement of Schubert's B-flat trio represents to me and many the *ne plus ultra* of energy and passion; yet this very movement was described by Schumann as "tender, girlish, confiding."

4. Take twenty bits of music, each presenting the same definable character, such as melancholy or triumph. Now if the stirring of this emotion is the whole business of any one of these tunes, how is anybody the richer for knowing the other nineteen? for in respect of this stirring character they are all on a par, and one of them would do completely all that could be done. In reality, of course, each of them is an individual, with a beauty peculiar to itself, and each is, to one who loves it, a new source of otherwise unknown delight.

5. Why should the mere expression of some mode of feeling by an abstract musical emotion be more adequate to stir us than the expression of it by the gestures of some uninteresting concrete personage? Apart, indeed, from some independent source of impressiveness, it would seem far less adequate. . . .

Take two musical movements, alike in agitated pace and rhythm, and in what we may call physical character; both equally express, if we will, an agitated state of feeling: but will anyone seriously maintain that the varieties and nuances of Ideal Motion,[12] which make every phrase and bar of the one totally different from every phrase and bar of the other, correspond with varieties and nuances of extra-musical mood?

12. A concept of Gurney's which for our purposes I do not think it necessary to go into.

Such an instance is alone utterly subversive of the hypothesis that musical emotion is effective by doing *more delicately and minutely* what physical motion does roughly and generally.[13]

Some persons (Gurney continues) who may deny that music should evoke a specifiable emotion hold that it should (or does) evoke a general mood, a *Gemuthsstimmung*. To this Gurney raises two objections: "(1) In thousands of cases it is as impossible to name any general mood as to name any more definite emotions. (2) It is just in connection with Gemuthsstimmung that a difficulty already noticed is at its maximum: if we try to assign corresponding moods to the passages of some long exciting instrumental movement, we often cannot stick to one for a dozen bars together. . . ."[14]

Critics holding the views of Hanslick and Gurney point also to the fact that most persons, as they become better acquainted with music, cease to talk about it in "emotive" terms and use strictly musical phraseology. It would probably be superfluous here to quote even a small fraction of the enormous experimental evidence on this point which has grown up since the time of Hanslick and Gurney. It is contained in numerous magazine articles and books, most of which contain in turn the results of many experiments in music-listening. It would be an extremely incautious procedure for me to attempt a brief summary of all these results. But one fact emerges with rather startling clearness: no matter how many classifications of listeners these writers introduce, there seem to be two principal well-defined groups: those who hear music "pure," without "emotive" meanings or associations from life, and those who hear it as an expression of emotions or some other extra-musical content. And the more experienced a listener

13. *Ibid.,* pp. 339-43. We have already seen (in discussing symbolization) that there is no necessary relationship or correlation between any given physical pattern of notes and a given reaction on the part of the listener. In the present chapter we may, if we wish, remove a possible complication from the issue by interpreting the argument subjectively, with no inter-subjective commitments: we may, that is, take the argument merely to oppose the notion that the importance of music for any given individual lies in its evocation of life-emotions (regardless of whether the life-emotions evoked vary from one listener to another).

14. *Ibid.,* p. 343.

becomes, the more he is inclined toward the former of the two groups.[15]

The ascription of emotional attributes to music is, according to the purist school, an indication of "impure" listening.

With the technically uninitiated "the feelings" play a predominant part, while, in the case of the trained musician, they are quite in the background.[16]

Instead of closely following the course of the music, these enthusiasts, reclining in their seats and only half awake, suffer themselves to be rocked and lulled by the mere flow of sound. . . .[17]

They will be apt to find their own meanings in the music, which merely shows that the sound has a stimulating or a soothing effect on their nerves, and acts as a congenial background for their subjective trains of thought and emotion. . . . To a trained ear a rapid and loud fugue on the organ, if previously unknown, is apt to be "full of sound

15. For example: research by Vernon Lee, quoted by Max Schoen, reports two types of listeners, the "emotional" or "associative" and the "purely musical." A third type, the "imaginal," seems to differ only slightly from the "purely musical." Vernon Lee reports of the associative type that the answers, "often covering many pages, showed that according to individual cases the 'message' was principally . . . visual or emotional, abstract or personal, but with many alterations and overlapping. But fragmentary, fluctuating, and elusive as it was often described as being, and only in rare cases defining itself as a coherent series of pictures, a dramatic sequence or intelligible story, the message was nevertheless always a message, inasmuch as it appeared to be an addition to the hearers' previous thoughts by the hearing of that music; and an addition to that music and ceasing with its cessation." The other ("purely musical") listeners, while not explicitly denying a meaning or message in music, nevertheless claimed that "whenever they found music completely satisfying, any other mind, anything like visual images or emotional suggestions, was excluded or reduced to utter unimportance. Indeed this class answered by a great majority that so far as emotion was concerned, music awakened in them an emotion *sui generis,* occasionally shot through with human joy or sadness, but on the whole analogous to the exaltation and tenderness and sense of sublimity awakened by the beautiful in other arts or in nature, but not to be compared with the feeling resulting from the vicissitudes of real life. It was nearly always persons answering in this sense who explicitly acquiesced in the fact that music could remain, in no derogatory sense, but quite the reverse, *just music.* . . . The more musical answers were also those who repudiated the message, who insisted that music had a meaning in itself, in fact, that it remained for them 'mere music.'" The one class, she concludes from this, listened to the music; the other only heard it—and sometimes only overheard it.—(Max Schoen, *The Beautiful in Music,* pp. 45-46.) For the most comprehensive discussion of this question see Professor Mursell's chapter on "The Psychology of Musical Listening" in his *The Psychology of Music.* Other references (books): Max Schoen, *The Effects of Music;* Redfield, *Music as a Science and an Art;* Gehring, *The Basis of Musical Pleasure;* Vernon Lee, *Music and Its Lovers.*

16. Hanslick, *The Beautiful in Music,* p. 137.

17. *Ibid.,* p. 125.

and fury, signifying nothing," and the same may often be said of elaborate polyphonic choruses: but to many persons who are capable of being strongly moved by music in a vague and mysterious manner it is a matter of indifference what is being played or sung, so long as the volume of tone is full and the quality agreeable...[18]

The conclusion drawn from all this may be listed as the second tenet of the purist school:

The merit of a work of music depends not upon its success in "expressing" (or evoking) certain emotions of life, but in a "peculiarly musical quality" which is intuited by those who are musically trained and gifted. The composer has what Gurney calls a "peculiarly musical faculty" which he employs in composing, and by which he is made aware of the "necessity" of certain combinations of notes, which result in great music, as opposed to other combinations, which produce trivial music. No reference to human emotions is involved, only to the "peculiarly musical faculty." Moreover, musical experts and connoisseurs recognize the excellence of musical compositions solely by exercising this musical faculty—not by feeling or remembering anything from life. Of two compositions, the one admittedly great music and the other admittedly trivial or banal,

... In what respect do they differ? Is it that one of them expresses more exalted feelings, or the same feelings more accurately? No, but simply because its musical structure is more beautiful. One piece of music is good, another bad, because one composer invents a theme full of life, another a commonplace one; because the former elaborates his music with ingenious originality,[19] whereas with the latter it becomes, if anything, worse and worse....

What it is that makes Halevy's music appear fantastic, that of Auber graceful—what enables us immediately to recognize Mendelssohn or Spohr—all this may be traced to purely *musical* causes, without having recourse to the mysterious element of the *feelings*.[20]

The thrilling effect of a theme is owing, not to the supposed extreme grief of the composer, but to the extreme intervals; not to the beating of his heart, but to the beating of the drums; not to the craving of his soul, but to the chromatic progression of the music.[21]

18. Gurney, *op. cit.*, p. 306. Cf. also pp. 308-9.
19. Hanslick, *op. cit.*, pp. 80-81.
20. *Ibid.*, p. 75.
21. *Ibid.*, p. 76.

Gurney explicitly sets forth the notion of a "peculiarly musical faculty." "Two series of notes," he says, "similar to one another on all the adduced grounds, may present the whole difference of possessing beauty and *not* possessing it; ... the problem presented by this variety of qualities is altogether distinct from any *general* considerational power in music." This, he says, unmistakably points to "a unique isolated faculty, whose decisions can no more be justified than they can be impugned by any law or from any standpoint external to the impressions in each case."[22] And again, "In music our attention is centered on forms which are for us the unique inhabitants of a perfectly unique world, disconnected from the interest of visible things."[23] Moreover:

the faculty of discernment ... is one whose nature and action have to be accepted as unique and ultimate facts, and whose judgments are absolute, unreasoning, and unquestionable. ... No examination of their structure from outside throws the slightest light on that musical character and its varieties: no rules can be framed which will not be so general as to include the bad as well as the good. ... The exercise of the musical faculty on such and such a form is found pleasurable ... its exercise on such and such another is found neutral, or unsatisfactory and irritating; and that is all: a mode of perception which is unique defies illustration, and on this ground the only answer to the questions which present themselves is the showing why they are unanswerable.[24]

2

The arguments of the purist school are without doubt compelling ones; yet many persons are not convinced by them. The following are a few random remarks by dissenters:

No one who listens to great music and abstains from surrendering himself merely to the emotion which it is apt to excite, who tries to listen to it as music, can help feeling its affinity in obscure ways to the great goings on of nature and human affairs.[25]

It is quite impossible in describing how non-musical experiences enter into musical ones to avoid using non-musical words to apply to musical events. ... And if further evidence is required, there are the composers—

22. Gurney, *op. cit.*, p. 177.
23. *Ibid.*, p. 340.
24. *Ibid.*, p. 317.
25. Samuel Alexander, *Beauty and Other Forms of Value*, p. 147.

and the great composers—who tell us that their compositions express non-musical feelings and events. Finally there is the union of music with words and drama and movement in song, opera, and dance, a union which would surely be impossible were music not in some degree expressive of things outside itself.[26]

... We hear purists talk loosely of music as though it consisted simply of patterns—as though Bach at his most formal was ever less than sounding, moving, rhythmic, thrilling, acting upon the muscles and the breath and the blood.[27]

On the one hand the "pure" listener may possess on the margin of his consciousness non-musical images and organic and mental activities which he does not introspectively discern; and it is sometimes a kind of musical snobbery which inhibits him from discerning them. He will be pure at all costs. On the other hand it is, I think, a mistake to hold that "purity" won at the price of exclusiveness is good or finally best even if it can be achieved. Musical education may have at a certain stage to urge exclusiveness simply in order to direct attention to the proper place, namely, the forms of the music. But, whilst it is certain that [certain] types ... are musically uneducated and can never as such enter into the delight of pure listening, the best listening, on the other hand, may be less pure than purists love to think, and the best kind of musical experience may be one in which physiological and conative and imaginal elements—all kept in their due, subordinate place—contribute vitally to the life of the whole.[28]

I think the main tenor of these remarks is clear; all of them insist that music is somehow related to life and does not inhabit a world apart, although the precise nature and extent of the relation may be extremely difficult to state. The only systematic presentation of this point of view to parallel that of Hanslick and Gurney, so far as I know, is that of J. W. N. Sullivan in the opening chapters of *Beethoven: His Spiritual Development.*

Sullivan's discussion begins as an explicit criticism of Gurney's views. Gurney's theory, he says, would have us believe that while poets and painters make reference to the world, composers simply invent sequences of sounds without reference to anything; we judge some sequences good and some bad, but this judgment is based on a "purely musical faculty." Music, on this view, testifies

26. L. A. Reid, *Proceedings of the Aristotelian Society,* Vol. XLI, 1940-41, p. 120.
27. *Ibid.,* p. 116.
28. *Ibid.,* p. 126. See also Max Rieser, "On Musical Semantics," Journal of Philosophy, July 30, 1942, Vol. XXXIX, No. 16, pp. 424-25.

to nothing outside itself. But such a position does great violence to musical experience: "We do feel, in our most valued musical experiences, that we are making contact with a great spirit, and not simply with a prodigious musical faculty." It is always possible to contend, as Gurney does, that those who do not hear music "pure" are careless listeners, or "not really musical"; but Sullivan points out that there are many highly trained musicians, as well as large numbers of careful listeners, who would not subscribe to Gurney's theory of "music as isolated."

Musical phrases, like lines of poetry, are unique, but they are not thereby isolated. It is perfectly possible that there is a *unique* musical faculty, as unique as the sense of hearing itself, but it is not thereby an *isolated* faculty. Musical experiences do not form a closed world of their own. The highest function of music is to express the musician's experience and his organization of it. The whole man collaborates to make the composition. . . .[29]

The uniqueness of music is a theme which I shall develop in a moment (as it appears in Sullivan); what I am concerned just now to present is the notion that music is not isolated; and I think I can do this most clearly by violating Sullivan's own order of presentation.

Poetic experiences are quite as unique as musical experiences, but nobody imagines that they form a closed world of their own, that they are wholly dissociated from the rest of the poet's nature and from his experience of life. It is true that, for the appreciation of a work of art in any medium, special sensibilities are required, and such sensibilities can be pleasurably exercised in almost complete independence of any other interests. Thus much of Spenser's poetry may perhaps be regarded as existing in a moral and spiritual vacuum; it has, so to say, almost no discoverable context. Here the specific poetic sensibilities are being exercised "for their own sakes." Music, much more than poetry, affords specimens of works which lead this curiously independent existence, but it need be no more true of music than of poetry that it must be essentially meaningless. If, therefore, we find that some compositions irresistibly suggest to us some spiritual context we need not resist this impulse on theoretical grounds. We need not suppose that we are the victims of a literary culture and an imperfectly developed musical faculty. As a matter of fact, all the greatest music in the world, and some of the worst,

does suggest a spiritual context. It does more than suggest; its whole being is conditioned by this context, and it lives to express it. This context is directly perceived even by those who, for theoretical reasons, do not explicitly admit its existence. The most ardent advocate of the isolation theory will, for example, describe one composition as more "profound" than another, will describe one melody as "noble" and another as "sentimental." Such judgments are incompatible with the isolation theory, for on that theory nothing could be said except that a piece of music afforded a greater or less degree of a unique and incommunicable pleasure. A composition could be no more profound or noble or sentimental than a wine. Yet such judgments, in the case of many compositions, are quite unavoidable.[30]

In terms of the distinctions which we developed in Chapter I, we might say that some works of art (parts of Spenser's poetry and many musical compositions) have esthetic surface and esthetic form without having what we called life-values. But this is not to say that a great deal of music does not demand reference to this third dimension.

Music which impresses us as expressing spiritual experiences and as springing from a spiritual context is still music. It must satisfy the musical faculty; it must obey all the criteria that "pure" music obeys. But the musical experiences it communicates are less isolated than those of pure music; a greater extent, as it were, of the artist's nature has been concerned in their creation; more comprehensive and, probably, deeper needs are satisfied by them. Amongst musical phrases are some which do more than please our musical faculty. They stir other elements in us; they reverberate throughout a larger part of our being. Certain emotions and expectations are aroused beside those that accompany our reactions to pure music.[31]

For example, the difference between Beethoven's imaginative realization of the death of a hero (in the slow movement of the *Eroica*) and Wagner's in the third act of *Die Götterdämerung* is not primarily a musical one; the difference is due to the comparative poverty of Wagner's inner spiritual resources. It is chiefly a difference of "spiritual context."

This spiritual context should not be confused with "program." Sullivan is as much opposed to "programs" for music as the purists

30. *Ibid.*, pp. 38-40.
31. *Ibid.*, pp. 42-43.

are. Nor does Sullivan approve without qualification the use of words to describe musical experiences; words are not equal to this task. For, while music is not isolated, it is unique, and what it means to us is quite incapable of being stated in words or in any other medium than just the music itself. The words usually used to describe music are what Sullivan calls "vague portmanteau-words like triumph, joy, pain, etc.," which cover an indefinitely large number of individual and unique states of feeling. In this connection the following passage is of the utmost importance:

That the experience cannot be communicated in other terms is not surprising. The reason that our reactions to a work of art cannot be adequately described is not that some unique and isolated faculty is in-volved, but that art is not superfluous, that it exists to convey what can-not be otherwise expressed. Musical experiences, no more than poetic experiences, are isolated. It does not follow that they are not unique. It may be that our musical experiences, or some of them, cannot be evoked in any other way. But this is no more likely in the case of music than in the case of any of the other arts. Man's capacity of response, as it were, is almost infinite. It is perfectly possible that between certain reactions and stimuli there may be a one-to-one correspondence. A poem, in its effect on us, may have no equivalent. A dawn or a sunset, a melody or a cry in the night, may evoke in us a reaction which is unique. It is even possible that most of our reactions, both to nature and to art, are unique. Art is no substitute for nature, and the arts are not substitutes for one another. . . . Nevertheless, there are resemblances between unique things, as in the case of two eggs. Mendelssohn thinks words too vague and indefinite to convey his musical experience of the song, but he would agree that some combinations of words come nearer than some others to expressing his experience. Amongst our musical experiences are some which are more analogous than others to certain extra-musical experiences. These experiences need not be more or less valuable than those musical experiences for which we can find no analogues. The strictly unique character of musical experiences is a rather trivial fact about them. But that they exist in isolation would be, if true, a very important characteristic. For it would follow that music exists to do nothing but employ, agreeably, a special faculty. The musi-cian's experience of life and what he has made of it, the extent and depth of his inner life, could find, on this theory, no reflection in his music. A more meaningless and irrelevant addendum to life than music could not well be conceived. . . .[32]

32. *Ibid.*, pp. 34-36.

The fact that words and language are so inept for describing the reactions evoked by music must thus be blamed on the poverty of language, not on any lack of relation between the states and events and situations which language normally describes and the musical experience. Language is particularly deficient in words describing emotional states, and has only crude "portmanteau-words" which do not even approximately describe the experience. Its inability to describe a complex and sensitive reaction to music is, therefore, not surprising.

Thus the passage from Mendelssohn which Gurney quotes in his own favor (quoted above) could equally well be quoted by the opposing school—as indeed it is quoted by Sullivan himself; for all that Mendelssohn was concerned to insist upon was that the musical meaning could not be stated in words—and with this Sullivan fully agrees. What he insists upon is that it is not irrelevant to life, not "isolated"—a contention which I have no doubt whatever that Mendelssohn shared.

3

It is difficult not to be swayed by both of these points of view, and I daresay that we naturally find so much that we agree with in both of them that we can scarcely help wondering whether (or to what extent) they really contradict each other. And with that in view I shall attempt briefly to criticize these two theories.

First of all, Sullivan agrees that what music means is not statable in words. This, says Sullivan, is due to the poverty of our language; for example, we have one generic word "joy" which we use to cover an indefinitely large number of different shades of feeling, all of which are most inadequately represented by the word "joy"; the word suffices merely as a very rough classification. Thus, to the extent that Gurney's charges are based upon the lack of *definable* evocation in music, Sullivan has successfully answered him. When, for example, Gurney asserts that "In an immense amount of beautiful music the element of definable expression is absent . . . in describing the phenomena under that aspect, we seem to get about as near the reality as when we attempt descriptions of things in the vocabulary of some unfamiliar foreign language. . ." Sullivan has

only to reply that this does not refute his contention at all, because the reason why words leave us so far from the reality is that the musical experience is not statable in language owing to the poverty of our language in terms for subjective states. From the fact that the *words* of life may be inapplicable to music it does not follow that there are no life-*values* conveyed by the music; what is rather true is that words are incompetent to describe them. *Most* emotions, as Professor Ducasse rightly points out, have no names.

The feelings experienced by human beings are endlessly various, and only a very few, such as love, fear, anger, etc., have received names. The immense majority of them cannot be referred to by name because they have received none.

Only a few feelings, such as those already alluded to,—love, anger, fear, jealousy, anxiety, etc.—have names. They are feelings which are closely connected with typical, recurrent situations in life, and are usually accompanied by overt and easily recognizable modes of behavior. The terms "the emotions" and "the passions," designate principally those standard, labelled feelings, and indeed those feelings primarily as out of the esthetic status, that is to say, as mere accompaniments or incidents of practical endeavor of one sort or another. But to one such named feeling, there are a thousand that have received no name, but which are none the less real experiences of the very same general sort, viz. emotional.[33]

Our responses even to simple esthetic data, such as patches of colors, bits of lines, single tones, the patterns of rugs, etc., are unique; each experience has its individual and unnamed "feeling-tone."

Failure to recognize that the realm of feeling contains not merely love, fear, anger, and so on, but a vast wealth of other unnamed but just as truly emotional experiences, is I believe the principal explanation of such opposition as there is to "emotionalist" theories of art. The so-called formalists, like Hanslick, seem wholly blind to the fact that form is important in esthetic objects for the very reason that it itself, in contemplation, is the source of certain esthetic *emotions* which nothing else can objectify. . . .[34]

33. C. J. Ducasse, *The Philosophy of Art*, pp. 195-96.
34. *Ibid.*, pp. 197-98.

Certainly the truth of these observations cannot be disputed. And they cannot help but take some of the sting from the attacks of Hanslick and Gurney. Insofar as it is the use of *words* that they object to, one can simply concede their point and then point out that objection to the words does not constitute objection to the emotions which are so inadequately expressed by the words.

But it seems to me that Gurney's charges go deeper than this. In answer to Sullivan he would certainly say that it is *not* merely our verbal poverty which makes words so impotent to describe musical experiences. A million synonyms for "joy," even if we knew exactly what they meant, would not suffice; for, he would say, music is separated, isolated, from life-experience, so that no terms applicable to life-experience, no matter how numerous and finely differentiated, are applicable to musical experience. The latter, he would say, is a world by itself—it is not only unique (which Sullivan grants at once) but isolated. For example, to cite a part of a passage previously quoted from Gurney, "No matter what features we may decide upon as being connected with expressiveness, there are many musical selections which will not exhibit those features and which we yet perceive as impressive or beautiful." Or again, "The great 'subject' of the first movement of Schubert's B flat trio represents to me and many the *ne plus ultra* of energy and passion; yet this very movement was described by Schumann as 'tender, girlish, confiding' ";[35] adding that both he and Schumann held the movement in equally high regard as music. Now surely it cannot be that the difference here was merely due to the "poverty of our language"; if our language had (to repeat) a million synonyms for each emotion-word, it would still have been the case that Gurney and Schumann disagreed—indeed, their disagreement would have been all the more pronounced because of the more precise terms in which they would, with their improved vocabulary, be able to couch it; if they differed in assigning a rough classification, they certainly would disagree in a more exact one. No, it is rather the case, I think, that Gurney would

35. It does look as if Gurney is being unfaithful to his theory in offering this bit of autobiography. But we shall confine our attention to what Gurney preaches, ignoring what he practices.

agree that their emotional evaluation of the movement differed, but he would deny that this was relevant to the appreciation of the composition; to the latter, he would say, any considerations of "tender" or other life-emotions would be quite irrelevant. In short, Gurney would take the position that none of the life-emotions should enter into the enjoyment of the music, and Sullivan would say that they should. Sullivan would say that language is hopelessly *inadequate* to describe musical experiences; Gurney would say that language is not only inadequate, but *irrelevant*.

Now, to approach the matter from the other direction, I cannot think that when Gurney and Hanslick say that music has "no meaning" they intend to say that it should have no meaning in the sense of no evoked effects, that its effect upon the listener is of no consequence. If it produced no effects of any kind upon anybody, what would be the reason for its existence? When Hanslick says that "the beautiful, strictly speaking, *aims at nothing,* since it is nothing but a *form* which . . . has no aim beyond itself,"[36] is he not cutting music off from its only grounds for existing at all? If the *Prometheus* Overture existed merely to display the forms that Hanslick describes in the illustration I have quoted, nobody would care for it; who would care that a succession of descending fifths appeared in repeated 4-4 patterns, without taking into consideration the effects which those patterns were intended to produce? Why indeed did the composer choose these patterns rather than others? Evidently because of certain effects he intended these to have upon his listeners, But what Gurney and Hanslick are asserting (or at any rate, to make their position reasonable, could be said to "really mean to assert") is that those effects must be strictly *musical;* not merely that they are not describable in words which ordinarily apply to life-situations (for we have seen that a million synonyms for every shade of effect would still not suffice), but that the very reminder of life-situations and life-emotions is irrelevant. They mean to say, not that music *"has* no meaning" or "means *itself"* (as Hanslick asserts in one place!), but that music has no meaning in the sense of *life*-meaning; not that music should evoke *nothing* but that the experiences it evokes should

36. Hanslick, *op. cit.,* pp. 40-42.

have nothing in common with the experiences that any life-situa-
tion (any situation outside of music) evokes. This, I take it, is
what is meant by "unique *and isolated.*"

Thus, to summarize: Hanslick and Gurney object to the use of
words to describe music, and Sullivan "grants" that they are ob-
jectionable; while Sullivan insists that music does and must have
effects, and Hanslick and Gurney, while they do not admit this,
could (as we have just seen) by a *reductio ad absurdum* be forced
to admit the truth of this assertion. The sole difference between
them lies in what these effects should consist in. Both agree on the
uniqueness of music, but they do not agree on its isolation.

Now, it is quite probable that a *part* at least of the reason why
Hanslick and Gurney are so opposed to any kind of "meaning" in
music is simply that no account in words of what music "meant" to
anybody has ever seemed satisfactory to them, and they want par-
ticularly to avoid the unpardonable sins of critics who rush in
where angels fear to tread, in ascribing all sorts of "emotive" mean-
ings to music (cf. the description of Schubert's Unfinished Sym-
phony quoted on pp. 78-79 above). They are convinced, quite
rightly, that music is nothing like *that*—so they take all possible
precautions to avoid any such error by throwing out entirely all
connections of music with life. They have in mind too, doubtless,
the difficulty of what, if music "means anything," it may be said to
mean, and they are quite mindful of how impossible it is in this
matter to defend one opinion against another; so they simply put
an end to the controversy by declaring that music "does not mean
anything." But I daresay that even if they had not found it neces-
sary to take such precautions, or even if the ineptness of words for
describing musical experiences were understood and agreed on,
they would still diverge from Sullivan's view in the matter of the
isolation of music from life. And this divergence, so far as I can see,
is ultimately a temperamental one, and nothing can resolve it. The
one side is convinced that the most valuable musical experience is
the "isolated" one in the realm of "pure forms," and the other that
it is not. I do not see how either position could possibly be *proved.*
One can only set forth the real issue between them in as clear terms
as possible, so that one may know more precisely *what* is the core

of the dispute, marshal the arguments on each side, and then leave each listener to decide for himself.

However, I want to propose one other consideration which, while it would certainly not dispose of the ultimate temperamental disagreement between the two groups, might nevertheless serve to narrow somewhat the space between them. We have seen that every experience in life is specific and unique and that no words can perfectly describe it, since to use qualifying adjectives at all is to classify the experience under certain heads, thus lumping it together with other things which possess certain properties in common with it but also properties which are different. Even if we had a far richer vocabulary than we do, this would still be the case. But with experience of the arts this is even more the case, for here there is an added complication, namely, the fact that the emotion experienced in the presence of the work of art is different from the emotion experienced outside the work, the "sadness" in life is not the "sadness" in the second movement of the *Eroica* (nor, of course, is the "sadness" in the *Eroica* like the sadness of Tschaikovsky's *Pathétique* or Beethoven's Cavatina from the Opus 130 quartet). Even with this hypothetical wealth of synonyms for affective states, there would still be a difference between the emotion felt from a piece of music and the emotion felt from a corresponding life-experience (unless, of course, we are among those careless listeners who employ music merely as a stimulus for evoking the same old life-emotions over again—and then there is nothing peculiarly musical in our experience). The fact that it is *music* that gives us this feeling accounts for this difference; thus, while each life-experience is unique and at best only approximately describable, each musical experience is, if we may use the expression, even more unique—for here we have not only the rich individuality of the life-experiences but the difference between all of these and the musical experiences. It is as if we saw all of the life-experiences through an iridescent glass which enriched and multiplied their already infinite variety in an infinite number of ways, thus making the hopelessly inadequate words used to describe the original experiences even more hopelessly inadequate than before. But in spite of these great differences, there do seem

to be mysterious affinities between life-experiences and musical ones; for music does evoke in us experiences sufficiently like some experiences in life to make us use the same characterizing adjectives in describing them, inadequate as they are, and to do so with considerable regularity and insistence. The sadness we feel in hearing the music is never the sadness of personal bereavement, and yet the word is used in describing the music because of some felt correspondence between it and the emotion of daily life. There is a recognizable similarity, yet when we want to describe our musical experience, the words used in doing it seem even more inept than they do for describing our experiences in life from which the words we apply to music were derived. This is without doubt one of the most singular phenomena in all of experience, yet it is a persistent and recurring fact of that experience.

Now I suggest that a part of the reason why Hanslick and Gurney are reluctant to accept the notion that adjectives from life are in any way relevant to music may be that they realize how utterly different musical experience is (or should be) from *any* life-experience, and the use of the same characterizing adjectives *seems* to erase that difference—appears to blur a distinction which is so great as to seem to justify the retraction of the same word to characterize both situations—thus playing directly into the hands of those careless listeners for whom to hear the music is merely to experience the life-emotions over again. It sounds as if we had a certain emotion in life which was then transferred bodily from life into the music, when actually the emotion evoked by the music is quite a different thing from the same (general) emotion evoked in any situation outside music. If this fact were always kept in mind, it might well be that Hanslick and Gurney would not cling so tenaciously to the isolation of music as they do. We do sometimes use the same terms (for lack of better ones) to describe both the musical and the extra-musical experiences, and this is admittedly misleading; but once we have seen how different is the emotion-in-art from the emotion-in-life, there should hardly be so much horror of using the same terms, since we perceive how different is their application.

This consideration may also cast some light on the vexed ques-

tion of what reactions to music are "legitimately musical." Certainly we would not feel that the value of a person's appreciation of a work of music varies directly with the intensity of his emotional response to it. There are many persons who are immensely moved by music—it casts a spell over them, as it does over many dogs and birds and snakes—and there is no doubt that they are powerfully affected. But we have a strong suspicion that they are not moved by the music; for when we ask them what their reaction was to this change in rhythm or that melodic line, they cannot remember anything of it, and often cannot distinguish one melody from another that is of the same general mood. Since they cannot make any distinctions or discriminations in the music, the inevitable conclusion seems to be that the music is rather a springboard for them to indulge in an emotional debauch of their own— to start their own sentimental memories or trains of association into motion (the music acting merely as background)—rather than something to be listened to. On the other hand, we do not approve either of the person who can analyze the technique and architectonics of the music without having any emotional response to it. If he feels nothing, we say he has missed the point of the music, the end for which it was composed. Each of these represents an extreme due to the comparative lack of one element or the other in the response.

IN PAINTING

I

To appreciate a work of art we need bring with us nothing from life, no knowledge of its ideas and affairs, no familiarity with its emotions. Art transports us from the world of man's activity to a world of esthetic exaltation. For a moment we are shut off from human interests; our anticipations and memories are arrested; we are lifted above the stream of life ... Art ... inhabits a world with an intense and peculiar significance of its own; that significance is unrelated to the significance of life. In this world the emotions of life find no place. It is a world with emotions of its own.[37]

So begins the theory of Clive Bell, which is a close analogue in visual art of Hanslick's theory in music. Each is intent upon ex-

37. Clive Bell, *Art*, pp. 25-27.

cluding life-values from works of art in his own medium, and upon establishing form as the *sine qua non* of artistic appreciation and achievement. Painters who rely on representation for their effects are not true artists, since their works make the observer respond to the life-situation depicted, substituting the easy life-emotion (which is available outside works of art) for the more pure and difficult art-emotion.

A painter too feeble to create forms that provoke more than a little esthetic emotion will try to eke that little out by suggesting the emotions of life. To evoke the emotions of life, he must use representation. Thus a man will paint an execution, and, fearing to miss with his first barrel of significant form, will try to hit with his second by raising an emotion of fear or pity. But if in the artist an inclination to play upon the emotions of life is often the sign of a flickering inspiration, in the spectator a tendency to seek, behind form, the emotions of life is a sign of defective sensibility always. It means that his esthetic emotions are weak or, at any rate, imperfect. Before a work of art people who feel little or no emotion for pure form find themselves at a loss. They are deaf men at a concert. They know that they are in the presence of something great, but they lack the power of apprehending it. They know that they ought to feel for it a tremendous emotion, but it happens that the particular kind of emotion it can raise is one that they can feel hardly or not at all. And so they read into the forms of the work those facts and ideas for which they are capable of feeling emotion, and feel for them the emotions that they can feel—the ordinary emotions of life. When confronted by a picture, instinctively they refer back its forms to the world from which they came. They treat created form as though it were imitated form, a picture as though it were a photograph. Instead of going out on the stream of art into a new world of esthetic experience, they turn a sharp corner and come straight home to the world of human interests. For them the significance of a work of art depends on what they bring to it; no new thing is added to their lives, only the old material is stirred. A good work of visual art carries a person who is capable of appreciating it out of life into ecstasy: to use art as a means to the emotions of life is to use a telescope for reading the news. You will notice that people who cannot feel pure esthetic emotions remember pictures by their subjects; whereas people who can, as often as not, have no idea what the subject of a picture is. They have never noticed the representative element, and so when they discuss pictures they talk about the shapes of forms and the relations and quantities of colors. Often they can tell by the quality of a single line whether or no a man is a good artist. They are concerned only with lines and colors, their relations and quantities;

but from these they win an emotion more profound and far more sublime than any that can be given by the description of facts and ideas.[38]

The significance of any object in life, for painting, has nothing to do with its function in life or any of its ordinary associations. "What is a tree, a dog, a wall, a boat? What is the particular significance of anything? Certainly the essence of a boat is not that it conjures up visions of argosies with purple sails, nor yet that it carries coals to Newcastle. Imagine a boat in complete isolation, detach it from man and his urgent activities and fabulous history, what is it that remains, what is that to which we still react emotionally? What but pure form?"[39]

The exact nature of this pure form, or as Bell calls it, "significant form," is never described; Bell defines it in terms of the "esthetic emotion" (significant form being present when the esthetic emotion is aroused), but since he defines the esthetic emotion in terms of significant form (the esthetic emotion being limited to what is evoked by the presence of significant form), we are no further than we were before. And indeed Bell conveys the impression that the thing he is referring to can only be intuited but never precisely described. Bell's description is devoted largely to informing his readers what significant form is *not*. In music, for example, Bell explains the inferiority of his appreciation from the standpoint of his ideal of significant form:

At moments I do appreciate music as a pure musical form, as sounds combined according to the laws of a mysterious necessity, as pure art with a tremendous significance of its own and no relation whatever to the significance of life; and in those moments I lose myself in that infinitely sublime state of mind to which pure visual form transports me. How inferior is my normal state at a concert. Tired or perplexed, I let slip my sense of form, my esthetic emotion collapses, and I begin weaving into the harmonies that I cannot grasp, the ideas of life. Incapable of feeling the austere emotions of art, I begin to read into the musical forms human emotions of terror and mystery, love and hate, and spend the minutes, pleasantly enough, in a world of turbid and inferior feeling. . . . I have been using art as a means to the emotions of life and reading into it the ideas of life. I have been cutting blocks

38. *Ibid.*, pp. 28-30.
39. *Ibid.*, p. 213.

with a razor. I have tumbled from the superb peaks of esthetic exalta-
tion to the snug foothills of warm humanity. It is a jolly country. No
one need be ashamed of enjoying himself there. Only no one who has
ever been on the heights can help feeling a little crestfallen in the cozy
valleys. And let no one imagine, because he has made merry in the
warm tilth and quaint nooks of romance, that he can even guess at the
austere and thrilling raptures of those who have climbed the cold, white
peaks of art.[40]

Before proceeding further we must avoid several possible con-
fusions. The distinction between Bell's view and one which would
admit life-values is not the same as the distinction between ab-
stractions and representational schools of art. Abstract or non-
representational painting does not necessarily fulfill Bell's require-
ments for art, nor does it necessarily exclude life-values: Mondrian
uses no representational content at all but merely colored lines
intersecting at right angles; nevertheless he does not intend to ex-
clude life-values.

Impressed by the vastness of nature, I was trying to express its ex-
pansion, rest, and unity. At the same time, I was fully aware that the
visible expansion of nature is at the same time its limitation; vertical
and horizontal lines are the expression of two opposing forces; these
exist everywhere and dominate everything; their reciprocal action con-
stitutes "life"....[41]

Enough has been presented here to show that what Mondrian is
trying to "express" is something very relevant to life indeed—
expressive not of any particular objects or class of objects but of
something possessed by all objects in common (which is why he
chose abstract painting as the genre in which best to express it).
And on the other hand, we find a consistently representational
painter like Marc Chagall saying,

But please defend me against people who speak of "anecdote" and
"fairy tales" in my work. A cow and a woman to me are the same—in
a picture both are merely elements of a composition. In painting, the
images of a woman or of a cow have different values of plasticity,—but

40. *Ibid.*, pp. 31-33.
41. Piet Mondrian, "Toward the True Vision of Reality," pamphlet published by the
Valentine Gallery, New York.

not different poetic values. As far as literature goes, I feel myself more "abstract" than Mondrian or Kandinsky in my use of pictorial elements. "Abstract" in the sense that my painting does not recall reality. . . . In the case of the decapitated woman with the milk pails, I was first led to separating her head from her body merely because I happened to need an empty space there. In the large cow's head in *Moi et le Village* I made a small cow and a woman milking visible through its muzzle because I needed that sort of form, there, for my composition. Whatever else may have grown out of these compositional arrangements is secondary.[42]

From these two quotations it should be abundantly clear that the two sets of distinctions completely cut across each other.

Nor must the exclusion of life-values be confused with "reducing art to mere technique." In whatever sense the elusive word "technique" is used, Bell's ideal of "pure form" is quite a different thing. The very rarity of the achievement of significant form, as opposed to the comparative frequency of painters who are good technicians or "can handle their medium well," should suffice to establish this.

With these stumbling-blocks removed, we may consider briefly a conception of painting which is similar to Bell's. Roger Fry recognizes that the formal and life-values exist in a work of art—he calls them the plastic and dramatic respectively—but he says that the two exist side by side, separately, and generally interfere with each other. When dramatic and plastic values both appear in a painting the result is not a fusion but a tension of interests. "How can we keep the attention equally fixed on the spaceless world of psychological entities and relations and upon the apprehension of spatial relations? What, in fact, happens is that we constantly shift our attention backwards and forwards from one to the other."[43]

Fry illustrates this point at great length with descriptions of paintings of many different types, first those of almost purely psychological or dramatic interest, then those of almost purely plastic interest, and then those in which both appear and the at-

42. Marc Chagall, quoted in "An Interview with Marc Chagall," by James Johnson Sweeney, *Partisan Review,* Winter 1944, p. 90. The distinction between representation as an aid to life-values and representation as an aid to formal intensity is well discussed in an article by Mrs. Helen Knight, "Sense-form in Pictorial Art," *Aristotelian Society Proceedings,* XXXI (1930-31), 150-51.

43. Roger Fry, *Transformations,* p. 23.

tention must shift from the one to the other. For example, after describing Pieter Brueghel's *Carrying of the Cross,* he remarks:

We recognize at once that this is a great psychological invention, setting up profound vibrations of feeling within us by its poignant condensation of expression. . . . But it is, I repeat, purely literary, and throughout this picture it is clear that Brueghel has subordinated plastic to psychological considerations. It is indeed to my mind entirely trivial and inexpressive when judged as a plastic and spatial creation. In short, it is almost pure illustration, for we may as well use that as a convenient term for the visual arts employed on psychological material. And we must regard illustration as more closely akin in its essence to literature than it is to plastic art, although in its merely external and material aspect it belongs to the latter.[44]

On the other hand, in Poussin's *Achilles Discovered by Ulysses among the Daughters of Lycomedon,* the psychological values are negligible:

The delight of the daughters in the trinkets which they are examining is expressed in gestures of such dull conventional elegance that they remind me of the desolating effect of some early Victorian children's stories. Nor is Ulysses a more convincing psychological entity, and the eager pose of his assistant is too palpably made up because the artist wanted to break the rectangle behind and introduce a diagonal leading away from the upright of Ulysses. Finally, Achilles acts very ill the part of a man suddenly betrayed by an overwhelming instinct into an unintentional gesture. Decidedly the psychological complex is of the meagrest, least satisfactory, kind, and the imagination turns from it, if not with disgust, at least with relief at having done with so boring a performance. But on the other hand our contemplation of plastic and spatial relations is continually rewarded. We can dwell with delight on every interval, we accept the exact situation of every single thing with a thrilling sense of surprise that it should so exactly satisfy the demands which the rest of the composition sets up. How unexpectedly, how deliciously right! is our inner ejaculation as we turn from one detail to another or as we contemplate the mutual relations of the main volumes to the whole space. And this contemplation arouses in us a very definite mood, a mood which, if I speak for myself, has nothing whatever to do with psychological entities, which is as remote from any emotions suggested by the subject, as it would be if I listened to one of Bach's fugues. Nor does the story of Ulysses enter into this mood any more

44. *Ibid.,* pp. 15-16.

than it would into the music if I were told that Bach had composed the fugue after reading that story. As far as I can discover, whatever Poussin may have thought of the matter—and I suspect he would have been speechless with indignation at my analysis—the story of Achilles was merely a pretext for a purely plastic construction.[45]

Most regrettable are the occasions on which the two interfere with each other—where the plastic value is sacrificed or compromised to achieve some psychological end. Fry analyzes Daumier's *Gare St. Lazare* as an example of this.

In the case of Rembrandt both faculties were present in the highest degree. "His psychological imagination was so sublime that, had he expressed himself in words, he would, one cannot help believing, have been one of the greatest dramatists or novelists that has ever been, whilst his plastic constructions are equally supreme."[46] After giving a sensitive analysis of the psychological and dramatic values of Rembrandt's *Christ before Pilate,* he says, "Certainly as drama this seems to me a supreme example of what the art of illustration can accomplish. And as a plastic construction it is also full of interest and strange unexpected inventions. . . ."[47] And then he goes on to analyze the painting plastically. But even here, he concludes, the two values clash with each other, and our attention shifts from the one to the other. "I do not know whether the world would not have gained had Rembrandt frankly divided his immoderate genius into a writer's and a painter's portion and kept them separate."[48] "Pictures in which representation subserves poetical or dramatic ends are not simple works of art, but are in fact cases of the mixture of two distinct and separate arts; . . . such pictures imply the mixture of the art of illustration and the art of plastic volumes. . . ."[49] And since the art of illustration is really "literary" and quite extraneous to the plastic medium, wherever the literary values interfere with the plastic, it is the former that must go. For example: When we observe Raphael's *Transfiguration,* if we are insensitive to plastic values and see it

45. *Ibid.,* pp. 19-20.
46. *Ibid.,* p. 21.
47. *Ibid.,* p. 22.
48. *Ibid.,* p. 21.
49. *Ibid.,* p. 27.

"psychologically," we see a number of persons and objects represented in a certain situation; and if we are familiar with the Christian tradition the painting "brings together in a single composition two different events which occurred simultaneously at different places, the Transfiguration of Christ and the unsuccessful attempt of the Disciples during His absence to heal the lunatic boy. This at once arouses a number of complex ideas about which the intellect and feelings may occupy themselves."[50] But when we see esthetically, we see something quite different:

Let us now take for our spectator a person highly endowed with the special sensibility to form . . . [Such a spectator will be immensely excited by the extraordinary] coordination of many complex masses in a single inevitable whole, by the delicate equilibrium of many directions of line. He will at once feel that the apparent division into parts is only apparent, that they are coordinated by a quite peculiar power of grasping the possible correlations. He will almost certainly be immensely excited and moved, but his emotion will have nothing to do with the emotions which we have discussed hitherto, since in this case we have supposed our spectator to have no clue to them.[51]

One interesting claim which Fry makes in favor of his own case is that when, in the works of a historical painter, the plastic and the psychological values appear together, the psychological ones "evaporate" in the course of time, while the plastic ones remain as a source of permanent enjoyment for each succeeding generation. For example, in the case of El Greco:

. . . I suspect that for his own generation his psychological appeal was strong. His contemporaries knew intimately or at least admired profoundly, those moods of extravagant pietistic ecstasy which he depicts. Those abandoned poses, those upturned eyes brimming with penitential

50. Roger Fry, *Vision and Design*, p. 296.

51. *Ibid.*, p. 298. Cf. Clive Bell on illustrational painting: "I often enjoy an illustration, by which I mean a drawing the sole aim of which is to imply a situation by visual means. I delight in Peter Arno and Steig. When it comes to an artist, such as Daumier, whose real object was to create expressive forms but who was paid to tell a tale, I find, as a rule, either that the story gives me no pleasure because of its lack of subtlety, or that it positively vexes because the artist's efforts to tell it have been detrimental to his design. Anyhow, the stories told by the painters whose work you find in the National Gallery—albeit the Primitives were much concerned with story-telling—give me no pleasure at all. The reason seems fairly obvious; it would be hard to devise a technique worse suited to story-telling than that which artists have elaborated for the purpose of expressing their peculiar feelings about visual experience."—(Clive Bell, *Enjoying Pictures*, p. 19.)

tears, were the familiar indications of such states of mind. To us they seem strangely forced and hint a suspicion of insincerity which forbids our acquiescence, and we almost instinctively turn aside to invitations to a quite different mood which his intense and peculiar plasticity holds out.[52]

It is for his "significant form," his wonderful "plastic orchestration" that El Greco is valued today, and not for any psychological values he may have rendered. The latter, if anything, interfere. Seldom if ever do the two fuse.

It is doubtless with this in view, plus the growing conviction that the plastic values were of sole (or primary) importance to his work as an artist, that Whistler changed the name of his *Portrait of His Mother* to *Arrangement in Grey and Black*:

Why should I not call my works "symphonies," "arrangements," "harmonies," and "nocturnes"? I know that many good people think my nomenclature funny and myself "eccentric" . . .

The vast majority of English folk cannot and will not consider a picture as a picture, apart from any story which it may be supposed to tell.

My picture of "Harmony in Grey and Gold" is an illustration of my meaning—a snow scene with a single black figure and a lighted tavern. I care nothing for the past, present, or future of the black figure, placed there because the black was wanted at that spot. All that I know is that my combination of grey and gold is the basis of that picture. Now this is precisely what my friends cannot grasp.

They say, "Why not call it 'Trotty Veck,' and sell it for a round harmony of golden guineas?"—naively acknowledging that, without baptism, there is no . . . market!

But . . . I should hold it a vulgar and meretricious trick to excite people about Trotty Veck when, if they really could care for pictorial art at all, they would know that the picture should have its own merit, and not depend upon dramatic, or legendary, or local interest. . . .

The great musicians knew this. Beethoven and the rest wrote music—simply music; symphony in this key, concerto or sonata in that. . . .

Art should be independent of all clap-trap—should stand alone, and appeal to the artistic sense of eye or ear, without confounding this with emotions entirely foreign to it, as devotion, pity, love, patriotism, and the like. All these have no concern with it and that is why I insist on calling my works "arrangements" and "harmonies."[53]

52. Fry, *Transformations*, pp. 20-21.
53. James MacNeill Whistler, *The Gentle Art of Making Enemies*, pp. 126-28.

Seurat, probably aware of the same "interference-phenomenon," gradually compressed all the psychologically and dramatically interesting values out of his paintings, until nothing but "pure form" remained:

> In *La Baignade* there are still indications of muscles, and I have seen a study for one of the seated figures wherein the muscles are fully and very beautifully rendered; and if in such a picture as *Chahut* (1890) he has reduced muscles to their simplest geometrical equivalents that is not because he could not draw muscles with the best—or worst, but because by eliminating details he sought to give his design an easily apprehended intensity which would have been lost in a multiplicity of complicated forms. . . . Think of the processional movement of those figures, those cylinders, in *La Grande-Jatte:* here is an art nearer to architecture than to painting as understood and practised in 1886. . . .
>
> Few painters can have felt more passionately than Seurat; none perhaps has compressed his feelings more pitilessly. Every twist he gave the vice meant, at the first pang, the sacrifice of some charming quality; but every sacrifice was rewarded in the end by added intensity. Turn from his grand hieratic compositions to his studies of sea and shore at Grandchamp and Honfleur: all the familiar charm of sand and water has been squeezed out, but in exchange we are offered subtleties of tone —or rather of relations of tones—which I think I am right in saying had never before been rendered. . . . By the remorseless suppression of all those enchanting harmonies by which the Impressionists ravished and still ravish us, Seurat has contrived to reveal relations, to touch chords, I will not say more moving, but rarer and more acute. . . .[54]

Seurat struck out all these things, which would have been so tempting to include, because they interfered with the one all-important thing he wanted to bring out, the "pure form"; from this one supreme end these other factors, charming as they might be in themselves, could only detract. The appreciation of art, according to the Bell-Fry school, is only hindered by the inclusion of these irrelevant and distracting elements.[55]

54. Clive Bell, *Landmarks in Nineteenth-Century Painting*, pp. 200-3.

55. Bell admits that it is sometimes the case that certain representational factors can help to speed one's appreciation of the work of art, since without its aid the work would be hard to "get into"; but he vehemently denies that this representational element has any value in itself. "Let us make no mistake about this. To help the spectator to appreciate our design we have introduced into our picture a representative or cognitive element. This element has nothing whatever to do with art. The recognition of a correspondence between the forms of a work of art and the familiar forms of life cannot possibly provoke

2

How are we to combat these charges? I think we can best begin by pointing out that there is a difference between *illustrational* painting, in which the subject-matter interest or the story interest is the only excuse for the existence of the painting, and that kind of painting in which the life-values constitute a part of the work of art; and I want to show that criticisms of the one do not necessarily constitute criticisms of the other. A painting which has no artistic merit of its own but merely illustrates some theme from history or literature, and interests people because of the things it represents or the life-sentiments it evokes rather than by its merits as art, is, I should say, an illustrational painting.[56] Yet no one admits this to be art; to fight it is to fight a straw man.

Illustrational painting is analogous to program music in the worst sense. And just as program music can be valuable if it does not exist merely to imitate an object or tell the story to a program, so painting can be representational and still valuable as painting if it does not depend for its effect upon the subject-matter represented simply as subject-matter. Dr. Barnes illustrates this difference very well, first of all with an illustration from music:

> When we compare, let us say, a symphony of Haydn with Beethoven's *Eroica* and *Fifth,* it is impossible not to be conscious of a difference of a semi-literary quality. Beethoven's own title for his *Third Symphony* is "In Memory of a Great Man," and the symphony is heroic in es-

esthetic emotion. Only significant form can do that. Of course realistic forms may be esthetically significant, and out of them an artist may create a superb work of art, but it is with their esthetic value that we shall then be concerned. We shall treat them as though they were not representative of anything. The cognitive or representative element in a work of art can be useful as a means to the perception of formal relations and in no other way. It is valuable to the spectator, but it is of no value to the work of art; or rather it is valuable to the work of art as an ear-trumpet is valuable to one who would converse with the deaf: the speaker could do as well without it, the listener could not. The representative element may help the spectator; it can do the picture no good and it may do harm. It may ruin the design; that is to say, it may deprive the picture of its value as a whole; and it is as a whole, as an organization of forms, that a work of art provokes the most tremendous emotions."—(Clive Bell, *Art*, pp. 225-26.)

56. Bernhard Berenson defines illustrational painting as follows: "Illustration is everything which in a work of art appeals to us, not for any intrinsic quality, as of color or form or composition, contained in the work of art itself, but for the value the thing represented has elsewhere, whether in the world outside, or in the mind within."—(*The Central Italian Painters of the Renaissance*, p. 10.)

sence, as Haydn's is not. Our appreciation is of the intrinsic quality of the music itself, which has the objective quality indicated by the title, and our enjoyment seems to be for that reason not the less but the more esthetic.

In contrast, let us consider Tschaikowsky's overture entitled *1812*. With it there is a definite program which narrates Napoleon's invasion of Russia and his ultimate defeat there. After a solemn passage, suggesting the sacrificial frame of mind in which a nation springs to arms for the defense of its soil, we hear the *Marseillaise,* which struggles in the orchestra with the Russian national anthem, amidst the noise of battle. The Russian hymn is at first given out in snatches, abruptly broken off; but it gradually becomes firmer, and is at last triumphantly played through, while the *Marseillaise* wavers and disappears, and chimes and trumpets unite in a paean of victory. The pleasure afforded is largely amusement at a tour de force, and it is difficult not to feel that we are in the presence of what is essentially musical vaudeville. The device of representing a war by contention between the national anthems of the nations concerned, and of making music mimic a battle, seems unimaginative and childish. The total effect is sensational and offensive rather than esthetic. We feel that the association between the *Marseillaise* and France is, from the point of view of music, entirely adventitious, and similarly with the Russian hymn.[57]

The latter is simply "illustrational music"; Haydn and Beethoven are not. Nevertheless Beethoven's music is more "literary" than Haydn's; this, however (according to Dr. Barnes), does not make it any less meritorious as music, so long as the music does not exist simply to "illustrate" a program (as in the case of Beethoven's Battle Symphony); the thick esthetic values are, so to speak, "fused" with the thin. Similarly in painting, when a painting simply depends on its subject-matter values (which, as we saw in Chapter I, are outside the work of art) instead of content or life-values, and thus serves to evoke "the same life-emotions over again" —or as Bell says, "only the old material is stirred"—then it is illustrational. When our reaction to a painting of the Ascension depends simply upon our regard for the Ascension as an event in church history—that is, when the painting is designed to evoke religious feelings, regardless of artistic merit—when our interest in the painting results merely from interest in the subject-matter—

57. A. C. Barnes, *The Art in Painting,* p. 32.

then indeed we have not art but illustration. Once again, it is only what the artist has done with the subject-matter, not the subject-matter itself, that counts in a work of art—from which, as we saw in Chapter I, it does not follow that "only the form is important," since content counts just as much. To repeat a passage already quoted once: "Confusion of values arises only when the spectator is moved, not by what the artist shows him, but by what he does *not* show him—the historical event."[58]

Thus, illustrating the difference between life-values and illustration in painting, Barnes says, speaking of Renoir:

His painting catches the spirit of youth and springtime and vitality; he sees and draws forth the joyous and glamorous in the world. . . . The ornamental motif in evidence in Renoir is so fused with the structural elements that an enriched plastic form emerges. The picture sheds light upon what is represented and this revelation of the world has a value which, though in the strict sense illustrative, is truly plastic or pictorial, and not at all "literary."[59]

So much then for the distinction between illustrational and non-illustrational painting, between subject-matter interest and content-interest. Concerning this I can add little more except that we have "thick" as well as "thin" esthetic experiences, and the introduction of life-values does not render them unesthetic. But as yet I have not replied to Fry's claim that the two clash. Fry says, we may remember, that whenever the introduction into art of emotions from everyday life occurs, the latter interfere with the distinctively esthetic emotions produced by the interplay of forms, so that the observer must shift his attention from one to the other. And, as we have seen, he would amend the situation by abolishing the life-values entirely. Professor Reid replies to this in the following manner:

. . . Is not the cure worse than the disease? Does it not lead to an artificial idea of art and does it not impoverish art of much of its meaning? Life may be difficult to transform esthetically, but is it impossible? Must we simply abandon the attempt, choosing art *or* life, but not both?

. . . If the artist is interested *merely* in the "pure" formal relations of the human face, if he is interested, that is, simply in the general emo-

58. *Ibid.,* p. 25.
59. *Ibid.,* p. 34.

tional values of plastic forms and their relations, he is not painting a *human* face at all. His subject-matter is merely a general arrangement of plastic forms, which, as it happens, bears some resemblance to a human face. It is not a matter of the psychological factor being "emphasized" less; it is a case of the psychological factor not existing at all for the artist. But it is a strained and unnatural attitude. Of course the painter is interested in the expressiveness of visual *forms*. But he is interested in their *expressiveness*. The forms are "significant." And what does a human face express more definitely than human character? Surely the artist has more before him than "lines, planes, and volumes." Surely, if he is not ridden by theories, he is interested in character. Not the disembodied, purely mental character which is the object of the psychologist, but, once again, character plastically expressed in a face which interests him. If this interest can in some sense be called dramatic, it will not be true to say that the "dramatic" painter will give emphasis to ultra-plastic values, in the sense of values outside and independent of the plasticity. Rather, psychological values will become apprehended plastically.[60]

Thus it may well be that the shifting of attention from the plastic to the dramatic or psychological, and vice versa, is a peculiarity of Fry's esthetic experience, or it may be due to a faulty analysis of that experience. Professor Reid declares his own experiences to be quite otherwise:

It is not that we are interested in two things, side by side. Introspection of art experience makes this fairly clear. When I look esthetically at Verocchio's *Colleoni* I am not in the least interested in the character which the gentleman on the horse originally possessed. Yet I cannot but feel braced up and inspired by the intense vigor of character which is embodied in every inch of horse and man. Or when I see the fresco (in the Arena Chapel at Padua) of *Joachim Retiring to the Sheep-fold,* it may be that my first interest is psychological, or it may be that it is plastic (in my own case it was the latter). But in a full appreciation I cannot possibly cut out one or other element. In the whole, each becomes transformed. There is not, to repeat, when the experience is complete and mature, psychological interest *and* plastic interest. There is just the plastic-psychological expressiveness of the forms of the dignified old man with head bent, enwrapt in his mantle, in contrast to the different plastic-psychological expressiveness of the naive-looking shepherds who come to meet him. Our object is plastic psychology, plastic drama.

60. Reid, *A Study in Esthetics*, p. 321.

It is only if the psychological interest in paintings is an extrinsic interest . . . it is only where there are elements of external allusion and mere illustration, that psychological elements will tend to "evaporate." If the artist has imagined his way through to the end, the psychological interest will not evaporate because it will be intrinsic to the painting: the psychology is plastic psychology.[61]

There is, then, naturally an "evaporation" in *illustrational* painting; wherever, that is, the subject-matter of the painting loses its interest (for example, when the political squabbles of seventeenth-century France become outdated, or when medieval habits of dress lose their interest for most people), then, since the interest of the painting depends upon the interest in the subject-matter, the painting automatically loses its excuse for being. This is the inevitable fate of any alleged work of art that depends upon subject-matter for its appeal, and exists only to illustrate that subject-matter. It might be held that some subject-matters are eternal in their interest, such as human nature, love, passion, death, the sky and the fields. Although it is indeed true that these interests are more enduring than, for example, the political machinations of seventeenth-century France, it still remains true that as long as the response to the painting depends solely upon interest in its *subject-matter,* our interest is not in the painting as a work of art. Even if the painting should "reveal" or "disclose" some new insight (a topic which will occupy us in Part II), still we should not be likely to be able to approach that insight again and again with undiminished interest and enjoyment. This is the point of the distinction which Kenneth Burke makes between the "psychology of form" and the "psychology of information";[62] the psychology of information is bound to wear out in time—we cannot come back to it indefinitely and enjoy it more each time; once we have learned it, once we have grasped the insight, every repetition of the experience is likely to be less strong.[63]

61. *Ibid.,* pp. 321-22. *Vide* also Walter Abell, *Representation and Form.*

62. Kenneth Burke, *Counter-statement,* especially the chapter on "The Psychology of Form."

63. Cf. I. A. Richards, *Principles of Literary Criticism,* p. 275: "Remove the belief, once it has affected the attitude; the attitude collapses. . . . The belief has to grow more and more fervent, more and more convinced, in order to produce the same attitude."

A painting can be a work of art, however, even if this life-value is not present; some paintings, that is, are esthetic in the thin sense. But all I want to emphasize is that as an art painting is not limited to this "purely esthetic" (in the thin sense) interest; there are life-values that enter painting which are not adventitious, which do not exist merely to illustrate a scene from life or to arouse the same old life-emotion over again. This is not illustrational, since the emotion it evokes is a distinctively esthetic one; it is not duplicated (as we saw in the previous section in the case of music) by any emotion in life.

Mr. Fry, I think, is sometimes guilty of seeking after a too great simplicity of esthetic experience. The esthetic experience is (even when "pure") a complex experience and, even when much psychological fusion occurs, a complexity of meaning remains. This complexity must be fused and unified esthetically, but esthetic fusion does not mean the disappearance of the parts. The esthetic fusion, or assimilation or unification of parts, must simply be accepted as a fact which is irreducible.

To say all this is not to deny that the emphasis in different works may be on different things, or that in the same work the focus of our interest may not shift about. Indubitably the focus does shift. This does not mean the same thing as that of which Mr. Fry is speaking when he speaks of the "shifting of attention." In poetry the images and ideas may be an accompaniment of the delightful words; or the ideas and images may be the focus, and the sound of the words their accompaniment. In representative painting we may now be interested in the character-aspect of the content, and now in the formal aspect. . . . But the "shifting" is not from *mere* "dramatic," *mere* "psychological" interest, to *mere* formal interest. It is only, if the experience be an esthetic one, an emphasis on aspects of a whole, in which one aspect modifies and colors the others. In other words, and to repeat, emphasis upon and attention to this or that, is not incompatible with esthetic fusion.[64]

In the opinion of many critics, it is only when this fusion occurs that the highest peaks in painting are attained:

To create an effective pattern of line and color is something; if line and color are made instrumental to massiveness, to distance, to movement, that is an important addition; if the dynamic masses in deep space are so composed and interpreted as to render the spirit of place

64. Reid, *A Study in Esthetics*, p. 324.

in landscape, as in Claude or Constable, of religious elevation, as in Giotto, of drama and power, as in Tintoretto, of poignant humanity, as in Rembrandt, the total result attains or approaches the highest summits of artistic achievement.[65]

Take from Mozart his gaiety suddenly breaking off into solemnity, from Watteau his sensual melancholy, from Chardin his love of common things . . . and you will no doubt be left with valuable relations of pure form, but you will no longer have Mozart, Watteau or Chardin.[66]

One more comment must be made before I pass on to a consideration of meaning in literature. Even the pure formal values in a painting are not entirely "in a world apart," irrelevant to life. Significant form is, contrary to Bell's statement, significant *of* something in life. For, in the first place, whence come these forms? They arise from nature (though they are, needless to say, not for a moment a copying or transcription of forms to be found in nature) and also, I think, from the rhythms within our own bodily organisms. Bell cannot be quite right in saying that we need bring with us nothing from life to art, for the basis of our enjoyment of these forms lies in a feeling, conscious or unconscious, for the forms and rhythms within us and in the life around us. If we were not as we are, human things, the same forms when presented in a work of art would not evoke the peculiar emotion Bell speaks of. Fry himself admits, speaking of the source of the peculiar satisfaction found in works of art:

. . . It is not a mere recognition of order and interrelation; every part, as well as the whole, becomes suffused with an emotional tone. . . . The emotional tone is not due to any recognizable reminiscence or suggestion of the emotional experiences of life; but I sometimes wonder if it nevertheless does not get its force from arousing some very deep, very vague, and immensely generalized reminiscences. It looks as though art had got access to the substratum of all the emotional colors of life, to something which underlies all the particular and specialized emotions of actual life. . . . Or it may be that art really calls up, as it were, the residual traces left on the spirit by the different emotions of life, without however recalling the actual experiences, so that we get an

65. Barnes, *op. cit.,* p. 49.
66. Charles Mauron, *Esthetics and Psychology,* pp. 27-28.

echo of the emotion without the limitations and particular direction which it had in experience.[67]

And, in the second place, these forms are rediscovered in the world around us after we have contemplated these "formally significant" works of art; nature, to our vision, becomes imbued with these forms, and, to parody Pater's famous dictum, aspires to the condition of art. But of this more will be said in Part II. The point here is merely that although the "significant forms" of art are not literally copied from nature, nor are they represented in nature with anything like the fidelity that outright representational content (people, houses, trees) is, or even as the play of light and shadow or spatial extension, still they do have their basis in nature and hence are not, ultimately, as unrelated to it as Bell says.

These statements do not nullify the tripartite division made in Chapter I between surface, form, and life-value, since it *is* possible to observe a painting by merely contemplating and enjoying its abstract design and "plastic orchestration" without regard to any life-relevance it may have (just as we may contemplate color in a painting without seeing it as relevant to, or expressive of, any object in life, or of anything beyond itself). And that is why we still retain it (like color) as a "thinly esthetic" dimension, in spite of the fact that, as we have now seen, the forms perceived are the forms of life.

These observations take on a special importance now that the conception of form has become, in the minds of the greater number of artists and critics today, the essence and *sine qua non* of all painting.

The most numerous and characteristic moderns of today recognize along with the criteria important to earlier generations of art-lovers—along with the subject-and-meaning values and the technical craftsmanship—a super-value, a higher significance caught out of the center of creation in a sort of formal structure or orchestration, possible only to the painting medium, or the sculpture, or the architecture. . . . The achievement of this formal value, in each art according to its kind, affords the safest guide. It is the prime signpost to the appearance and

67. Roger Fry, last paragraph of "The Artist and Psychoanalysis."

reappearance of the stream of esthetic verity down the ages. It is the one unchanging indication of a timeless excellence.[68]

When discussing this mysterious form as the *sine qua non* of all great painting, Professor Cheney illustrates his point most aptly in his analysis of Chinese paintings.[69] But as to what this "significant form" is, he agrees with other artists that it is quite indefinable; there are no rules for constructing it, but when it is present, it is the one outshining excellence of all visual art. Professor Giles translates Hsieh Ho, a Chinese painter of the sixth century, as calling it "rhythmic vitality."[70] And according to Laurence Binyon, "Mr. Okakura renders it 'The life-movement of the Spirit through the Rhythm of things'; or, again, one might translate it 'The fusion of the rhythm of the spirit with the movement of living things.'"[71] This notion of "significant form" or "expressive form" was inaugurated in the Occident largely through Cézanne and other post-impressionists, and has been predominant in Western art since, although it appears in El Greco and indeed to some degree in all Western painters who are currently considered the greatest, since it is itself the chief criterion by which these painters are judged:

The people who have stressed an abstract design, a formal excellence, as the basic creative element in art, have been at the very center of the modernist advance. Some of them have gone on to the conclusion that nature must be wholly squeezed out of the picture, that the

68. Cheney, *A World History of Art*, pp. x-xi.

69. *Ibid.*, esp. pp. 290 ff.

70. Giles, *Introduction to the History of Chinese Pictorial Art*, p. 24.

71. Laurence Binyon, *The Flight of the Dragon: an Essay on the Theory and Practice of Art in China and Japan*, p. 13. Cf. in this connection Clive Bell's interesting footnote: "When Mr. Okakura, the Government editor of *The Temple Treasures of Japan*, first came to Europe, he found no difficulty in appreciating the pictures of those who from want of will or want of skill did not create illusions but concentrated their energies on the creation of form. He understood immediately the Byzantine masters and the French and Italian primitives. In the Renaissance painters, on the other hand, with their descriptive pre-occupations, their literary and anecdotic interests, he could see nothing but vulgarity and muddle. The universal and essential quality of art, significant form, was missing, or rather had dwindled to a shallow stream, overlaid and hidden beneath weeds, so the universal response, esthetic emotion, was not evoked. It was not till he came on to Henri Matisse that he again found himself in the familiar world of pure art. Similarly, sensitive Europeans who respond immediately to the significant forms of great Oriental art, are left cold by the trivial pieces of anecdote and social criticism so lovingly cherished by Chinese dilettanti."—(Clive Bell, *Art*, pp. 36-37 n.)

new art is to be wholly abstract—and then one has the "purists" and Kandinsky and Klee. From Cezannist to ruthless abstractionist, the factions all are known as "form-seeking," and there is talk of "plastic orchestration" for formal effect. There are even those who carry this effort into mystical regions, asserting that the abstract artist sets down a revelation of cosmic order.[72]

Most artists and critics permit art a much greater "life-relevance" than Bell does; hence their term *"expressive* form" rather than "significant form," since the latter term has been used by Bell to denote a significance which has nothing to do with the significance of anything in life. As we have seen, however, even Bell's "significant form" is significant of life in indirect and subtle ways.

There are many works of art—which I would consider very great works indeed—that demand *primarily* the kind of response which Bell champions: Cézanne, Seurat, Whistler, and any number of the moderns. But there are many others in which life-values are absolutely essential, and without a feeling for the life-values we quite "miss" the painting. Among these are Turner's flamboyant seascapes and Constable's country landscapes, Michelangelo's feeling for the human body and Rembrandt's for the human soul, Monet's rendition of light and Cézanne's of space. Most critics would refuse to call these "irrelevant to life"; yet they would also refuse not to call them great art. As we have already found in the case of music, they provide experiences different from any life-experience and hence unique, yet not wholly unrelated to it and hence not isolated.

IN LITERATURE

I

"Generalize Mr. Fry's contention regarding painting by extension to drama or poetry," says Dewey, "and the latter cease to be."[73] Literature, we have already seen, is the least esthetic of the arts; it is utterly dependent upon life-values for its existence and its efficacy. "Symphonies of colors and lines" are on display

72. Cheney, *A World History of Art*, p. 862.
73. Dewey, *Art as Experience*, p. 90.

at New York's Museum of Non-Objective Art, and these approach the point of complete irrelevance to life; but spoken words, apart from all meaning and association from life, simply for the pleasure of their esthetic surfaces and rhythms alone, would very soon fail of any effect. Words have far fewer esthetic (in the thin sense) elements than colors or sounds do, so there must be more thickening, more life-values "held in solution."

Literature, first of all, is capable of far less structural complexity than the other arts; it would be difficult indeed to wring an experience of *pure* "significant form" from literature. The formal devices we discussed in Chapter I are certainly operative in literature, but generally in a lesser degree of complexity. The fact that they *are* important, however, is easily seen by noting the effect produced when they are lacking:

I was present at a film which recorded the work of rescue from a ship wrecked off the coast of Portugal. One saw at a considerable distance the hull of the vessel stranded on a flat shore and in between crest after crest of huge waves. In the foreground men were working desperately pulling at a rope which ever so slowly drew away from the distant ship a small black object which swayed and swung from the guide rope. Again and again the waves washed over it in its slow progress shorewards. It was not till it was near shore that one realized that this was a basket with a human being in it. When it was finally landed the men rushed to it and took out—a man or a corpse, according to the luck of the passage or the resistance of the individual. The fact that one was watching a film cut off all those activities which, in the real situation, might have been a vent and mitigation of one's emotions. One was a pure, helplessly detached spectator, and yet a spectator of a real event with the real, not merely the simulated, issue of life and death.

For this reason no situation on the stage could be half so poignant, could grip the emotions of pity and terror half so tensely. If to do this were the end and purpose of drama, according to Aristotle's purgation theory, and not a means to some other and different end, then the cinema had surpassed the greatest tragedians. But, in point of fact, the experience, though it was far more acute and poignant, was recognisably distinct and was judged at once as of far less value and significance than the experience of a great tragic drama. And it became evident to me that the essential of great tragedy was not the emotional intensity of the events portrayed, but the vivid sense of the inevitability of their unfolding, the significance of the curve of crescendo and diminuendo

which their sequence describes, together with all the myriad subsidiary evocations which, at each point, poetic language can bring in to give fullness and density to the whole organic unity.[74]

It is very uncommon to find in literature the complexities of form that we find in a great deal of painting and, most of all, in music.[75] And if literature's formal potentialities are more limited than those of these other arts, it should be needless to say that this is even more true of its sensuous surface. Indeed, as marks on a printed page, literature has no sensuous surface at all; there is in literature no directly presented sensuous surface, either auditory (as in music) or visual (as in painting); it is as it stands simply a set of symbols which can become endowed with a surface only after an act of imaginative construction on the part of the reader in reading the symbols, in this instance the words. The fact that in literature we are not confronted directly with a sensuous percept, as we are in the other arts, is a very important one, and Mr. T. E. Jessop makes it the basis of a very important distinction between literature and all the other arts. The latter he calls sensory arts, the former, ideo-sensory:

In literature the medium is not, and cannot be, regarded as purely sensory. Words, phrases, sentences are not mere sounds, but sounds appointed to be operative as vehicles of determinate images and meanings and of the emotional evocations of these. . . . The so-called pure poetry desiderated by some of the moderns is not poetry, not literature, because its medium is not words but simply sounds; nor is it even music, for music is minimally a pattern of musical sounds, different both sensorily and physically from spoken sounds. Important, then, as sound-beauty may be in verbal art, it is subordinate. Its office is not to

74. Roger Fry, *Transformations,* pp. 9-10. Cf. also Douglas Moore's comparison of the musical structures to the structure of the drama, *Listening to Music,* p. 222.

75. Music is the supreme example of structural and formal complexity. "A picture composed with the rigor and subtlety of the most insignificant popular song seems like a masterpiece, because most of the pictures daily being brought into the world are hardly composed at all."—(Charles Mauron, *Esthetics and Psychology,* p. 80.) This is largely because "colors, forms, words . . . are all, first and foremost, signs by which we regulate action. Certain of their combinations form the objects or opinions we make use of in practical life, thus composing what we call the *natural order of things."* But musical notes have no existence in the world outside of art; "musical notes constitute one of those rare sensations which play no part in our active life. They are of no use, they mean nothing, and consequently they find no place in a utilitarian organization of the world. . . ." —(*Ibid.,* pp. 78-79.)

present itself, but to introduce and reinforce a system of images and meanings and emotions; and since images and meanings and emotions are the distinctive stuff and life of human experience, verbal beauty is indefeasibly humanistic, not only properly but inescapably ideal, representative, expressive, and evocative—which is another way of saying that it is inescapably related to that system of needs, interests, and evaluations which make us practical and moral beings.

This is not the case in painting. Here the medium can be apprehended in its purely sensory aspect without mutilation. It can stand alone entire. It is not a necessary part of color, line, and space to represent, express, or evoke. The sensory medium itself has a beauty all its own. Certain colors sit quietly side by side, others enhance each other; certain lines are graceful, directive, and organizing; certain masses are mutually supporting, coherent. These are the specific excellencies of color in its spatial setting, its own esthetic aspect. With nothing more than these, a picture is beautiful. . . . In no case is it necessary to know what a color-object stands for in order to appreciate its own beauty. . . . When what is represented is not centrally a visual thing, but some fragment of life's joy or pathos, itself perhaps beautiful, we have a *supervenient* beauty, that of the subject of the painting, not of the medium, of the painting as paint. If, then, painting and the other visual arts, and probably music, too, may be beautiful quite apart from what they represent or express, there is a beauty distinct from that of which alone literature is capable. To approach painting, sculpture, architecture, and music from the side of literature and require there what is always to be found here is to overlook the nature of the difference between the two kinds of media, one of which may, the other of which may not, forego all representative or expressive character. *A word ceases to be a word and therefore loses the beauty of a word when its signification and significance are not apprehended; a color is most a color when apprehended apart from what it may happen to represent, and then most reveals its own beauty. . . .*[76]

Even when poetry is read aloud, its sensuous surface is, by itself, far weaker in its sensuous appeal than that of painting and, most of all, music; even the most mellifluous succession of sounding words cannot compare with the directly sensuous appeal of a simple melody—that is, when the words are considered simply as sounds, apart from all life-meanings. This fact dooms from the beginning any theory of poetry as "pure sound." (The importance

76. T. E. Jessop, "The Definition of Beauty," in *Aristotelian Society Proceedings,* XXXIII (1932-33), 170-71. Italics mine.

of sound in poetry will be discussed more carefully in the next section.)

George Moore champions a theory of "pure poetry," but his ideal of pure poetry is not that it be purged of life-values, but rather that only certain life-values—those directly concerned with "the enduring world of things," rather than moral reflections, for example—are the proper subject of poetry.[77] And this contention is not under discussion here; what is of immediate relevance is that Moore's theory is not analogous to Hanslick's and Bell's. He is not advocating a complete dichotomy between art and life, as they are. He is rather trying to "purify" poetry by limiting its subject-matter to those things *in life* which he thinks are most enduring. What he advocates for poetry is analogous to the suggestion for painting that the painter should not occupy himself with the historical and topical but with the universal and enduring human values. And this is obviously different from the suggestion that art divorce itself from life. Many poems satisfy Moore's criteria for "pure poetry," but not the criteria of Hanslick and Bell.

One good test, it seems to me, of how prominent the "thick" element in any art-form is, is to consider how much knowledge and experience of life is necessary to understand works of art in this form. And it seems to me that in order to appreciate music we must (contrary to Hanslick) have a certain depth and richness of affective life, and also a certain breadth: we must have experienced joy, sorrow, pain, etc.; but *not* in any particular context. We need not have knowledge of any particular life-situation, for example, the one that may have inspired the composer. We must have lived as human beings, but not through any particular set of experience; nor need we be equipped with a considerable body of particular knowledge.[78] This is true also of much painting; we must know what trees, clouds, and people look like. Some acquaintance with human nature is also presupposed. Sometimes, in fact, we must have knowledge of a particular culture and his-

77. George Moore, *An Anthology of Pure Poetry*, pp. 17-19. Also in this connection cf. Professor Pottle's *The Idiom of Poetry*, Chapter 5.

78. Professor Leichtentritt to the contrary. Cf. Hugo Leichtentritt, *Music, History, and Ideas*, Introduction. Professor Lang's example of Debussy is another case in point, *Music in Western Civilization*, p. 1021.

torical situation—and the painting reflects that culture and that historical situation much more than music does. (The evolution of music can be traced *within* the form itself, and almost entirely without reference to social and economic conditions of any particular time or place.) It is often necessary in painting even to have certain particularized bits of knowledge within that culture or era: for example, a rather intimate acquaintance with medieval Christian iconography is presupposed in much Renaissance religious painting, and these paintings cannot be appreciated without this knowledge—a knowledge, be it observed, which must be acquired *outside* the work of art, and outside the history of the art form.[79] But in literature, particularly in the drama and the novel, we must know the most of all about particular facts of history, the culture of the time, the social milieu, etc. Works in these media are often written around particular historical situations or problems, acquaintance with which is presupposed. Thus all three arts presuppose *some* previous acquaintance with life; but literature by far the most. In literature the "life-component" (as opposed to the "form-component") is far more predominant than it is in painting or music.

The same observation may be made, incidentally, of the artists in these different media. The composer need know little if anything about his epoch; he need have few if any facts at his command. Mozart, without doubt the most gifted genius in the annals of music, knew little about anything—only music. His views on science, history, philosophy, and society were in no way distinguished among the common people of his day. The painter, as often as not, requires no acquaintance with any department of knowledge—Cézanne is an excellent case in point. But the painter's visions are, unlike the composer's, based upon an observation of the world, of the human beings and nature around him. And often much more particularized knowledge than this goes into the painting. But the author—except perhaps the lyric poet, who is more like the painter—must know of persons, things, ideas, feelings, facts, to a degree unparalleled by the artists in the other

79. Cf. on this point, T. M. Greene, *The Arts and the Art of Criticism*, pp. 286-88, and Rhys Carpenter, *The Esthetic Basis of Greek Art*, p. 24.

media. The social dramatist must often have at his command a depth of insight and detail of facts such as would almost necessitate his being, in addition to a dramatic artist, a specialist in the field which he makes the subject-matter of his drama.

2

A poem, like any work of art, "means" to us simply what it evokes in us—and if the evocation is successful, what is evoked is not what I have already referred to as "the same old life-emotions over again," nor yet an isolated state unrelated to anything else we experience in life, but a state which is different (unique) and yet not isolated. In literature the life-component of the compound— to make an analogy with chemistry—is more prominent than in the other arts, but even here there are many variations of emphasis.[80]

One question which confronts us at once in discussing poetic "meaning" is the extent to which the referential (logical, informative) meanings of words are important for the meaning of a poem. For purposes of "pure communication," these words have no value in themselves; they are "transparent"; being symbols for things other than themselves, they are useful only insofar as they symbolize these other things. The same is true of the sentences in which they occur; the sentence which symbolizes a situation depends for its (communicative) success on the degree to which it symbolizes that situation. Scientific writing doubtless constitutes the chief illustration of words and sentences used entirely in this fashion; here the words are of no intrinsic importance, and the referents are all-important. Writers in the exact sciences deliberately set out to restrict their words to this purely symbolic use, to "take all the color out of them." They want to communicate; they are interested in referents, not the means by which the referents are

80. Cf. Santayana, *The Sense of Beauty*, p. 128: "Poets may be divided into two classes: the musicians and the psychologists. The first are masters of significant language as harmony; they know what notes to sound together and in succession; they can produce, by the marshalling of sounds and images, by the fugue of passion and the snap of wit, a thousand brilliant effects out of old materials. The Ciceronian orator, the epigrammatic, lyric, and elegiac poets, give examples of this art. The psychologists, on the other hand, gain their effect not by the intrinsic mastery of language, but by the closer adaptation of it to things. The dramatic poets naturally furnish an illustration."

understood. However, it may be doubted whether in even the most colorless piece of writing the words are completely transparent—not only understanding of their meanings, but also a feeling-tone or affective "fringe" is evoked. Nevertheless, perfect transparency is the professed aim of this kind of writing. Now how does the case stand with literature?

It is *possible* to approach a poem without knowing what the words in it refer to. If one is able to pronounce the words of the language in which the poem is written, one can enjoy it for its sounds alone, without knowing the meanings (by which is meant, of course, referential meanings).[81] But in poetry, and much more still in prose, such enjoyment will not get one very far.

Is there anything in poetry comparable to the expressiveness of single tones or of colors like red and blue and yellow? To this, I think, the answer must be, little or nothing. Almost all the expressiveness of single words comes from their meaning. At all events, the sound and meaning of a word are so inextricably fused that, even when we suspect that it may have some expressiveness on its own account, we are nearly incapable of disentangling it. As William James remarked, a word-sound, when taken by itself apart from its meaning, gives an impression of mere queerness.[82]

The sounds of words, divorced from their meanings, will generally have little effect upon the listener, and there are only a comparatively small number of poems in any language in which the poem or any part of it is enjoyable for its sound-effects (to which

81. Although, as Mr. Empson points out, we cannot get the inflections of sound and rhythm correctly unless we know what the words mean. William Empson, *Seven Types of Ambiguity*, pp. 10-11.

82. DeWitt Parker, *The Principles of Esthetics*, p. 198. Cf. also Carritt, *The Theory of Beauty*, pp. 266-70; Reid, *A Study in Esthetics*, pp. 108-13; and the following two passages:

"The sound qualities that we admire in good poetry are not anything that would have any particular value in abstraction from the emotive and informative meanings of the words. The sounds are good when used to express *this* sense and to suggest *this* emotion. . . ."—(Karl Britton, *Communication*, p. 252.)

"Mere sonority does not account for the beauty peculiar to poetry; for mere sonority is not beautiful at all for long. Language which is not expressive soon becomes simply tiresome; syllables as pure sound will not hold our attention. Schliemann is said to have been captivated in his boyhood by the sound of Homer's hexameters; but he did not remain thus captivated any longer than he could help: he learned Greek as soon as he could, and the natural beauty of Greek syllables then became merged in the poetic beauty of sound that is *understood*.—(Abercrombie, *The Theory of Poetry,* p. 169.)

we may add rhythmical effects) at all. Even the following pulsating rhythms and colorful alliterations of Byron's *Destruction of Sennacherib,*

> The Assyrian came down like a wolf on the fold,
> And his cohorts were gleaming with purple and gold;
> And the sheen of their spears was like stars on the sea,
> When the blue wave rolls nightly on deep Galilee,

would have but little effect if we did not associate the sounds and rhythms with the known meanings of the words. As I. A. Richards points out, the immense difference in evoked effect between "Deep within a gloomy grot" and "Peep within a roomy cot" is not due to the comparatively slight difference between the sounds of the two lines. Moreover, for the appreciation of much poetry the symbolic meanings of words must be known even down to their finest shades, beyond what is required in ordinary discourse. The inability of immigrants to grasp the spirit of contemporary American poetry, even though they "know in general what the words mean," is due at least in part to the fact that these finer shades of meanings (many of the words have almost local significances) elude them; as we say, they do not know the American idiom.

Knowledge of the referential meanings of words is of course not enough. One must also be acquainted with the cluster of affective associations which gather around every word—the emotions they normally evoke, the images to which they give rise. This is often more difficult than knowing the referential meanings, since it cannot be learned from a dictionary. One of the reasons why it is so difficult for many persons to enjoy seventeenth-century English poetry is that they are not acquainted with these subtler shades of meaning, even though they know what the words refer to; when even one image fails to "catch," the point of the poem is lost on them. Acquaintance with these affective meanings can be gained only gradually by steeping oneself in the poetry of the period and noting in what contexts and with what probable intentions the words are used.

Appreciation of poetry, then, requires and presupposes knowledge of the symbolic meanings of words, but this is not enough.

The poet's employment of language is more than symbolic. I think this point is sometimes lost sight of in discussions of poetry. It is said, for example, that the symbols (words) are iridescent rather than transparent, that they shine with their own lustre and do not merely act as vehicles for the conveyance of their referential meanings. And this is true, but not in the way in which discussions of the matter would often lead us to believe. They talk as if words in poetry were not completely but only *partly* symbolic—for example, that they do not mean to refer unambiguously to their referents, but to obscure them somewhat—as if the glass obscured the landscape beyond it to some degree, and that it was partly the charm of the glass itself that made word-usage in poetry different from that of ordinary discourse. This is intimated, for example, by Santayana in the following passage:

> Euphony and phonetic laws are principles governing language without any reference to its meaning; here speech is still a sort of music. At the other extreme lies that ultimate form of prose which we see in mathematical reasoning or in a telegraphic style, where absolutely nothing is rhetorical and speech is denuded of every feature not indispensable to its symbolic role. Between these two extremes lies the broad field of poetry. . . .[83]

But to talk about pure communication on the one hand, and pure music on the other, with the field of poetry constantly gravitating between the two, is misleading because it seems to imply that only part of the referential meanings of words need be known, while actually they should be known to the finest detail, and more besides. Poetry is not partly symbolic, but more than symbolic.

An interesting corollary can be drawn here with regard to the vexed distinction between poetry and prose. I would suggest that the difference between them is not that the one uses the referential function of language and the other not (or less), for both use it to the full. But the language of exact science, theoretically at least, consists of nothing *but* this referential or symbolic usage, while the language of poetry consists of something *more*. Whether a given piece of writing is poetry or prose is thus "a matter of degree"; the more nearly it approaches the purely referential use

83. Santayana, *Reason in Art*, p. 75.

of language, the more nearly it approximates the state of pure prose.

Thus in answer to the question, "How important is the referential function of language in poetry?" we may now answer that it is important as a *prerequisite*. To appreciate the poem we must know what the symbols refer to; but once we know this, we are no further along than we are in music when presented simply with sounds. And while words, unlike the primary materials of the other arts, are conventional symbols, poems (though composed out of words) do not possess referential meaning in virtue of their peculiar function as poetry, but merely as a prerequisite for that function. Words *and* their meanings are the primary material of literature.

3

The referential meanings of words, as we have just seen, constitute *one* factor in poetic effects; we must know them before we can appreciate the work as poetry. But there are other factors as well. Different writers have classified them in different ways. Professor Parker in his *Principles of Esthetics* employs four categories: sound, meaning (referential), emotion, and image.[84] I. A. Richards uses four different ones: sense, feeling, tone, and intention.[85] It seems to me, however, that some of these classifications overlap, and moveover are somewhat confused; some of the distinctions seem to refer to properties of the poem, others to the effects evoked, and still others to what the poet had in mind while he was writing.

I do not think it is necessary to discuss just how much emphasis should be placed on each factor in poetic effects. Mr. Richards assigns most of the poetic "meaning" to the emotion-evoking power of the words, while Max Eastman emphasizes the images that are evoked rather than the emotions. Some critics, like Professor Parkhurst in her book *Beauty,* find the use of images, particularly metaphor, the central factor in all poetry, while others declare the metaphor is not necessary to poetry at all. (The predominance

84. Parker, *The Principles of Esthetics,* Chapter 9.
85. I. A. Richards, *Practical Criticism,* Part III, Chapter I.

of metaphor would naturally tend to make the image-evoking quality the most important aspect of poetic meaning.) Some critics place much emphasis on rhythm and cadence; others almost ignore it.

It would be safe, no doubt, to say that all of them are right; there has been much fine poetry which literally lives by metaphor, and much fine poetry without; to take any one of these factors and make it paramount would probably be a mistake. Most of Shakespeare is fairly dripping with metaphor. Wordsworth's *Lucy,* on the other hand, ending

> She lived unknown, and few could know
> When Lucy ceased to be;
> But she is in her grave, and O!
> The difference to me!

is immensely effective without a single figure of speech. The simple words are sufficient to evoke the most powerful emotions. While many poems are effective chiefly through figures of speech, and most poems are so in great part, there is only one figure of speech in the entire Potion Scene of *Romeo and Juliet,* yet no one will deny that it is poetry of tremendous intensity. The same is true of non-dramatic poetry—for example, Shakespeare's Sonnet 129. There are also poems which are primarily nature-descriptions which contain hardly any images but yet create a vivid picture before the mind. Robert Bridges' *Winter Nightfall* is an example. The first stanza of Matthew Arnold's *Dover Beach* is powerfully effective poetry without metaphor:

> The sea is calm tonight,
> The tide is full, the moon lies fair
> Upon the straits;—on the French coast the light
> Gleams and is gone; the cliffs of England stand,
> Glimmering and vast, out in the tranquil bay.
> Come to the window, sweet is the night-air!
> Only, from the long line of spray
> Where the sea meets the moon-blanched land,
> Listen! you hear the grating roar
> Of pebbles which the waves draw back, and fling,
> At their return, up the high strand,

Begin, and cease, and then again begin,
With tremulous cadence slow, and bring
The eternal note of sadness in.

The moral of this seems to be that one should assign no limit to the number of ways in which poetry can be effective.[86]

We must above all not fall into the error of assuming that all poetic meaning is (or should be) "emotive." "Evocative" is often confused with "emotive"; and while what is evoked *is* all-important, what *emotions* are evoked need not be. There are other kinds of evocations than emotive ones. Often it is the image or picture evoked that is of primary importance; doubtless the image is accompanied by emotion, but the emotion itself is secondary and accidental. Mr. Richards falls into this fallacy when he infers that because language in poetry is not used merely *referentially,* it is therefore used *emotively.*[87] But this is not a true disjunction. Language not used referentially can be used evocatively or expressively; and emotions are only one of the things evoked when language is used evocatively; for example, it may also evoke images. The fallacy of assuming that all poetic meaning is emotive is indeed a widespread one—committed, among others, by John Stuart Mill when he declares bluntly that the purpose of poetry is simply to act upon the emotions,[88] and it is well contested by Professor James when he says:

It is misleading even in regard to intensely personal poetry, to speak of poetry as using language "emotively." Poetry is never concerned primarily to awaken "emotion" and "attitude"; its concern is to convey an imaginative idea of, among other things, emotions. . . . This contemplative excitement is impersonal, as impersonal as that which may accompany intellectual comprehension. Poetry can be as impersonal as science—and in relation to matters in which impersonality is enormously difficult. . . .[89]

86. An excellent discussion of this question is to be found in Chapter III of D. G. James, *Scepticism and Poetry. Vide* also Michael Roberts, *Critique of Poetry.*

87. Richards, *Principles of Literary Criticism,* p. 267.

88. John Stuart Mill, "Thoughts on Poetry and Its Varieties," from *Dissertations and Discussions,* Vol. I.

89. James, *Scepticism and Poetry,* pp. 119-20. On the other hand, it must not be forgotten that it is not just the "imaginative picture" in the poem that is important—it is the listener's response, be that response primarily emotional or not. If there were *no* response,

4

Because poetry is not limited to the referential use of language, it can give a much more precise effect—what Prall calls the "precise specification of the emotions"—than can words used referentially alone. Many feelings, visions, and states of mind are extremely difficult to *describe,* but they can be *evoked* by the proper juxtaposition of words on the part of the poet. A skillful poet can evoke in a sensitive reader images and emotions of the greatest intensity and complexity by juxtaposing words of great evocative and associative power—and can evoke certain calculated effects more precisely than he could ever do if he tried it by using language descriptively. The words of the poem, to use T. S. Eliot's terminology, are the *objective correlative* for the evocata; they succeed in evoking in the reader just the precise image or state of feeling that the poet intended when he employed this particular combination of words.

But poetry must pay for this admittedly great advantage at some cost. For while it has this enormous evocative power, the latter is almost completely lost in the process of translation into another language. For the logical (referential) meaning of words alone can be translated from one language into another, and poetry employs far more than the logical meaning of words. Thus "cat" means the same thing, that is, has exactly the same referent, as "Katze," "felix," "chat," etc. If the foreign language does not happen to have a word with quite the same referent or set of referents as the one in the original language, then one can be coined; this is done constantly in scientific discourse. But the fact (which seems to puzzle many critics and impel others to make mystical pronouncements about poetry) that poetic meaning is untranslatable is due simply to the fact that poetic meaning is not the same thing as logical meaning. The sounds in one language are instrumental in the evoked effect—but the word in the other language has quite

there would be no point in having a poem. Certainly the imaginative picture in the poem is important only because it alone will evoke a certain kind of response—a response which (as Richards sometimes seems to forget) *nothing else* will arouse. Professor James comes dangerously close to saying that the response does not matter—a result of bending backwards from the notion that the sole purpose of poetry is to "evoke emotion." We have already noted a similar tendency in Hanslick, in saying that music "has no purpose beyond itself."

a different sound and, what is more important, a new cluster of associations. "Θάλασσα" sounds very pale when it is translated into "sea," although when Homer uses the first and Tennyson the second, they have exactly the same referents, that is, they refer to the same thing, have the same extension. But poetically, the two are worlds apart; "if the sea could speak," it has been said, "it would certainly prefer to be called 'Θάλασσα.'"[90] I daresay that what poetic value the word "sea" has for us is due not to the sound but to the notion of the sea itself—the concept, not the word, is poetic (the calm sea, the stormy sea, the tropical sea, etc., suggesting all sorts of moods and imaginative situations), and the immense image-making power of the notion of the sea itself is responsible for the effectiveness of the word "sea" when it occurs in a poem.

Poetry is just as unique in its evoked effects as music, and just as untranslatable into any other medium, including that of another system of conventional symbols, i.e., another language. But there is no mystery about this. Poetic meaning is untranslatable simply because poetic meaning is not referential meaning; if it were, it *would* be—at least potentially—translatable.

Any purely symbolic use of words can be reproduced if in the two vocabularies similar symbolic distinctions have been developed. Otherwise periphrases or new symbols will be required, and the degree of possible correspondence is a matter which can be simply investigated. On the other hand, the more the emotive functions are involved the less easy will be the task of blending several of these in the two vocabularies. And further, the greater the use made in the original of the direct effects of words through rhythm, vowel-quality, etc., the more difficult will it be to secure similar effects in the same way in a different sound-medium. Thus some equivalent method has to be introduced, and this tends to disturb the other functions so that what is called the "success" of a translation is often due chiefly to its own intrinsic merits.[91]

Thus a good translation of a poem, one which is poetry in the language into which it is translated, is not merely a transliteration, but a new imaginative construction in its own right—the

90. H. V. Routh in *God, Man, and Epic Poetry*, Vol. I.
91. Ogden and Richards, *The Meaning of Meaning*, pp. 229-30.

work of a poet; for the word-sounds, associations, affective tone, and image-making power of words is largely lost in the translation of the referential meanings from one language to another, and since these are the important things in the poem, they must (if the translation is itself to be a poem) be created anew in the other language, sometimes (justifiably) doing violence to the logical or referential meaning while in the process of acquiring these poetically more important things. It is only when we disentangle the logical from the other senses of meaning that we can say to what degree the meaning of a given poem changes when it is translated; to the extent that the referential meaning of a poem is predominant, to that extent it can be translated—and to that extent, one might be tempted to add, the original was not a good poem.

It need scarcely be remarked that for the same reason that a poem cannot be translated into another language, it cannot be translated into other words of the same language. Only logical meanings, we have seen, can be translated, and poetry is not primarily concerned with these meanings; any loss of these more-than-referential values of a word is an irreparable loss to poetry, and this is exactly what is lost when a poem is taken out of its original idiom, from just those precise words in which it was written. Hence any "prose statements" or "summaries of the content of" a poem are hopelessly inadequate and misleading—they leave nothing but an empty shell; and there is no means of telling from them whether the original was a good poem or not.

Critics and poets are often wont to speak as if there were some "message" given by poetry which could be given in no other terms than just those of the poem itself. And this is certainly true—provided the message is not entirely an intellectual (referential) one, and depends in part at least upon the evocative powers (through images, emotions, etc.) of the words employed. To the extent that the poet's "message" consists merely in grasping the referential meanings of the words and sentences he uses, this message *can,* as we have seen, be rendered in other terms. But the poet's message is not of such a nature, and hence it is quite right to say that his message is untranslatable. It is only those "poets" who are not poetic whose messages can be translated without loss—

poets whose interest is in the subject-matter rather than in the poetry. Hence their "poems" are often rhymed versions of prosaic appeals, curiosities, and propaganda. Such poems are like sugar-coated pills, in which the pill (the message) is separable from the coating (the manner of its presentation), the "poetic quality" being a kind of varnish which can be scratched off without affecting the texture of the wood underneath. In such translation nothing but the sugar-coating is lost. "If we want to write down exactly what the poem says to us, there is no way of doing so except by writing down the poem itself."[92] Only the poem in its original language, with the affective power of the original words, can produce the same effects, i.e., have the same poetic meaning.

Thus far we have been speaking only of poetry, but the same is true of all literary art, including prose fiction:

The most tempting account of the relation of the story to its theme is that which explains the story merely as an *illustration* of the theme: accordingly the story gives a concrete instance of the generalization, and furthermore, it recommends the abstract generalization to us by clothing it in emotional terms. The danger of this account is twofold: (1) it overemphasizes the didactic element in fiction and thus distorts the writer's intention; more important still, (2) it neglects the fact that the organization of the story, if it is valid, does much more than illustrate—it qualifies and modifies the theme. The form of the story states the theme so precisely that for an *exact* statement of it we must turn to the whole body of the story itself. The brief, condensed statements of the "theme" which we use may serve well enough as a sort of short-hand account of a quite complicated matter. But they are not equivalent to the story itself, and they are not equivalent, *even in terms of statement*. If we want to know precisely what *The Man Who Would Be King* says, we must read the story. Anything less is merely a reduced paraphrase.[93]

And again, with regard to metaphor:

The metaphysical poets reveal the essentially functional character of all metaphor. We cannot remove the comparisons from the poems, as we might remove ornaments or illustrations attached to a statement,

92. Abercrombie, *The Theory of Poetry*, p. 49.
93. Cleanth Brooks and Robert Penn Warren, *Understanding Fiction*, pp. 286-87.

without demolishing the poems. The comparison *is* the poem in a structural sense.[94]

If the metaphor were merely a comparison such as is sometimes found in factual writings, another might do as well; at any rate the principle being illustrated by the metaphor would be unaffected by the change of comparison, or even by the total absence of one—only its "pedagogical value" would be changed; the principle, that is, might not be as easily communicated as it would be with the comparison. But in the poem the metaphor is integral—if either the tenor or the vehicle[95] were changed the other would also change; their relation is an organic one. This impossibility of translation or change of any kind from just the precise words of the poem itself is characteristic of poetry and, we might venture, one test of its presence. Poetic meaning is untranslatable; that is to say, this precise effect can be conveyed in no other way. It must remain just as it was presented or be destroyed.

5

One more point must be mentioned here. It is sometimes asserted that poetry "has a logic of its own," that it "moves by laws" which are different from (or even superior to) "the laws of logic." Now it is quite true that there are developments and progressions in poetry, as in the other arts, which bear some analogy to the premises and conclusion of an argument; moreover, some words and phrases and images seem to "fit" with others, and some to "clash with" or "contradict" them: for example, we would doubtless shrink from a juxtaposition of images such as, "To pass from the sunny fields of France into the pleasant olive-orchards of Italy is like jumping from the frying-pan into the fire," as we would (or should) from a formal contradiction in logic. And yet it must be plain that the two are entirely different things. We may, if we wish, use the word "contradict" in an analogical way such that the above pair of images would become a contradiction (a contradiction being defined as anything that caused a mental "clash"

94. Brooks, *Modern Poetry and the Tradition*, p. 15.
95. Richards' terminology in dealing with metaphor in *The Philosophy of Rhetoric*.

or repulsion), provided we are fully aware that the usage of the word *is* analogical and that we do *not* mean by it *"logically* contradict." Images, for example, do not logically contradict each other—no assertion is even made, and only assertions can logically contradict each other; and on the other hand, if two statements in a poem do contradict each other, or if a word is left so ambiguous in the poem that it can be interpreted in either of two contradictory ways, this may not be in the least harmful to the poetic effect,— it may in fact enhance it more than any other device could.[96]

Thus Karl Britton seems to me to be perfectly right when he says that there is

> no grammar, no logic that is a genuine alternative to the logic and grammar of scientific and historical language. Where we use language that is *exempt* from the canons of scientific and historical writing and has its own canons, we find that *we are not using words to convey information at all.* And conversely, wherever we wish to convey matters of fact (whether in prose or verse) we must employ the rules of clarity and consistency. Poetry offers us no pretext for talking of alternative logics.[97]

In all this I may seem to be belaboring the obvious; but the caution does seem to be a necessary one, in view of writers on poetry who in their desire to lend dignity and stature and significance to poetry (as if it stood in need of these things!) try to attribute to it logical properties and logical significances which, if the very authors of those statements took them seriously, would ruin poetry for them. We simply have to assume that they do not really mean what they say. They spend much time in transferring logical terms into poetic contexts, thinking perhaps that by a change of terminology they can change the true state of affairs.

6

To give an adequate account of "the nature of beauty" in literature or any other art would require a volume to itself; it would

96. Cf. the examples of outright contradiction in poetry which are used to heighten the poetic effect, in William Empson's *Seven Types of Ambiguity;* also Karl Britton, *Communication,* especially pp. 257-59.

97. Britton, *Communication,* p. 276.

require first of all an exhaustive analysis of how people actually use the words "beauty" and "beautiful," to determine what (if anything) all these usages possess in common. But regardless of what the analysis of "beauty" may be, we can clarify its usage by making a distinction which has pervaded the discussion of artistic meaning. "Beauty" can be used in a thick or a thin sense, and confusions and disagreements may arise through a failure to specify in which way one is using the word. One might say, for example, that the objects presented for contemplation in many works of art are in themselves rather repulsive, although the works themselves are beautiful—such as Grünewald's *Temptation of St. Anthony* in painting, *Macbeth* in drama. On the other hand one might distinguish between the "goodness" and the "beauty" of a work of art by saying, "This Rembrandt is a better painting, but the Matisse is more beautiful," and he would then be employing the word beautiful in the thin sense. The word "beautiful" is being used in the two cases to denote two different dimensions of esthetic effects. In the thick sense, Beethoven's late quartets would generally be classed among the most beautiful compositions in existence, although in the thin sense they would be considered less beautiful than the quartets of Haydn, and Keats's sonnets more beautiful than *King Lear*. When Browning replied to critics of his *Soliloquy on the Spanish Cloister* who said it was not beautiful, "What do I care for your idea of beauty? It was the Monk I was after; and I think I have got him,"[98] he presumably meant beauty in the thin sense. I believe this is the same distinction which Mr. Jessop has in mind in speaking of the controversy between "formalism" and "expressionism": "For the first, all beauty is sensory, for the second, ideo-sensory. For me there are both kinds, irreducible to each other."[99] Those who make "beauty" synonymous with sounding surface or formal arrangement or even the technical mastery of the medium, and then conclude that since art rightfully does more than this its aim must be "more than beauty," are using the term "beauty" in an unnecessarily narrow sense.

98. Quoted in Abercrombie, *The Theory of Poetry*, p. 167.
99. Jessop, *op. cit.*, p. 172.

The same distinction that has been emphasized throughout our discussion of artistic meaning, and found applicable to the analysis of "beauty," may be applied to the concept of "artistic greatness." This concept, like that of beauty, is too vague as it stands for analysis here. But again the term may be used in two different ways, depending on whether the term is or is not applied exclusively to the thick dimension. In Professor Greene's terminology, "artistic greatness" is a function of "artistic content," which, in the terminology here adopted, is to say that it is a function of the *thick* esthetic values.[100] Thus if a work of art is beautiful entirely or almost entirely in the thin dimension, it is beautiful without being great. On the other hand, if its beauty lies chiefly in the thick dimension, it may be artistically great without having much formal or surface beauty (Dostoyevsky, Van Gogh). The extent to which artistic greatness may be present without beauty in the thin sense may well be a matter for controversy.

Dewey, however, is opposed to this conception of artistic greatness. Speaking of the attempt to contrast "fineness" with "greatness" in art, he says:

Art is fine, it is said, when form is perfected, but it is great because of the intrinsic scope and weight of the subject-matter dealt with, even though the manner of dealing with it is less fine. The novels of Jane Austen and of Sir Walter Scott have been used to illustrate the alleged distinction. I cannot find that it is valid. . . . A clear pool, a gem, a miniature, an illuminated manuscript, a short story have their own perfection, each after its kind. The single quality that dominates in each may be carried through more adequately than is any single system of relations in objects of greater scope and complexity. But the multiplication of effects in the latter, when they conduce to an unified experience, makes the latter "greater."[101]

For Dewey, to say that a work of art is great is simply to say that it is a successful work of art, or a good work of art—"goodness" being a general evaluation based upon the merits of the work of art in *both* the thin and thick dimensions.

I shall not try to decide between these terminologies; it is suf-

100. Greene, *op. cit.,* pp. 461-67.
101. Dewey, *op. cit.,* p. 171.

ficient for the ambiguity to be kept in mind. One point must be noted, however (and here I think Dewey perhaps misinterprets his opponents): in neither sense does "greatness" apply to subject-matter. Greatness of subject-matter would not be *artistic* greatness, since, as we have seen, the value of subject-matter is not the value of anything within the work of art. Only the artist's handling of the subject-matter, what he does with it, can make it artistically great—it must be "greatly treated"; but it can be greatly treated in two senses: Greene's applying to content-values only, and Dewey's applying to content-and-form values together (thick and thin). Thus if Professor Greene's view is objectionable, it is not so on the grounds of confusing subject-matter with content, for this is a distinction which he makes quite clear. *Artistic* greatness, to repeat, is measured by what is *in* the work of art; and subject-matter is pre-artistic, outside the work of art. It is true of course that some subject-matters lend themselves more readily to artistic treatment than others do; nevertheless artistic greatness lies in the treatment rather than in the subject-matter itself. Subject-matter in the sense of "what is presented there on the canvas" may be said to be in the work of art, but this too, as we saw in Chapter I, is not of artistic relevance. That there are three ladies in this painting is of itself no artistic merit or demerit.

The term "significance" is often applied to art in this connection. It too has two senses.[102] It may be used in the literal sense of "to signify," "to be a sign or symbol of," or it may be used in the general sense of "importance." Used in this latter sense, "artistic significance" is, so far as I can see, synonymous with artistic greatness, usually in Professor Greene's sense of that term.

We have now concluded our survey of artistic meaning. But we have not yet inquired whether the arts have any cognitive value, whether they "have anything to say" about life, whether they give us "truth" or "insight into reality," or fulfill any of a number of similar claims which are often made for them. To this issue we must now turn.

102. Greene, *op. cit.*, p. 229 n.

Part II:

Truth in the Arts

5

Propositional Truth

I

DISCUSSIONS ABOUT TRUTH in art are often vitiated before they get well under way because the participants either have different things in mind by "truth," vary their meanings of the word without specifying this fact, or have nothing very definite in mind at all. I shall accordingly try to clear the air at the outset by mentioning some senses in which the word has been used (chiefly by philosophers) and in which I do *not* intend to use it in the following discussion.

1. Truth as equivalent to sincerity. I. A. Richards defines truth in this sense as "the absence of any attempt on the part of the artist to work effects upon the reader which do not work for himself."[1] A work of art is occasionally said to be "true" when it displays sincerity on the part of the artist, when it reflects what the artist really felt. Now, surely no one will deny the desirability of this characteristic in art; many—such as Henry James in his *Art of the Novel*—have made it the chief measure of the merit of a work of art (though he, happily, did not call it "truth"). But much confusion arises when this is equated with "truth." Doing so would give two words the same meaning, which now have distinct meanings, and would remove from one of them the distinct meaning which it now has. It might be replied that not simply "sincerity" but "artistic sincerity" is meant; but this is hardly satisfactory until "artistic sincerity" has been defined. (Does

1. I. A. Richards, *Principles of Literary Criticism*, p. 271. *Vide* also Bernard C. Heyl, *New Bearings in Esthetics and Art Criticism*, pp. 57-60. Dr. Heyl's book is one of the few works in esthetics known to me which displays an acute sensitivity to the nature and function of words and definitions in esthetic theory.

it mean any more than that in addition to being sincere the writer must also be an artist, as opposed to "the poet next door" who is very sincere but is no poet? But in this case the meaning of the word "sincerity" has not changed, only something has been added to it as a requisite for "artistic sincerity.") In any event, this concept is surely not identical with that of truth in any usual sense.

2. Truth as acceptability. "The 'truth' of *Robinson Crusoe* is the acceptability of the things we are told, their acceptability in the interests of the effects of the narrative, not their correspondence with any actual facts involving Alexander Selkirk or another. Similarly the falsity of happy endings to *Lear* or to *Don Quixote* is their failure to be acceptable to those who have fully responded to the rest of the work. It is in this sense that 'truth' is equivalent to 'internal necessity' or rightness. That is 'true' or 'internally necessary' which completes or accords with the rest of the experience, which cooperates to arouse our ordered response, whether the response of Beauty or another. 'What the Imagination seizes as Beauty must be Truth,' said Keats, using this sense of 'truth,' though not without confusion."[2] The term "acceptability" here is not quite clear. Some things, of course, are acceptable because they are *true;* but the presumption in the above quotation is that something may be acceptable for a wide variety of reasons—for example, an ending to a drama may be acceptable because it is a continuation or fulfillment of the mood which has been established; it is for this reason that attempts to end *Lear* happily are not acceptable, and hence, in this sense, not "true." Again, this is a confusing use of the word.

3. Truth as value for mankind. "Imaginative writing has its quite distinctive 'truth' and 'falsity'. . . . For the 'truth' that is peculiar to poetry—its validity—is simply its value for men."[3]

4. Truth as coherence of parts. "Sometimes . . . 'truth' in art may be taken to mean internal *coherence* of a work of art, and falsity its incoherence. When used thus, 'truth' and 'falsity' becomes synonymous with 'beauty' and 'ugliness.' Thus a 'false' note is a note which does not fit into the expressive whole, it is a note

2. *Ibid.*, p. 269.
3. Karl Britton, *Communication*, p. 275.

which jars upon us, which is ugly. A 'false' character in a play is not merely a character which does not correspond to real life, but a character who is falsely drawn in the sense that it is not consistently worked out. Sentimentality may enter; what ought to be tragedy may be given a 'happy' but incongruous ending. If this is 'falsity,' 'truth' will be the harmonious tension of mutually fulfilling parts; it will be expressiveness, beauty."[4] This notion of truth overlaps several others I have already mentioned, and indeed is rather ambiguous itself. "Coherence," whatever precisely it may mean, certainly *need* not constitute "beauty" or "expressiveness." The reference to sentimentality and "false notes" sounds like class (1), while the very next clause, referring to the incongruous happy ending, sounds like class (2). But all that it is necessary to note here is that this sense of "truth," whatever its precise import may be, is not one which we shall employ.

5. Truth as consistency. By this is not meant the logical consistency of the statements made—if indeed there are statements made at all, which is not the case in the non-literary arts. The word "truth" here refers to a kind of "internal necessity" akin to what has been suggested in the preceding paragraph. According to Professor Greene, who discusses this requirement at some length, the chief characteristics of this kind of consistency are that the artist must have "exploited adequately the expressive potentialities of his medium"; that his "interpretations of the subject-matter do not contradict one another" (not logically contradict, but contradict in the analogical sense of presenting clashing styles, as would be the case if in a single painting we found different objects treated in the manner of Corot, Cézanne, Matisse, etc.: "We would exclaim: 'The painter has contradicted himself in almost every stroke'");[5] and that his work possess "ideational coherence," something which "is achieved only in proportion as all the interpretations of the several portions of the specific subject-matter *complement* one another so that the work of art as a whole expresses a complex and coherent commentary on the

4. Reid, *A Study in Esthetics*, pp. 250-51.
5. T. M. Greene, *The Arts and the Art of Criticism*, pp. 449-50.

nature and import of the entire subject-matter in question."[6] Now, I have no quarrel at this point with these requirements, except that the language is vague and the precise import of many crucial terms does not seem to me to be at all clear; but what I here object to is the use of the term "truth" to designate the characteristics of which he speaks.[7] It seems to me that to call any or all of these things "truth" introduces much confusion, and arises, in this case, from a false analogy of art with logic (in using words such as "consistency" to describe the relation of various items in works of art) which arises in turn from an identification of works of art with propositions—of which more later in this chapter.

6. Truth as greatness. " 'Truth' may be used to denote 'deep significance,' or greatness. We say, How true! meaning simply, How great! The 'truest' work of art in this sense is that which is most profound, in the experience of which as a whole we are aware of a deep sense of 'reality' (as the saying is). And often it will happen that in this harmonious satisfaction of our profoundest impulses we feel a tremendous conviction of knowledge, which is accompanied sometimes by a sense of the superiority of such knowledge to other forms of it."[8] Here again we have wandered from the point: "greatness," whatever it may be interpreted to mean exactly, need not necessarily be accompanied by this sense of "reality" or "tremendous conviction of knowledge" (of which I shall have more to say later), so that they can scarcely be incorporated in the *same* sense of "truth." But once again, the ambiguity here does not matter since we are not going to use the word in this way.

As to *why* the word "truth" has been used in all of these senses, I do not pretend to know, and it is not my purpose here to try to give an account of the matter. Doubtless the word "true" becomes, for many persons, a general honorific term which they apply for lack of any other, in order to give art greater dignity or stature. If they cannot find other words with which to praise a work of art, they will at any rate call it "true."

6. *Ibid.*, p. 450.
7. *Vide* the criticism of Professor Greene's terminology in Heyl, *op. cit.*, pp. 62-64.
8. Reid, *op. cit.*, p. 251.

What usages of "truth," then, *are* we going to examine? I would be tempted to say "the ordinary usage," or "what we ordinarily mean when we use the word," except that what we ordinarily mean is unfortunately not itself unambiguous. Nevertheless, I do not want to wrench the word out of its usual connotations, substituting it for some other word which already has a place in current usage, which is what the above senses seem to do. To put the matter roughly, I want to examine whether or not, in some not-too-unconventional sense, art "is true," "gives us insight into reality."

2

Our first impulse would doubtless be to say that a work of art is true if it is composed of statements all of which are true. Literature, of course, is the only art which makes statements at all, and literature would then be the only art to which the notion of truth would apply. Without inquiring at the moment what truth consits in or what it is that makes a statement true, let us pursue this notion a little. The essay is of course the most obvious example, but since its place as an art is sometimes disputed, we may take instead the novel, which is more generally accepted as an art form.

The notion that the novel should "tell the truth," should "report the facts"—the ideal of *verisimilitude*—is the chief tenet of the realist school in literature, and has often indeed been held to be the sole purpose or function of the novel. "Realism," said William Dean Howells, "is nothing more nor less than the truthful presentation of material." And Emile Zola, in his gospel of "pure realism," *The Experimental Novel,* declares:

. . . . the naturalistic novel is simply an inquiry into nature, beings, and things. It no longer interests itself in the ingenuity of a well-invented story, developed according to certain rules. Imagination has no longer place, plot matters little to the novelist, who bothers himself with neither development, mystery, nor denouement; I mean that he does not intervene to take away from or add to reality; he does not construct a framework out of the whole cloth, according to the needs of a preconceived idea. You start from the point that nature is sufficient, that you must accept it as it is, without modification or pruning; it is grand enough, beautiful enough to supply its own beginning, its

middle, and its end. Instead of imagining an adventure, of complicating it, of arranging stage effects, which scene by scene will lead to a final conclusion, you simply take the life study of a person or group of persons, whose actions you faithfully depict. The work becomes a report, nothing more; it has but the merit of exact observation, of more or less profound penetration and analysis, of the logical connection of facts. . . .[9]

The novelist is like the experimental scientist:

The novelist is but a recorder who is forbidden to judge and to conclude. The strict role of a savant is to expose the facts, to go to the end of analysis without venturing into synthesis; the facts are thus: experiment tried in such and such conditions gives such and such results; and he stops there; for if he wishes to go beyond the phenomena he will enter into hypothesis; we shall have probabilities, not science. Well! the novelist should equally keep to known facts, to the scrupulous study of nature, if he does not wish to stray among lying conclusions. He himself disappears, he keeps his emotion well in hand, he simply shows what he has seen. Here is the truth; shiver or laugh before it, draw from it whatever lesson you please, the only task of the author has been to put before you the true data. . . . One cannot well imagine a chemist becoming incensed with a zote, because this body is injurious to life, or sympathizing with oxygen for the contrary reason. In the same way, a novelist who feels the need of becoming indignant with vice, or applauding virtue, not only spoils the data he produces, for his intervention is as trying as it is useless, but the work loses its strength; it is no longer a marble page, hewn from the block of reality; it is matter worked up, kneaded by the emotions of the author, and such emotions are always subject to prejudices and errors. A true work will be eternal, while an impressionable work can at best tickle only the sentiment of a certain age.

Thus the naturalistic novelist never interferes, any more than the savant. . . . We teach the bitter science of life, we give the high lesson of reality. Here is what exists; endeavor to repair it. We are but savants, analyzers, anatomists; and our works have the certainty, the solidity, and the practical applications of scientific works. I know of no school more moral or more austere.[10]

Leaving aside for the moment the reflection that the choice Zola proposes between "giving the truth" in the sense he proposes and dressing it up with moral or emotional predilections is not an

9. Zola, *The Experimental Novel*, pp. 123-24. Zola uses the term "naturalistic" instead of "realistic"; but see Note 17 on page 153 below.
10. *Ibid.*, pp. 125-26.

exhaustive disjunction, let us suppose that the goal of the novelist is simply verisimilitude, or copying in the above sense. There are certain limitations which would inevitably restrict such a procedure so as to keep the novelist forever from fulfilling his ideal.[11] For example: (1) "Truthful presentation of material" presumably means perfect objectivity in the transcription of what one observes. But the glasses through which one observes the world are always colored in one way or another; the "personal equation" can never be entirely eliminated. This is true in the writing of history, and even more so in literature.[12] (2) Language itself is a barrier to perfect realism. No word, I think, expresses precisely the thought or feeling which impelled it. Our experiences, when we try to transcribe them, are like a flood of water being poured through a drum-head in which there are a great many very small holes: the holes are the words by whose means the ideas must be conveyed; and most of the drops, finding their direct paths blocked, must be diverted and find an exit in the nearest hole. It is surely more difficult to put an idea into words than to translate it (already in words) from one language into another. (3) No matter how objective one may be in recording one's observations, one's style of writing always colors the effect. Putting something into words requires putting it there in some manner, in some style— which invariably affects the impression which is left by the ma-

11. It may seem in the following discussion as if we are making a too-detailed survey of a position which is so palpably absurd as to require no refutation. To which I would reply that (1) some, such as Zola, have preached it, even if they have never practiced it; (2) often a position can be best grasped when presented in its extremest form; and (3) we must keep it very clearly in mind to show the extent to which all art deviates from it, and the latter is what we shall be concerned to bring out in the following pages. It is a "pure case" from which all art departs to greater or less degree.

12. If we want to pursue the matter further—doubtless beyond the realists' intentions— we might say that the notion of seeing something "as it is" has no real meaning. When I see a tree, I see it from a point of view, through my eyes, etc.; normally I say I see it as it is when I am seeing it under maximum conditions of lighting and such a degree of proximity as enables me to make out *some* of the details; but when I get a better pair of spectacles, do I then see it still *more* as it is? "As it is" seems to be a metaphysical state quite unattainable to observation and, to me at least, quite meaningless. If we want to use the phrase, we can best define it, I think, in terms of possible perception: we see something "as it is" when we see it under optimum lighting conditions and with eyes or lenses which permit the largest possible discrimination of features. (But then we would be seeing it more "as it is" when we look at it through a microscope! There is no end to this process.)

terial itself. The style, as well as the nature of the observations themselves, colors the account. (4) The very fact that it is necessary to *select* some materials and reject others presupposes some basis for preference on the author's part. Even if he could record with complete objectivity (whatever that might mean), in words which perfectly reflected his ideas, and with faultlessly self-effacing style, he still could not record everything. He would have to select a subject-matter from the infinite stream of facts, and he would have to present a limited aspect of that; and the fact of his selecting one thing at the expense of another would indicate his own predilections and color his account. Zola claimed that the author, having decided on his subject, had only to observe and record what he sees; but he cannot record more than some details and aspects of what he sees. Zola himself, in taking Nana through a single day, had to select certain occurrences and neglect others: he did not, for example, in describing Nana's breakfast, give an account of every move her arms made as she lifted the spoon to her mouth. I suppose that an account of such an event, lasting only a few seconds, could be made to last an almost infinite amount of time if every aspect of it were described. This one example, which carries the thing to an absurdity, is enough to illustrate how necessary *some* principle of selection is in even the most heavily documented piece of realism. (5) Moreover, even the most literal transcription of an event which could be recorded—such as a conversation—if recorded exactly as it occurred, together with an accurate (though, as we have seen, necessarily selective) description of each gesture and mannerism, would actually seem "unreal." The historical occurrence would have to be changed somewhat to make it seem real on paper—intensified in some places, subdued in others, and in general, concentrated. The change of medium—from speech to the printed page—requires a commensurate change in the language employed in order to preserve the flavor of the original. The language that gives the most heightened "sense of reality" is certainly not the language of ordinary discourse. When we read what the court-reporter has transcribed, it seems flat and actually unreal, even though it may be painstakingly accurate. Realism must "change the reality" in order to remain "real."

These observations, while they certainly do not exhaust the fund of remarks that might be made under this head, should be more than enough to show that the ideal of "pure realism" is absurd and impossible. Moreover, none of our alleged realists in the novel has ever come near to achieving it. All the above objections to "pure realism" have supposed that the writer was trying to copy some historical incident. But as a matter of fact, not even realistic writers do this. Zola, it is true, took detailed trips through the mines and collected much information about all aspects of the mining situation before writing *Germinal,* but none of his scenes professes to copy actual historical ones; and even if some actual observed scene might have served as (secondary) material for some scene in the novel, it was never an exact model. And the moment we get away from accurate, literal historical truth, this whole conception of realism vanishes, for when we leave "what has been observed" for "what *might* be observed," we leave the realm of reporting and enter the realm of the imagination.[13] And here only, we might add, does creative artistry begin.

In any other literary medium than the novel, the realistic ideal becomes even more absurd. Imagine it, for example, in a poem. Even in a drama, the "truth" must be warped out of all recognition, into acts, scenes, and uniform settings; there must be condensations, rearrangements of events for dramatic effect, and the like. It is needless to say that the drama never does "stick to the truth" in this sense.[14]

13. Zola himself elsewhere admits that the novelist must invent scenes of his own—as Zola himself, of course, constantly did, and romanticized them besides. But we are not presenting Zola here as a historical theory, in which case we would have to touch all aspects of it, but rather as an instance of the absurd extreme to which the ideal of realism can be carried. In general, Zola is as good a figure as any to represent that extreme.

14. To make the point perfectly clear, we may take an extremely obvious example from that photographic (and in a way, most capable of being realistic) art, the motion picture; the long trial scene in *The Life of Emile Zola,* noted for its realism, in which even the actual historical speeches which Zola and others delivered were reproduced (or at least used as models), was made more intense, more theatrical, more poignant than the historical fact. It contained no irrelevancies or bypaths; every speech, every action, propelled the drama toward its powerful climax; and to give it the keen edge which the actual trial must have had, and which we who were not there could not otherwise feel, brief scenes showing Dreyfus at Devil's Island were interspersed into the trial scene at psychological moments—although obviously the historical episode did not occur in any such fashion —thus giving the sense of "reality" which we, lacking the environment, knowledge, and

3

Strictly speaking, the notion of literal truth applies only where words are involved, since it is only here that statements are made; but since the remarks just made present a strong analogy to a similar phenomenon in visual art, we may touch briefly at this point on the notion of "photographic truth" in painting. (Music is not amenable to this kind of treatment since, as was seen in Chapter II, it is not a representational art. Only where actual objects or events or situations are copied can the question arise.)

On this view of painting, the painter duplicates the work of the camera. "Un peintre ne doit peindre que ce que ses yeux peuvent voir."[15] Certainly the development of photography might be said to relieve the painter of any such feeling of obligation. But let us see for a moment where this notion carries us.

The "perfectly realistic" painter is confronted at once with the same difficulties we mentioned in connection with literature; his photographic truth is hampered by the fact that he must select some details and not others, and in his selection some aim or purpose is already indicated; moreover, he can present only what is perceptible through the visual medium—he cannot go beyond the visual sense-modality to present, for example, sounds or smells; he must present the illusion of three dimensions in two dimensions, and so on.[16]

strong feeling of the time and place, would not otherwise have been able to receive. In the novel there are, perhaps, fewer limitations; but here too the characters and setting must be introduced, the plot begun somewhere, the atmosphere built up, and appropriate and representative scenes must be devised for this purpose.

15. Quoting Courbet in Duret, *Courbet,* p. 126. Cf. also: "Beauty lies in nature. . . . The painter has no right to add to this expression of nature, to change the form of it and thereby weaken it. The beauty afforded by nature stands above all artistic conventions. Such is the very foundation of my beliefs about art."—(Cheney, quoting Courbet in *The Story of Modern Art,* p. 130.)

16. The camera itself, which it must be this painter's aim to imitate, is not perfectly "objective." Cameras are notoriously "false" in reproducing color, for example. They can achieve whatever color-effects they wish by varying the film; ordinary film is more sensitive to violet and less to red, than the eye is; the brightness of a star on a photographic plate can be varied at will by using different sorts of film and different time-exposures. All sorts of trick effects can be produced in this way. Even spatial relations can be distorted; witness the trick effects obtained by varying the aperture. The lens, moreover, can sharpen or dull the contours of the object photographed, and can even make it disappear in a mist (by putting it out of focus). Some films and lenses are sensitive to ultra-violet

Certainly it must be evident without further discussion that surface realism, or verisimilitude, in painting as well as in literature, is quite a hopeless ideal, and moreover irrelevant as art. "Realists" like Courbet, fortunately, never lived up to their credos (in this they were analogous to Zola in literature); they always introduced *some* design, some balance, some unity, and I daresay they never copied any particular scene in nature in the way that a camera does.

However much this progress is continued, there cannot be more than a specious approximation to the photographically true and exact. Between the eye which sees and the hand which gives back the seen, there intervenes a something which never lies between the camera lens and the photographic plate: I mean the mind, to which the eye reports and from which the hand takes its instruction.[17]

Nature contains the elements, in color and form, of all pictures, as the keyboard contains the notes of all music. But the artist is born to pick, and choose, and group with skill, these elements, that the result may be beautiful—as the musician gathers his notes, and forms his chords, until he brings forth from chaos glorious harmony.

To say to the painter, that Nature is to be taken as she is, is to say to the player, that he may sit upon the piano.

That Nature is always right, is an assertion, artistically, as untrue, as it is one whose truth is universally taken for granted. Nature is very rarely right, to such an extent even that it might almost be said that Nature is usually wrong; that is to say, the condition of things that shall bring about the perfection and harmony worthy of a picture is rare, and not common at all. . . . Seldom does Nature succeed in producing a picture.[18]

and some to infra-red, thus changing entirely the resulting picture. Infra-red, for example, pierces through clouds and presents the scene as no human eye could see it, as if the clouds were not there. X-ray photographs penetrate through skin and tissue, and certainly do not give "surface realism." A photograph, moreover, even if true to the surface details of the moment as the normal eye sees them, may yet distort the object as seen over a longer period of time—this is what we mean when we say, "The picture doesn't look like him at all," although we do not accuse the camera of deliberate deceit. But it should not be necessary to continue this account. The only respect in which the dictum "Cameras can't lie" is true is in the fact that a camera cannot falsify what is presented to it, although what is presented to it may not be what the normal human eye would see, because of lens, exposure, film, etc.

17. Rhys Carpenter, *The Esthetic Basis of Greek Art*, p. 132. On Courbet in connection with this point, see the excellent discussion by Roger Fry in *Transformations*, pp. 35-40.

18. Whistler, *The Gentle Art of Making Enemies*, pp. 142-43.

Dutch painting has been widely criticized for being too photographically realistic—in trying to paint every hair on the head, every leg on the spider, every little object in an interior; but always, even here, there is *some* design, perspective, selection, and idealization: the atmosphere in Vermeer's paintings, for instance, is marvelously clear and pure, quite unlike anything we have seen with the physical eye. And the ultra-photographic mania, the passion for minute details such that the objects on a hill a mile away can be seen with as full and clear a detail as if they were being viewed through a telescope, is just as much an example of "changing nature to suit the imagination" as would be the cutting and selective elimination of this detail. Photographic reproduction, we may conclude, is not among the aims of art; and even where it has been popular in theory, it has, fortunately, never been achieved in practice.

Before closing this section I want to make one observation with regard to the kind of realism now under discussion. It seems to me that art may be (or may profess to be) realistic on either or both of two grounds: (1) in the selection of the material which it presents, and (2) in the manner of presentation of this material. It is important to keep the two distinct, since much ambiguity in discussions about realism arises from their confusion. A novelist such as William Dean Howells may be said to be fairly realistic (photographic) in presenting what facts he does select—he is a "surface realist" and he presents his statements without prejudice, without himself entering into the novel or even making his attitude particularly felt—but he is rather rigid in what he selects; he selects only scenes from upper-class life, and he meticulously excludes all reference to the baser passions. That is, Howells is a realist with regard to technique, but not with regard to the selection of objects upon which to exercise that technique. On the other hand, Thomas Wolfe is a realist when it comes to selection (as much as anyone can be, that is, for he seems to employ almost no principle of selection at all); but his manner of presentation is far from being "surface realism": (1) the inner and non-photographic nature of his characters is constantly brought out, and (even if we extend "photography" to include "photography of

inner events") (2) his own intense personality and emotional predilections constantly color and pervade the scenes; the tremendous zest and vigor of his own nature, for example, enter into each characterization to an extent far beyond that which real-life specimens possess.

According to some critics, realism is "merely a technique," a manner ("objective") of approaching the material; according to others, it is a principle of selection—a determination not to bias the issue by selecting, but rather to present "the whole unvarnished truth." In other words, there is (1) a decision not to exercise selection in what one transcribes, and (2) a decision to transcribe faithfully ("objectively") those details which one does select. Realism, as ordinarily practiced, includes some of both. Zola's *Experimental Novel* preaches perfection in both.

Zola calls his credo "naturalistic," and this is confusing because what has generally been known as naturalism is somewhat different. As it happens, however, Zola is also a naturalist. Naturalism in literature differs from realism chiefly in its selection of details rather than in the manner of their presentation; naturalism, that is, professes to be as objective as realism in the manner of presentation, the attitude or approach to the material; but in its selection of details it is (in practice if not in theory) definitely biased, it exercises a definite principle of selection: reacting from the Romantic emphasis upon the selection of sentimentally or imaginatively appealing details, it deliberately sets out to present and emphasize those details which are unpleasant, obscene, shocking, or horrible. (To this is often appended a philosophical creed about the nature of the universe, asserting causal determinism and the non-existence of God. In this respect also it differs from realism.)

Romanticism, I think, differs from realism *both* in selection of details and in manner of presenting them. It is possible, I daresay, to select only the details which are pleasant and far-away (in the way F. L. Lucas describes in the first chapter, "La Princesse Lointaine," in *The Decline and Fall of the Romantic Ideal*), that is, to select moonlit glades and mountain lakes instead of Kansas prairies and city slums, and still to present with a semblance of photo-

graphic realism (not letting one's personality intrude itself, etc.) what one does present. On the other hand, it is equally possible to select any and every detail, no matter how realistically unpleasant, but to cover it with a romantic glaze—seeing everything through romantic lenses, as it were. But as a rule romanticism does both; the two seem to be so well adapted to each other that they generally go hand in hand; and thus romanticism is distinguished from realism on both counts.[19]

4

This chapter began with an inquiry about whether a work of art is "true" if it is composed of statements every one of which is true, and we were thence led into a discussion of verisimilitude in literature (and thus into painting), emerging with the conclusion that in neither case is realism of this kind either possible or desirable in art. And since the realism we were discussing advocated the mere transcribing or copying of observed historical events, we have in effect already discussed the question of historical truth in art. Art does not merely copy or transcribe what has occurred. The functions of art and history are quite at variance. Historical

19. Thus I think that it is possible to define Realism and Romanticism entirely in esthetic terms, and not make them *moral* terms as J. Middleton Murry does (*The Problem of Style*, p. 146, note 31). Realistic or Romantic literature may reflect this or that type of moral nature, but as terms of criticism they occur within works of art, not in the biographies of the artists.

Realism and Romanticism, though as we have seen they differ in selection of material and in method of approach to it, are alike in this, that they are controversies about life-values in art, not about the specifically art-values such as form. In this respect they both differ from Classicism, which, as I conceive it, holds to the *formal* values of unity, coherence, etc., regardless of what subject-matter is employed. In this respect Professor Foerster is quite right in saying (*American Criticism*, p. 231) that Realism and Romanticism, as opposed to Classicism, are combatants under the same roof.

However, the terms "Classic" and "Classicism" are so loosely tossed about that any single definition would be arbitrary. Here are some other usages of the term: (1) Whatever deals with Greek or Roman themes is Classic, no matter when the work of art was created. (2) Whatever was created in a Roman or Greek manner is Classic—however that manner be defined. (3) Only the art of Classical antiquity is Classic; if some art of modern times resembles it or seems to be fashioned in its mould, it is best called Neo-Classic, Pseudo-Classic, etc., to distinguish it from the truly Classic. (4) Classic, à la Irving Babbitt and J. M. Murry, is a *moral* term, denoting a spirit of mind, a restraint and "vital control." These qualities may find an echo in the work of art, but are really moral qualities, and "classic" is a term of *moral* approbation.

truths may occur in works of art, and often do occur, but this does not make them art.

What of scientific truth? or empirical truth of any sort? (I prefer to say "empirical truth" rather than "scientific truth" because there are some empirical or factual truths which are not the subject-matter of any science. For example, statements like "This chair is brown," and "Lucy has a clear complexion," while they are empirical truths, are not of the sort found in scientific textbooks, although as individual facts they may furnish *material* for science. Science proper is concerned only with universal statements.)

Certainly the answer here should be equally obvious: scientific truths may occur in literature but they do not necessarily make it good literature. Art is not a transcription of scientific truths any more than it is of historical ones. And yet this point is often mistaken.

Art is not in competition with science any more than it is with history. The repeated attempts to prove that literature must inevitably be conquered in the battle with science would lead one to believe that many persons are possessed of the notion that they are competitors in the same field. For example, Max Eastman spends a good part of his time in *The Literary Mind* showing that with the rapid march of science in modern times, "poetic truth" is rapidly being squeezed out, never to return. Science, says Mr. Eastman, finds out what is true and what is false about the empirical world, and it has all the experimental techniques for achieving this end; and if literature, without employing any of these techniques, still claims to give us truths, it is always on insecure ground because a well-aimed scientific discovery is likely to disprove and overthrow it at any time. Too many literary people, continues Mr. Eastman, make statements about the world without any measure of experimental verification, and then try to exonerate themselves from the necessity for such verification just because their works are great works of literature. And while they may once have been able to get away with this, this is rapidly becoming impossible because science is disproving one by one these pronouncements. For example:

Emerson would look foolish enough coming forward in our times with his solemn annunciation of a "Law of Compensation." We are too familiar with valid laws and the manner in which their validity is established. To his assertion that "labor is watched over" by this mystic law, we should reply by pointing to the statute law and to a pile of documents called "compensation statistics." For all his high art in the poetry of ideas, Emerson would be put down as a crank or a mountebank if he came out on our bookstalls with his grave essay on "Compensation"—and yet that is a fair sample of what is called "literary truth," a fair operation of that faculty which Emerson, like other men of letters in the nineteenth century, called "intellect" in conscious opposition to the activities of the mind in science.[20]

The realm of "literary truth," says Mr. Eastman, includes (1) statements which may be true but have not yet been capable of being verified one way or the other, so that literary men are for the moment safe in asserting them to be true (although science may at any moment find them to be false—as in the case of the Emerson statement just quoted), and (2) statements which science might discover to be true or false if it cared to go to the trouble, but probably never will, with the result that these statements will forever remain "literary truths." It would be a ghastly mistake, continues Mr. Eastman, if we were to continue to accept such "literary truths" in spite of our scientific advances. Literature should be enjoyed for other purposes, but not for the facts it contains, else we are enjoying it as science and not as literature.

Now certainly it is true that literature is not science, nor is it equipped as science is to "give us the facts." Insofar as people have gone to literature to learn facts about the world, and accepted literature's statements, not on the basis of evidence, but just because they were literature, they have made a serious mistake; they have accepted such statements as they would accept a sugar-coated pill. The mere fact that some idea happens to be written nicely does not entitle it one whit more to be considered true, although the fact of its being nicely written may increase the emotional urge to accept it as true; and it is just here that literary pronouncements uttered as truth can be the most misleading, for they can sometimes persuade us to believe what we have no grounds for believ-

20. Max Eastman, *The Literary Mind*, p. 243.

ing; and as long as what we are invited to believe is in the realm of empirical *facts* and *statements,* we should unswervingly believe the hard, tested fact which the scientist offers us. To repeat, *if* the poet is to give us truths in the sense of statements, facts, then there is no alternative but the one that Mr. Eastman suggests; the poet cannot be relieved of traveling the hard, laborious road to truth just because he is a poet. But, as Eastman then proceeds to say and as I shall shortly discuss, the function of poetry lies elsewhere; and if this other function can also be called "truth," it is most important to keep in mind that it is truth of quite a different kind.

5

Certainly it must be obvious by this time that the function of literature is not to state facts, either of science or of history, or of philosophy or theology or any field whatever. These truths belong to these separate fields, and not to literature. Works of literature may incidentally state truths which are enlightening in these other fields, but *only* incidentally—it is not in virtue of the fact that they contribute, for example, to sociological knowledge that they find their way into anthologies of literature.

Moreover, we must not be misled by the fact that there are many statements in works of literature. For while this is perfectly true, these statements *do not generally function as assertions.* Although many of the sentences even in poems are declarative in form, such that judging by their form alone one would imagine that they were intended to communicate facts, their function in the poem is actually an evocative one and not an informative one. This can easily be seen from the fact that, taken simply as assertions, most of the statements in poems are not documented enough for us to be able in any way to verify them. To take a random example, in Housman's poem beginning, "The lads in their hundreds to Ludlow come in for the fair . . ." if one is to take it as a declarative sentence how is one to proceed to test it? One must know *what* lads, who, where, when. None of this information of course is supplied. And this should already be sufficient indication, if any were needed, that at least many of the statements in poetry do not function as statements in the poem.

Furthermore, if the truth of the statements in a poem or novel were what constitutes artistic truth, then it would follow that the question of artistic truth, or of truth in the arts, would arise only in connection with literature, since it is only in language that statements are made.

This assertion calls for some clarification, and the point is too important a one for us to skip over. It is generally agreed by philosophers that the notion of truth applies only to propositions, not to states of affairs; the table in the corner is not true or false, but the proposition *that* there is a table in the corner is true or false. (I do not think it is necessary here to go into the problem of "the nature of truth": Whether truth is a quality or a relation, whether it consists in correspondence or coherence, etc.) Truth and falsity are predicable only of propositions, not of things; indeed, a proposition is sometimes defined as "anything which can be said to be true or false."[21]

A proposition is not the same thing as a sentence; a sentence only states or expresses a proposition. Different sentences can state the same proposition: "Hic vir est" and "This is a man," for example, are different sentences stating the same proposition. A sentence is a group of physical marks on paper or a group of spoken sounds; a sentence may be composed of five words and contain the letter "e" three times; a proposition does not do these things. "A sentence is a group of words, and words, like other symbols, are in themselves physical objects, distinct from that to which they refer or which they symbolize."[22] But although a proposition *is* not the sentence (or series of verbal symbols) which states it, it is impossible for a proposition to be conveyed or communicated without a symbolic medium of some sort. Moreover, "the structure of the proposition must . . . be expressed and communicated by an appropriate structure of the symbols, so that not every combination of symbols can convey a proposition."[23] For example, "walking sat eat very" is a group of symbols but does not express a proposition. Also an exclamation, such as "Would

21. Cohen and Nagel, *An Introduction to Logic and Scientific Method*, p. 27.
22. *Ibid.*
23. *Ibid.*

that I were dead!" or a question, such as "Why do you want to go?" is not a proposition; wishes, questions, and commands are not true or false. Similarly, definitions and resolutions about the use of words (for example, "Three feet make a yard") are not true or false and hence not propositions. We simply use the word "yard" in such a way that at each occurrence of it we can substitute the expression "three feet." Nor are propositions to be identified (as Cohen and Nagel point out) with the mental acts required to think them; they are not judgments, for a judgment is an act of thought, while a proposition has no such psychological reference—it is not an act of thought but rather may be the object of an act of thought.

It is an agreed fact that propositions are true or false, and that sentences state or express propositions. Now the question is, can anything other than sentences express propositions? Are words the only possible symbols by which propositions can be mediated?

Professor Greene, for one, says that they are not. He agrees that propositions and only propositions can be true or false, but he adds that propositions can be expressed in an indefinite number of different media, and hence can be true or false in all these media.[24] Some of these media, such as that of subjective images, are private to a single individual; but others, such as those of painting and music, are public and can be the media of works of art. Symphonies and water-colors, then, can express propositions which are true or false, just as well as sentences in a language can.

Now I do not see how this view of Professor Greene can possibly be correct, and for the following reason: if a proposition is to be stated or expressed in any medium, there must be a rule or *convention* of some sort by which this is brought about. In language, for instance, we have *words* to stand for certain things, relations, and concepts. It is by *convention* that the words represent or symbolize those things, relations, and concepts. Thus, knowing the convention, we know what, if anything, is being asserted when we hear certain groups of words uttered in certain specified relationships to each other. But, as we saw in the section on symbolization, this is not true in the case of colors or sounds. If a group of colors

24. Greene, *The Arts and the Art of Criticism*, p. 425.

in a painting symbolizes something, then *what* does it symbolize?
If musical notes express propositions, *what* propositions do they
express? In propositions, something is always *asserted* to be the
case; but what, in the case of colors and sounds, is being asserted?
How can they be said to be making assertions at all?

It is true that a group of colors *might* be used to state a proposi-
tion, if there were a stipulated convention about it; words after
all are not the only possible symbols, they only happen to be the
most convenient ones for most purposes. For example, at an
afternoon tea I might (by previous agreement) wave my handker-
chief at a friend to indicate, "Mrs. Snob has just entered the room."
Or I might shake my head or blow my nose to express the same
proposition. To Paul Revere the sight of two lanterns on the
church-tower meant, "They're coming by sea." To most of us the
sight of a triangular red flag means "There's danger in the vicinity
—drive slowly," or something of the sort, depending on the con-
text. Certainly it need not be the words of a language, and those
alone, that stand for propositions; language is simply the most flex-
ible and easily available means at our disposal. But no matter what
the mode of expression is, whether it be the clanging of a bell or
the shot of a rifle or the waving of a flag, there must be some pre-
viously agreed upon *convention* as to what signs are to stand for
what propositions; otherwise how could one possibly know what
proposition was being expressed?

And what I want to insist upon here is that in the case of paint-
ings and musical compositions there is no such convention. How,
then, can we say that they express propositions? Unless there were
some such convention, we could neither say what the proposition
was nor hope to settle any differences of opinion about it. It seems
to me that no further refutation of Professor Greene's claims on
this point is necessary.

Professor Greene might have sought a way out which in fact he
does not, namely, to say that works of art are *implied* assertions
even if they are not themselves assertions (or else that they imply
assertions). This is Professor Urban's view.[25] Every work of art,
says Professor Urban, is an implied assertion (or implied proposi-

25. Wilbur M. Urban, *Language and Reality*, Chapter 10, esp. pp. 498-500.

tion). But how, we may ask, does (and can) a work of art contain a proposition or assertion implicitly within itself? What kind of implication is here meant? Is the implied proposition *logically* implied? But if not logically, then how? And *what* are the proposition or propositions which are in each case implied? How are we to discover what they are, and settle disagreements on the issue? Here we run into the same difficulties as we have already mentioned in criticizing Professor Greene's position, and more besides. It seems to me that to call a work of art an "implied proposition" or an "implied assertion" is not a very successful dodge.

6

"Artistic Truth"

THE SORT OF TRUTH we have been discussing thus far is the truth of *assertions* and might be called "propositional truth," or truths stating *facts about* some subject-matter or other. And we have already seen that it is not the function of literature to assert truths about science or philosophy or any other subject-matter at all, and that as long as one judges a work of literature by whether or not it reveals facts in any domain of inquiry, he is making a grave error. We have also seen that art does not give us "verisimilitude," the ideal of pure realism; neither paintings nor novels *photograph* the world in the way the camera photographs visual objects and the sound-film transcribes a bit of history.

But to admit this is not to admit that the question of truth does not arise in connection with the arts at all. If art is unconcerned with the truth of assertions, there are other things which in common parlance go by the name of "truth" which are not so irrelevant to art.

I

To plunge at once *in medias res* and give some account of "another sort" of truth: The truth we have been considering thus far is truth-*about* things; but what I should like to discuss now is truth-*to* things. We speak of a dream being true-to life, or a character in a novel being true-to some human type in the life around us. "Truth-to," we may observe at once, is not the truth of propositions, although we may state propositions to the effect that some character is (for example) true-to life.

The notion of "true-to," first of all, has several different senses, I am not quite certain how many. To say of a dream that it is true-

to life may mean merely that it is vivid, or it may mean the kind of true-to we are going to discuss in this chapter. Again, in a perfectly proper sense of the word, a photograph may be said to be true-to whatever it is a photograph of, or a man may be true-to his word. In both these cases, I think, there is a *one-to-one correspondence:* between the photograph and its original, between a man's promises and his fulfillment of them.[1]

I mention these examples in order to make it clear that there are many cases of truth-to which are not related to this inquiry, which is concerned only with art. A number of relevant cases will now be distinguished in turn.

2

When we say that Thackeray's Becky Sharp is true-to life, or to a certain recurrent type of human nature which we find in experience, we do not mean that there is a perfect one-to-one correspondence between the character and some observable individual; nevertheless we do recognize that there *are* these recurring types and that they are probably more clearly set forth in works of literature (we shall come to painting later) than they are ever exemplified in particular human beings. They are, so to speak, "more true than life itself," more revealing of human nature than any individual persons we have met. This is a very curious phenomenon, and we can do no better in investigating it than to begin with the famous dictum of Aristotle:

Poetry is a more philosophical and a more serious thing than history; for poetry is chiefly conversant about universal truth, history about particular. In what manner, for example, any person of a certain character would speak or act, probably or necessarily—this is universal; and this is the object of poetry. But what Alcibiades did, or what happened to him—this is particular truth.[2]

1. There are of course other instances of one-to-one correspondence, for example, between certain lines on a map and the country the map is of, or between the rise in temperature and the rise in a column of mercury, or between the equation "x times 2y equals 6," for any particular values of x and y and the position of the curve on the graph for those values. And, although we may not ordinarily employ the term here, we might possibly say that what is referred to by the first term of the relation in each of these cases is *true-to* what is referred to by the second term.

2. Aristotle, *Poetics,* 1451 b.

This statement is so brief and to the point that most attempts to apply it require and presuppose considerable exegesis. Accordingly, before venturing any comments of my own I shall quote a few relevant passages from a standard authority on the *Poetics,* Professor S. H. Butcher. Concerning the above passage he says:

Imitative art in its highest form, namely poetry, is an expression of the universal element in human life. . . . Fine art eliminates what is transient and particular and reveals the permanent and essential features of the original. It discovers the "form" (*eidos*) towards which an object tends, the result which nature strives to attain, but rarely or never can attain. Beneath the individual it finds the universal. It passes beyond the bare reality given by nature, and expresses a purified form of reality disengaged from accident, and freed from conditions which thwart its development. The real and the ideal from this point of view are not opposites, as they are sometimes conceived to be. The ideal is the real, but rid of contradictions, unfolding itself according to the laws of its own being, apart from alien influences and the disturbances of chance.[3]

The first distinguishing mark of poetry is that it has a higher subject-matter than history; it expresses the universal not the particular, the permanent possibilities of human nature; it does not merely tell the story of the individual life, "what Alcibiades did or suffered." . . . History is based upon facts, and with these it is primarily concerned; poetry transforms facts into truths. The history of Herodotus, in spite of the epic grandeur of the theme and a unity of design, which though obscured is not effaced by the numerous digressions, would still, as Aristotle says, be history and not poetry even if it were put into verse. Next, poetry exhibits a more rigorous connection of events; cause and effect are linked together in "probable or necessary sequence". Historical compositions, as Aristotle observes in a later chapter, are a record of actual facts, of particular events, strung together in the order of time but without any clear causal connection. Not only in the development of the plot but also in the internal working of character, the drama observes a stricter and more logical order than that of actual experience. The rule of probability which Aristotle enjoins is not the narrow *vraisemblance* which it was understood to mean by many of the older French critics, which would shut the poet out from the higher regions of the imagination and confine him to the trivial round of immediate reality. . . . The rule of "probability", as also that of "necessity", refers rather to the internal structure of a poem; it is the inner law which secures the cohesion of the parts.[4]

3. Butcher, *Aristotle's Theory of Poetry and Fine Art*, pp. 150-51.
4. *Ibid.*, pp. 164-66.

The poet has to extract the ore from a rude mass of legendary or historical fact: to free it from the accidental, the trivial, the irrelevant; to purify it, in a word, from the dross which always mingles with empirical reality. . . . The truth, then, of poetry is essentially different from the truth of fact. Things that are outside and beyond the range of our experience, that never have happened and never will happen, may be more true, poetically speaking,—more profoundly true than those daily occurrences which we can with confidence predict.[5]

To sum in a word the results of this discussion. The whole tenor and purpose of the *Poetics* makes it abundantly clear that poetry is not a mere reproduction of empirical fact, a picture of life with all its trivialities and accidents. The world of the possible which poetry creates is more intelligible than the world of experience. The poet presents permanent and eternal facts, free from the elements of unreason which disturb our comprehension of real events and of human conduct. In fashioning his material he may transcend nature, but he may not contradict her; he must not be disobedient to her habits and principles. He may re-create the actual, but he must avoid the lawless, the fantastic, the impossible. Poetic truth passes the bounds of reality, but it does not wantonly violate the laws which make the real world rational.[6]

It would be a colossal and thankless task to try to analyze even the four brief passages just quoted, since every sentence contains crucial words which are filled with suggested questions. A good deal of it (as is the case with most of the commentators of Aristotle on this point) is "just words." When Butcher talks about the "elements of unreason" in the world or about poetic truth passing the bounds of reality, one does not know what to make of them, since he does not explain them further, and they cry out for explanation. Moreover, he is not entirely self-consistent, as we shall see in a moment. But let us note only a few of the most important points:

The first important observation to be made is that the "form toward which an object tends" is not a moral end, nor is it a moral ideal which art is true-to. The characters in tragedies are not ideal in the sense of being "good" characters. When art is said to imitate "things as they ought to be," no moral "ought" is intended; the word "ideal" here derives rather from "eidos," the "form," the "purified form . . . disengaged from accident."

5. *Ibid.*, p. 170. 6. *Ibid.*, p. 184.

And what is meant by that? This is not a very easy notion to grasp fully, and I shall offer here a rather common-sense analysis, without metaphysical trappings:

The career of any single individual is filled with all sorts of conflicting cross-currents of actions and events; seldom is a single dominant tendency or humanly significant course of action followed through to completion. If art were to present all these, it would be cluttered with all kinds of irrelevant detail; but poetry (and Aristotle was speaking primarily of tragedy) must retain its dramatic unity; it must follow one dominant idea or course of action through to a finish, thus to realize its human import and eliminate all such irrelevancies. "History is just one damn thing after another"; but poetry must pick out from this welter of events those which are relevant to the theme of the particular work of art. Hence, for example, the necessity for pursuing *one* causal chain of events; not all events that occur in temporal succession are related in such a way as to form an organic unity such as is required in the structure of a drama; therefore many interesting but causally irrelevant things must be deleted.

But this, it must be observed at once, is not enough. For thus far we have considered the "purging away of irrelevancies" only as a *literary device,* that is, for the sake of the unity of the work, the sharpening of effect, the achievement of development and climax—in short, for enhancing the esthetic form as I have described it in Chapter I. Thus far we have considered the distortions from historical truth as a manner of enforcing a certain desired esthetic effect, and *not* as a means to any kind of truth. And the two must not be confused. If the former alone were the reason for Aristotle's suggestions for departure from photographic truth, it would have no place in this chapter. It is the latter that we shall try now to make clear:

The characters (we shall deal with actions later) selected must be true-to human nature, not to any particular human beings who have historically existed, but to certain "universals" or recurring characteristics and dominant tendencies in human nature. Almost always this can be brought out far better in a situation of the artist's own invention than in the selection without change of any

particular character and sequence of events from history. The individual characters portrayed in the drama need never have existed át all; they can be more "true-to human nature," in most cases, if they have not; and even if they have, many of the events which occurred in their lives (for example, the life of Alcibiades) would be irrelevant to the theme in hand and would have to be omitted from the drama—not merely from the point of view of dramaturgy and the requirements of esthetic form (though this is generally true also), but also from the point of view of "bringing out the 'human' truth." As a rule the sort of action and the sort of person giving the clearest and profoundest picture of what the poet wants to present will be brought out not by following the career of any given character in history but by constructing a (historically) fictitious character. Becky Sharp never existed in the flesh, yet the world is full of Becky Sharps, and probably Thackeray's heroine is a truer, more convincing picture of Becky Sharps everywhere than any of the particular historical members of the class ever have been or will be. Nor did anyone in history probably have quite the set of experiences related by Thackeray; yet they give expression to the character more fully and convincingly, probably, than any that the historical Becky Sharps ever went through. This, I think, is approximately what is meant when it is said that characters in great literature are *universal*.

This does not mean that the characters must be *types*. A "type" character is one which possesses only the least common denominator of the characteristics of a certain class of individuals; no "pure type" exists, and the representation of such a pure type is never "universal" any more than is the person who is so extremely individual and eccentric that he has nothing in common with other human beings and hence is not "of our ken" (such as the inmates of certain asylums). The person portrayed must be a full-bodied individual just as much as he must embody the universal characters common to human beings; the "type" character, drained of all but one characteristic, is not even remotely to be met with anywhere.

Hamlet is both a very unusual and a very complex character; he is vividly imagined, which is to say that he is a thoroughly concrete in-

dividual, yet for that reason I believe that he satisfies all which we legitimately mean by our demand for the artistic "universal"; he acts and speaks as a man of such a character and his situation necessarily or probably would. The truthful historian of Denmark could hardly have achieved this "universality" or consistently imaginable character, for but few events can be observed in life with that internal probability or possibility which makes the presentation of them artistic. The historian must deal with a collection of acts apparently accidental, arbitrary and unconvincing. The poet creates an individual every atom of which should be organically connected with every other, thoroughly consistent even in its extremest and most lifelike inconsistency.[7]

We may keep a note-book in our memory, or even in our pocket, with studious observations of the language, manners, dress, gesture, and history of the people we meet, classifying our statistics under such heads as innkeepers, soldiers, housemaids, governesses, adventuresses, Germans, Frenchmen. . . .

But it is not by this method that the most famous or most living characters have been conceived. This method gives the average, or at most the salient, points of the type, but the great characters of poetry— a Hamlet, a Don Quixote, an Achilles—are no averages, they are not even a collection of salient traits common to certain classes of men. They seem to be persons; that is, their actions and words seem to spring from the inward nature of an individual soul. Goethe is reported to have said that he conceived the character of his Gretchen entirely without observation of originals. And, indeed, he would probably not have found any. His creation rather is the original to which we may occasionally think we see some likeness in real maidens. It is the fiction here that is the standard of naturalness. And on this, as on so many occasions, we may repeat the saying that poetry is truer than history. Perhaps no actual maid ever spoke and acted so naturally as this imaginary one. . . .

. . . Those who appeal most to us, either in themselves or by the emphasis they borrow from their similarity to other individuals, are those we remember and regard as the centres around which variations oscillate.[8]

Such are the "universal" characters of great literature. In each of these characters, no matter how different from ourselves they may be, we must be able to recognize the common human nature which we share with them; this is a necessary basis for all imaginative sympathy and insight into a character in literature.

7. E. F. Carritt, *The Theory of Beauty*, pp. 83-84.
8. Santayana, *The Sense of Beauty*, pp. 134-36.

What we look for in novels and poetry is truth about what we may call the human heart. If, as we read, we are convinced that this is how a human being could feel and has felt, however misguidedly, then we have poetic or imaginative truth. And to be convinced of this we must recognize the feeling as one of which we ourselves are capable, had our circumstances been different. We must feel the seeds of it, however unhappily stifled, however heroically weeded out, to have been once within our own hearts.[9]

Thus interpreted, Aristotle's analysis can apply to lyric poems as well as to epics, dramas, and novels. In lyric poems there are often no characters, yet the criterion of universality can apply, since the emotion conveyed by the poem, even if trifling or fragmentary, can still be human and universal in the sense we have described. Even in fantasy, which often transcends the bounds of even the remotely possible (such as Kenneth Grahame's *The Wind in the Willows*) the essential humanity of the characters is retained, and the human truth can best appear to advantage in a context torn away from the everyday human associations.

The same general notion we have been describing is sometimes put into the language of "essence"; what we have in a certain plot or characterization, it is said, is "the essence" (or sometimes "an essence") of human nature, a type of human nature, or some sort of universal; art reveals the *essence* which surface realism cannot touch. Now I have no objection to this kind of language provided that the "essence" is not hypostatized into a metaphysical entity.[10]

In the foregoing paragraphs we have occasionally included "actions" along with "character" in our analysis of universality.

9. E. F. Carritt, *What Is Beauty?*, pp. 32-33.

10. Santayana has the same general conception in mind in a passage such as the following, where he uses a terminology not contained in his earlier books: "If facts are to be dramatized, they must not be reproduced. They must be recast selectively on a grand scale, and precipitated towards some climax in which the heart is concerned. Yet if they are to be fully dramatic, these relations must not be invented. They must subsist in the realm of truth. Intuition simply comes to disengage them from what is morally irrelevant, and to trace the red vein of destiny running through the world. . . . Dramatic fiction may thus reveal to us the gist of existence, as flat experience and prosaic observation could never do."—(*The Realm of Truth*, pp. 61-62.)

Cf. also Marcel Proust, *The Past Recaptured*, pp. 224-28, and the following interesting analogy from Laurence Buermeyer, *The Esthetic Experience*, p. 83: "Art is to the life of feeling what the laboratory is to science, a place from which distracting factors may be excluded, and things so controlled as to reveal their maximum significance."

And certainly it must be apparent that the same analysis can apply to both: we can have actions as well as characters that are true-to life. Indeed, the two are really not separable; for human character is manifested in actions, and actions cannot help bringing out human character. They are two sides of the same coin.

There are, however, a number of difficulties about this conception (with particular reference to Aristotle) which badly need to be ironed out and which no commentator on Aristotle, so far as I know, has done; all of them have in fact made the matter worse by introducing all sorts of incongruous notions and imprecise terms, even in a worse manner than Professor Butcher. Let us examine a few of these problems.

1. The most important difficulty is that Aristotle himself is ambiguous in his meaning: he sometimes talks as if the "distortions," the departures from photographic truth, should occur only for the sake of unity and dramatic power—on his own theory, to facilitate the emotional effect of catharsis—rather than to "bring out the truth." Not truth, but emotional effect, seems in some passages to be his aim. This curious duality runs all through the *Poetics,* though it must be said that most of the time Aristotle keeps the primary goal of "ideal-imitation" clearly in view. Professor Butcher himself points out the contradiction:

> It is probably not possible to acquit Aristotle of some inconsistency of treatment. According to his general theory of esthetics as a branch of art, its end ought to be the purely objective end of realizing the *eidos* in concrete form. But in dealing with particular arts, such as poetry and music, he assumes a subjective end consisting in a certain pleasurable emotion. There is here a formal contradiction from which there appears to be no escape. It would seem that Aristotle in generalizing from the observed effects of works of art raises the subjective side of fine art into a prominence which is hardly in keeping with his whole philosophical system.[11]

But then Professor Butcher is himself guilty of the same fallacy when he says, in one of the quotations presented above, that the rule of "probability" (when an improbable event was more desirable in a drama than an event attested by history) "refers rather

11. Butcher, *op. cit.,* pp. 208-9.

to the structure of the poem; it is the inner law which secures the cohesion of the parts."[12] But certainly the character or situation presented is true-to something *outside* the poem; not true-to any single physical appearance or historical event, but true-to some salient character or essence in the way we have explained. And if the rule Professor Butcher refers to were invoked only for the reason which he there sets forth, namely for the sake of structure or internal cohesion, then, I repeat, it would obviously not be for the sake of being true-to anything that the departures from historical and photographic accuracy were made, but rather for the very thing which he declares, in the passage just quoted, to be "hardly in keeping with (Aristotle's) whole philosophical system."

2. Does the criterion of dramatic relevancy forbid entirely the introduction of chance events into dramatic works, even though such events are extremely frequent in life? Of course it is true that it is generally sound advice to tell an author not to resort to chance events to solve his plot (not to resolve the situation with a *deus ex machina,* etc.), since once the floodgates are opened to this sort of thing there is no stopping the deluge. Nevertheless, chance events do occur with considerable frequency, even at the most important junctures of life; and since they are so characteristic of life, why must they be excluded from literature? The apparent irrationality of life, particularly with regard to the fact that so much of what determines one's course of life and one's happiness is a matter of chance, for example, the utter dependence of events of the most tremendous import upon the smallest of chance events must often have struck poets and philosophers alike; but must the poet, on Aristotle's rule, be prohibited from presenting this in his work?[13]

12. *Ibid.,* p. 166.

13. Perhaps one could answer this question by saying that the portrayal of chance in any particular manifestation (e.g., *deus ex machina*) would be false to the more general or universal nature of it which is exhibited, not only by this one particular human life or chain of events, but by many. The fact of chance as it enters, as it certainly does to a tremendous degree, into the life of every human being surely should (on this theory) be presented, for it is no small part of the truth of human affairs; and perhaps some of this element must always enter into the portrayal of whatever individual is created or chosen by the author as a symbol of a wider humanity, because it is absent from no individual— and absence of that *would* be a falsification of the significant facts of human nature. But the particular chance events that happened to particular people (Alcibiades) would then

3. To what extent must the theme and plot be "rational" just because of the requirements of dramatic structure? A tragedy like *Agamemnon* carries through to its "logical" conclusion a whole series of events inspired by the human motives of hate, greed, and vengeance in one particular situation. At the end of the drama, the network of events initiated before the drama began has "worked itself out." Now, in the case of a human being who showed possibilities in various directions, initiated a great many courses of events which would eventually have brought him, let us say, to greatness or nobility, but who was killed in some accident before he was able to realize these potentialities (such as Chausson, killed in a bicycle accident), an accident moreover which had no significance for the rest of his nature (an automobile crash if he was habitually reckless with automobiles would not do), Aristotle would, I take it, not accept such a theme because an irrelevant event like the accident had cut the whole causal chain in the middle. Such a series of events, Aristotle would say, is history—for in history such things do happen—but cannot be depicted in dramatic art. But can art refuse to accept such themes? The author might want to portray, among other things, the hostility of the universe, or as Thomas Hardy does, the interference of brute nature with the fulfillment of man's fondest hopes. In the case of *Agamemnon,* Aeschylus presumably wanted to emphasize the end-products of hate and revenge when these are carried through to completion in a causal chain of actions. In short, such examples of irrationality and "blind nature" (not merely chance, which we have already touched upon—though this too is included) are universal if anything is, and most intensely true-to life; in all of it we can find a common feeling and an echo in our own experience; why, then, should they be excluded from art? Do not the facts of human life and the artistic demands of unity and coherence come into conflict here?

I have cited the above problems because so far as I know they

have, as Aristotle affirms, no place in art; they would interrupt the course of the very thing the author was trying so clearly to present; only the chance events that best reveal the nature of chance itself, the "chance universal," (for example, the chaos in the working out of the destinies of men), would belong there. But it is very difficult to distinguish, in any particular instance, these two kinds of chance.

have never received adequate treatment. But no matter how they may be dealt with, I am confident that few persons would deny that literature is true-to human life in the sense described. When we find some character or characteristic untrue to human nature, we consider it a serious flaw in the work. Hawthorne says somewhere that the one principle which the literary artist must never violate is truth to the human heart. And I think it is a common experience that we gain more truth-to human nature from great works of literature than we do from most textbooks in psychology; nothing gives us quite the human insight that great literature does. If this were not the case, literature would not occupy so important a place in college curricula, nor would so much time be spent in discussing characterizations by great dramatists in literature classes.

Once again I want to emphasize that literature does not present us with propositions which are empirically verifiable like those of science and history; few if any statements in novels, that is, depicting the action or thought of a fictional character, can be verified in the way that informative propositions can. And yet they are true-*to* human nature as we know it. Thus in a way we *can* verify what the artist has presented; we can verify his insights in our own further observations of people and actions.

3

The same phenomenon as just discussed occurs in painting. Here again we have, in some works in this medium, characters which are true-to human nature. Painting, of course, by the very nature of its medium, cannot be true-to a succession of events such as is presented in a tragedy; nor indeed to anything which requires a temporal sequence of presentations. But yet painting is capable of presenting powerful and convincing characterizations. Certainly no one would deny, for example, that Rembrandt's late self-portraits are true-to a universal or essence of human nature in pretty much the same way that a character in a drama or novel can be. The Aristotelian principle certainly seems capable of extension here. Photographic truth in painting, as in literature, is departed from, "distorted" (what artists call "necessary distortion"), in

order to reveal the essence or universal. An obvious example of this, from sculpture, is the enlargement of the heads and shoulders of the Etruscan warriors (in the Metropolitan Museum of Art) in order to emphasize their strength, power, and savagery; the effect is overpowering and overwhelmingly true-to certain traits and impulses which we instantly recognize in human beings and feel within ourselves. Or again,

El Greco distorted natural aspect, certainly. In general he narrowed the faces, elongated the foreheads, dwelt upon the flame-like lights of the head, and refined the hands, too, until they become sensitized indicators of emotion and character. . . . The distortion, the departure from camera truth, is not only for rhythmic and sensuous effect, but for the truthful revelation of character.[14]

Any student of visual art should be able to multiply examples of this indefinitely.

However, as we shall soon discover, being true-to human character is of far less importance in painting than it is in literature. Painting is much less "human," much more "art." (Or at least it is human in a far more abstract sense.) Many artists (Cézanne, Seurat), though perfectly able to depict human values, forego them in favor of other values such as significant form. Most art-critics, I think, would agree that to say of a character in fiction, "He is just like somebody I used to know," would not be particularly out of place (though if he then went on to describe the real-life person, he would certainly not be offering a criticism of the work of art); but of a character on a canvas it would be much more likely to be out of place. Not only the purists like Bell and Fry hold this, but even Dewey himself, as is evident from the incident from William James which he quotes as an example of the depths to which "appreciation" can descend:

"I remember seeing an English couple sit for more than an hour on a piercing February day in the Academy in Venice before the celebrated *Assumption* by Titian; and when I, after being chased from room to room by the cold, concluded to get into the sunshine as fast as possible and let the pictures go, but before leaving drew reverently near to them to learn with what superior forms of susceptibility they might be en-

dowed, all I overheard was the woman's voice murmuring, 'What a *deprecatory* expression her face wears! What self-abne*gation!* How *unworthy* she feels of the honor she is receiving.'"[15]

Indeed, it is often the case in painting, as it certainly never is in literature, that it does not matter whether this figure on the canvas is a man or a woman, or indeed whether it is a human being at all.

4

But human character and action is certainly not all that art can be true-to. If asked what else it might be true-to, I think we might simply say, "The felt qualities of experience in general." This, however, is a very crude way of putting it, and its meaning can become evident only as our discussion proceeds.

Let us begin with literature, and in particular with poetry, since it is in poetry (especially in lyric poetry) that this truth-to experience comes out in most striking relief. Poetry, according to Max Eastman, "suggests the qualities of experience," and he makes this notion the cornerstone of his whole theory of poetry. We have already noted Mr. Eastman's protests against the notion that poetry's function is to give us truths about the world; what poetry does convey to us, according to Mr. Eastman, is rather the "look," the "feel," the "tang" of experience itself—"the given," not any construction out of the given. Poetry presents us with the experienced qualities of things, as the poets have experienced them and as we too can experience them; and since this, for Mr. Eastman, is the poet's aim, the poet must use language (which was devised for practical communication) in a way in which people do not employ it in ordinary conversation where they merely "label" and classify their experiences:

Poetic diction suggests the qualities of experience; it does this more than is practically necessary to theoretic understanding. When a prosaic or practical companion would be content merely to point to something, a tree for instance to which he wishes you to attach a clothes-line, a poet will take the trouble to say "Hitch it to that old hickory," or perhaps he will say "that shaggy old hickory." He is interested in the quality of the thing, and not wholly focused upon its use. And when,

15. Dewey, *Art as Experience*, p. 91.

in the absence of things, a poet wishes to remind you of them, he again goes farther than is necessary for mere purposes of identification. He speaks of old trees, even when he is not talking about any particular ones, as "knotty, knarry, barren," because he likes to remember trees. And when he is talking about a whole woodsful of these abstract trees he calls it "some branchy bunchy bushybowered wood," because he wants to feel as though it were here. Even indeed when there are no trees in question, and no "thing" in question at all—only the poetry itself, as in these days seems often the case—the poet is still trying to convey the quality of experience. And to make us clearly, or intensely, or richly, or vividly conscious of this quality is the whole of his effort. It is an effort, as Miss Edith Sitwell very accurately affirms, to *heighten consciousness*. Pure poetry is the pure effort to heighten consciousness; it is poetry spoken when a practical person would have nothing at all to say. Prose, on the other hand, is merely the practical way of talking. . . .[16]

For example, "Robert Frost has built him a little rustic philosophy with which he thinks to lift poetry back to her place among the ways of knowledge";[17] but Mr. Eastman, after laying low Frost's pretentions in this direction, says that actually Frost's contribution is much more valuable, is that of the true poet: "We do not go to Robert Frost for education. We go to him for the almost uneducated simplicity—the almost indolent simplicity—with which he communicates to us a kind of experience not elsewhere accessible and which we like to touch."[18]

When Mr. Eastman uses the word "truth," he is always speaking of what we have called "truth-about"—some interpretation or classification of experience rather than the immediately felt qualities of experience itself. But certainly, in the way that we have been using "true-to," it may be said that according to Mr. Eastman poetry is *true-to* experience. He says of the poets (those who are not obsessed with the delusion that they can give us knowledge) that

. . . we find them more occupied with "what it feels like" to believe something than with whether it is true. . . . It is not their specialty to conceive things truly but to live them vividly. We slake our own thirst

16. Eastman, *The Literary Mind*, pp. 169-70.
17. *Ibid.*, p. 148.
18. *Ibid.*, p. 149.

for experience in their poems, and we should be rash to allow a little thing like truth or the meanings of words to stand between us and the fountain of life.[19]

That Mr. Eastman is not alone in this conception of poetry is evident from examples he gives.[20] I do not want to contend here that

19. *Ibid.*, p. 317.

20. *Ibid.*, pp. 171-72. I may add a couple of examples of my own. Lascelles Abercrombie in *The Theory of Poetry* says that "the whole purpose of a poet's technique is to make a moment of his experience come to life in other minds than his" (p. 83); and that "poetry consists in conveying experience itself, undiminished in any vital character, out of the poet's mind into ours" (p. 138); and again (p. 154), "The value of things in poetry is the value of experience simply as such; the value which living spirit must feel in every vivid motion of its life. . . . Long before it was worth man's while to express his reasoned or moralized view of things, it was worth his while to express his sense of being a spirit delighting in its powers and faculties, and in whatever will call them into use; and it was worth his while to manage words for that purpose with such art that he could delight in an added mastery—in knowing he could impose his own peculiar delight on the minds of others. The energy that finds expression in poetry must exercise itself in infinitely various moods; but let it be in rage or in hatred itself, in love or in exultation, there is a joy in it; the core of it is the spirit's primitive relish for *experience*. And whatever can be accepted without arguable valuation, frankly as experience, is matter for poetry; it bears its value on the face of it, a value which is instantly decisive, which will not alter, and cannot be stated in any arguable verdict; for it immediately declares the essential virtue of spiritual life—the virtue of delightedly conscious activity. What is there that cannot be so accepted? It is even possible for trains of reasoning and moralizations to be so accepted; and for this it is not in the least necessary that they should convince us. What is necessary is that we should be able to enjoy the excitements of exercising the power of reason, without having to ask ourselves whether we are intellectually in agreement with its results. . . ." And on page 155: "If anyone were to give us the Forty-seventh proposition of Euclid's first book, not merely so as to *prove* the proposition, but so as to infect us completely and unmistakably with the rapture, say, of Hobbes' delighted *experience* of that train of thought—would he not be giving us poetry?"

One entire chapter of Hugo Münsterberg's *The Principles of Art Education* ("Connection in Science and Isolation in Art") is given over to this theme of experience (poetry) vs. knowledge (science). Another interesting chapter, defending almost the identical thesis that Mr. Eastman does, is Professor Pottle's chapter on "What Is Poetry?" in his *The Idiom of Poetry*. And Arnold Bennett champions the notion of poetry as true-to experience (though he does not use the word) in his *Literary Taste:* "The makers of literature are those who have seen and felt the miraculous interestingness of the universe. And the greatest makers of literature are those whose vision has been the widest, and whose feeling has been the most intense. Your own fragment of insight was accidental, and perhaps temporary. *Their* lives are one long ecstasy of denying that the world is a dull place. Is it nothing to you to be led out of the tunnel on the hillside, to have all your senses quickened, to be invigorated by the true savor of life . . . ? These makers of literature render you their equals.

"The aim of literary study is not to amuse the hours of leisure; it is to awake oneself, it is to be alive, to intensify one's capacity for pleasure, for sympathy, and for comprehension. It is not to affect one hour, but twenty-four hours. It is to change utterly one's relations with the world. . . . People who don't want to live, people who would sooner hibernate than feel intensely, will be wise to eschew literature. They had better,

this "communication of the felt qualities of experience" is the one aim or function of poetry; I do not propose to enter into the question of what *"the* function" of poetry is; I only want to emphasize that poetry is, or can be, true-to experience in the way that Eastman (and the other writers whom I have relegated to footnotes) have set forth.

Being true-to the experienced qualities of things, like being true-to human nature, often involves distortion from the "photographic reality"; one must leave the literal truth to get at the "essence." Partly for this reason, the poet must jerk words out of their usual contexts into contexts where one would not ordinarily employ them. For example, when Mr. E. E. Cummings, "in his delicately almost sublime poem of a cathedral at sunset, introduces the word 'bloated' to describe the rose acres in the evening sky—a word sacred so far as I can testify to the memory of dead fish,"[21] he is no more being true-to naturalistic appearances than is T. S. Eliot when he says that the moon smooths the hair of the grass or that the damp souls of housemaids sprout despondently at area gates.[22] Yet the figures of speech "hold"—as we ordinarily say, "there's something in them"—they capture an essence, an aspect of the perceived world; and the insight we get from them enriches our subsequent perception of the world around us. The more of these "essences" are revealed through poetry, the greater the enhancement of our experience; and this enhancement, I daresay, is one of the chief delights and benefits which we derive from poetry. The very essence of art, says Dewey, is the enhancement of experience.[23] T. E. Hulme quotes the line from Keats's *Isabella,*

And she forgot the blue above the trees. . . .

and asks, "Why did he put 'blue above the trees' and not 'sky'? 'Sky' is just as attractive an expression. Simply for this reason, that he instinctively felt that the word 'sky' would not convey over the

to quote from the finest passage in a fine poem, 'sit around and eat blackberries.' The sight of 'a common bush afire with God' might upset their nerves."—(Arnold Bennett, *Literary Taste,* Penguin Classics edition, pp. 19-21.)

21. Eastman, *op. cit.,* p. 168.

22. From *Rhapsody on a Windy Night* and *Morning at the Window,* respectively.

23. Dewey, *Art as Experience,* p. 320.

actual vividness and the actuality of the feeling he wanted to express."[24] And in another place he comments on "The hill is *ruffed* with trees" as over against "The hill is *clothed* with trees."[25] In short, the one juxtaposition of figures gives us a startling image, conveys some new essence, which the other does not; and this essence, once grasped, makes the experienced world for us richer and more alive. "The artist picks out of reality something which we, owing to a certain hardening of our perceptions, have been unable to see ourselves."[26]

Between nature and ourselves, even between ourselves and our own consciousness, there is a veil, a veil that is dense with the ordinary man, transparent for the artist and the poet. What made this veil?

Life is action, it represents the acceptance of the utilitarian side of things in order to respond to them by appropriate actions. I look, I listen, I hear, I think I am seeing, I think I am hearing everything, and when I examine myself I think I am examining my own mind.

But I am not.

What I see and hear is simply a selection made by my senses to serve as a light for my conduct. My senses and my consciousness give me no more than a practical simplification of reality. In the usual perception I have of reality all the differences useless to man have been suppressed. My perception runs in certain moulds. Things have been classified with a view to the use I can make of them. It is this classification I perceive rather than the real shape of things. I hardly see an object, but merely notice what class it belongs to—what ticket I ought to apply to it.

Everybody is familiar with the fact that the ordinary man does not see things as they are, but only sees certain *fixed types*. . . . We never ever perceive the real shape and individuality of objects. We only see stock types. We tend to see not *the* table but only *a* table.

. . . Suppose that the various kinds of emotions and other things which one wants to represent are represented by various curved lines. There are in reality an infinite number of these curves all differing slightly from each other. But language does not and could not take account of all these curves. What it does do is to provide you with a certain number of standard types by which you can roughly indicate the different classes into which the curves fall. It is something like the wooden curves which architects employ—circles, ellipses, and so forth— by suitable combinations of which they can draw approximately any

24. Hulme, *Speculations*, pp. 163-64.
25. *Ibid.*, p. 151.
26. *Ibid.*, p. 156.

curve they want, but only approximately. Now the artist, I take it, is the person who in the first place is able to see an individual curve. The vision he has of the individuality of the curve breeds in him a dissatisfaction with the conventional means of expression which allow all his individualities to escape.[27]

When Hulme (following Bergson, whose theory of art he is here describing) talks about "absolute reality" as being what the artist reveals, we shall have to postpone judgment until we take up these points in Chapter VIII; what is of interest here is that the poet's vision is true-to experience, that the poet has intuited a viable essence which we too can grasp. I do not think that there is anything abtruse or metaphysical about this; it is a common experience among readers of poetry.

There are just three more comments I want to make before turning to an analysis of painting.

1. This renewed and enhanced vision, imparted to us by poetry, requires us, as has already been intimated, to be "shocked out of" our ordinary ways of looking at things, our practical everyday sensibilities; and, since consciousness arises only when there is a conflict between two modes of behavior, these new and hitherto unaccustomed ways of looking at things result in a *heightened consciousness* which is one of the most conspicuous features of the poetic experience. Mr. Eastman and T. E. Hulme describe the process very well, the latter with a novel metaphysical twist.[28]

2. The poet, as Hulme points out, has a double difficulty to over-

27. *Ibid.,* pp. 158-60.
28. *The Literary Mind,* pp. 177-94, particularly the analogy on p. 187. Also T. E. Hulme, with a metaphysical theory, in *Speculations,* pp. 143-69. And Professor Schramm brings out the point very well by examples in *Literary Scholarship* (ed. Norman Foerster) when he says, "Goethe pointed out that the poet (and every writer is a 'poet in the sense that he is a maker) is like a child who wanders around an unfamiliar world bestowing names, calling the lampshade a skirt for the light, noticing that the setting sun is lying down to sleep on the hill, characterizing a person by such a pungent sentence as that which Robert Frost quotes from a boy's conversation: 'He is the kind of person who wounds with his shield.' The child will probably forget these names and grow up to use the hackneyed tags adults rely upon, but if he is to grow up a writer each sunrise must remain 'herrlich wie am ersten Tag.' He must apply this fresh quality of observation to a world infinitely more subtle and complex, call upon a storehouse of naming material infinitely more subtle and complete than 'on the first day.' He must scrape the barnacles off old names and let the salt get into them. He must take name-mummies, unwrap them, breathe life and personality into them. . . ."—(pp. 187-88.)

come. "He has in the first place to be a person who is emancipated from the very strong habits of the mind which make us see not individual things but stock types."[29] The second difficulty lies in putting his vision into words—in turning words, which were devised for practical purposes, to other uses for which they were not intended. Not only our minds, but "language . . . also has its fixed ways. It is only by a certain tension of mind that he is able to force the mechanism of expression out of the way in which it tends to go and into the way he wants. . . ."[30] It is no wonder then that a great poet is so rare a phenomenon: not only must he be able to uproot himself from the practical modes of seeing to capture his vision or essence, but he must also be such a master of words that he can communicate his vision through this highly resistant medium.

In this connection we may touch upon a point which has been mentioned once before: Language descriptively used is not as adequate to give insight into the object of the poet's vision as language evocatively used. To describe the experiences of a sensitive poet would be a hopeless task; but if the poet selects his words properly, and is sufficiently a master of the verbal medium, he may be able to communicate his insight to the reader not by describing but by *evoking* in the reader, by means of just these combinations of words, the same kind of vision (picture, emotion, etc.) which was vouchsafed to him, the poet. That is, the words act as an *objective correlative* of the poetic vision; the latter cannot be transferred bodily from one mind to another, but the communication *may* be effected by means of this objective correlative, the words evoking in the reader the same syndrome of pictures and emotions as the poet intended. Poetry is in the position of trying to convey the "given-in-experience" when there are no words for the "given-in-experience." So the poet must bend and distort words all out of their normal context in order to communicate some aspect of the given through this recalcitrant medium. No poets have been more dedicated to the communication of the strictly given than the poets of our own day; this may account in some measure for the extremes

29. Hulme, *Speculations*, p. 160.
30. *Ibid.*

of distortion, the "shocking of sensibilities," to which they seem to be driven. This fact is still further brought out by a third consideration:

3. Science, as opposed to poetry, is not interested in the given experience itself, but rather in the conceptual framework into which given experience is to be fitted.

Science does not merely refer to things in our experience and state what they "are," but interprets them and states how they are to be "conceived" in relation to other experiences, and to the interests and modes of behavior of the conceiving mind. . . .

Long before science begins, the very language with which it begins has already accomplished a vast work of practical and theoretic interpretation. We are far from the experienced facts when we begin to talk about them. Professor Lewis has demonstrated as convincingly as Bergson, and without any ulterior motives of a mystical order, how persistently all words, and indeed all thoughts, interpret experiences from the standpoint of purposes and modes of behavior and social cooperation—so much so that it is impossible, he thinks, even to allude to an experience without so interpreting it. There is such a thing, he comforts us, as the uninterpreted *quale,* the "given-in-experience," but it is not to be communicated in language. To describe a thing as "edible" is quite obviously to interpret it for purposes of action, but to describe it as "an apple" also contains such interpretation. Even to call it "a thing" is false to the sheer "feel or quality." Trying desperately to suggest what the sheer feel or quality is, which being interpreted becomes an apple, Professor Lewis calls it "a round, ruddy, tangy-smelling somewhat," thus startling with one phrase of poetry the most strenuously prosaic volume I have read in years. It could not be otherwise, for poetry *is* the attempt to make words suggest the given-in-experience.[31]

Nevertheless, remarks Mr. Eastman, language is not *entirely* opaque to the communication of the given; certain words, for instance, have survived although their conceptual meaning duplicated that of other words, simply because of their superior image-evoking power; and here Mr. Eastman chooses Professor Lewis' own example:

The growth of language must obviously be, like the use of it, partly poetic and partly practical. That word *ruddy,* for instance, has probably

31. Eastman, *op. cit.,* pp. 137, 174-75. Cf. also C. I. Lewis, *Mind and the World Order,* esp. the chapter on "The Given," and the Appendix on "Esthetics and Esthesis."

survived or been revived alongside its cousin *red,* because of its value in exactly the function to which Professor Lewis devotes it. With its more colorful vowel and that hard and yet dancing *ddy* at the end, it suggests a quality of experience whose difference from red would not often matter practically, but is worth communicating for its own sake. *Tang* also is a word to some extent, I think, intrinsically poetic. Poetry at any rate is not merely a trick that we have learned to perform with a practical instrument; it has played its part in creating the instrument.[32]

This doubtless lightens the poet's task somewhat; but there still remains the fact that words refer only to *types* or *classes* of things—universals—and the poet's task is much more specialized and difficult than merely to indicate class-inclusions; the poet must make the vision much more precise, and this he can do only by the appropriate juxtapositions of words with an eye to just the right evocation. The situation might be improved if there were, for example, a million synonyms for "joy," and we all knew just what shade of feeling was denoted by each of them (a possibility discussed in the section on musical meaning); but since our language is not so richly stocked, we can only use the portmanteau-words we have and put them together in evocative ways, thus serving a purpose which was far from their intention when the words were coined.[33]

5

We have already seen that painters, like poets, can be true-to human nature in their works; but again, as in poetry, human character is not all that the work can be true-to. In painting, as well as in poetry, we have truth or fidelity to the directly experienced qualities of nature (and it is important to observe here that paintings are not true-to nature conceived simply as a collection of physical objects, but true-to nature *as* felt and experienced by human beings). In the medium of painting we have a decided limitation in the fact that only visual data can be presented, so that the range of data that the work of art can be true-to is here definitely limited, as opposed to literature, which can present

32. Eastman, *op. cit.,* p. 176.

33. I shall not emphasize here the distinction between science and poetry because in the chapter on "Reality" the point will be brought up again.

data from every conceivable sense-modality, internal and external. But there is a compensating advantage too: in painting the presentation is *there* on the canvas, directly before us, while in poetry we must reconstruct it from the words: which is only to say what we saw in Part I, that painting is a directly sensuous medium, while literature is a symbolic one and hence at one remove from the sensuous presentation. Moreover, language has a richer storehouse when it comes to describing the objects of vision than it does for describing what is perceived through the other senses, particularly the internal (organic) sensations; and we shall find this a help to us in our analysis, since we shall better be able than in the case of poetry to fix our attention directly upon certain objects (trees, light, texture of rocks, etc., in the painting) rather than simply to refer to "the felt qualities of experience" and nothing more.

To begin then: painting, like poetry, enables us to capture certain "essences," aspects of the world around us which we would not otherwise have observed and which we can "verify in experience." Through the painting we can be made to see what the artist has seen; and we can verify his vision

... by learning from his art to see his subject-matter through his eyes and then checking the artist's observations with observations of our own. . . . Thus, by studying a number of Cézanne's landscapes, or even a single landscape of his, we can become aware of his particular interest in color, in "edges," and in the three-dimensional solidity of physical objects. We can then go directly to nature, either in retrospect or by means of new perceptual observations, and test the accuracy of his recorded observations in terms of Cézanne's own cognitive preoccupation. This is what every sensitive critic does, consciously or unconsciously, if he takes seriously Cézanne's interpretation of natural objects and is not content merely to enjoy the surface pattern of his pictures. And if he tests Cézanne's observations in this manner, the critic cannot but be impressed by the objectivity of Cézanne's vision, or fail to realize that what Cézanne saw we too can see, and that what had significance for him can have significance for us. . . .[34]

It has often been said that only if we know painting do we really *see* the world; and painting more than any other art sharpens and

34. Greene, *The Arts and the Art of Criticism,* p. 454.

enriches our visual sensibilities, enabling us to break away from our usual, practical way of seeing things. This point is brought out in a very remarkable manner by Roger Fry:

The needs of our actual life are so imperative, that the sense of vision becomes highly specialized in their service. With an admirable economy we learn to see only so much as is needful for our purposes; but this is in fact very little, just enough to recognize and identify each object or person; that done, they go into an entry in our mental catalogue and are no more really seen. In actual life the normal person really only reads the labels as it were on the objects around him and troubles no further. Almost all the things which are useful in any way put on more or less this cap of invisibility. It is only when an object exists in our lives for no other purpose than to be seen that we really look at it, as for instance at a China ornament or a precious stone, and towards such even the most normal person adopts to some extent the artistic attitude of pure vision abstracted from necessity.

Now this specialization of vision goes so far that *ordinary people have almost no idea of what things really look like,* so that oddly enough the one standard that popular criticism applies to painting, namely, whether it is like nature or not, is one which most people are, by the whole tenor of their lives, prevented from applying properly. The only things they have ever really *looked* at being other pictures; the moment an artist who has looked at nature brings to them a clear report of something definitely seen by him, *they are wildly indignant at its untruth to nature.* This has happened so constantly in our own time that there is no need to prove it. One instance will suffice. Monet is an artist whose chief claim to recognition lies in the fact of his astonishing power of faithfully reproducing certain aspects of nature, but his really naive innocence and sincerity were taken by the public to be the most audacious humbug, and it required the teaching of men like Bastien-Lepage, who cleverly compromised between the truth and an accepted convention of what things looked like, to bring the world gradually round to admitting truths which a single walk in the country with purely unbiased vision would have established beyond doubt.[35]

What we have said about poetry re-educating our perceptions and making us aware of our world for the first time is equally true, and probably more true, of painting. And Bergson's theory of course applies to painting as well as to poetry.

This point is well illustrated by a fragment from Mr. Edwyn Bevan's *Symbolism and Belief:*

35. Roger Fry, *Vision and Design,* pp. 24-26. Italics mine.

When a new school of art begins to represent things in nature which had not been represented before, men come to see those things in a new way, they instinctively imagine natural scenes as pictures of that particular kind. I remember once at Oxford, at the Ashmolean, looking through, not very carefully, a series of water-colors by Turner of Oxford, and when I went out again from the Museum into the Oxford streets, it all looked different; there were new lights on trees and houses; it all looked like a painted picture by Turner. . . .[36]

Turner had "captured an essence," an aspect of nature which Professor Bevan had never before seen, and which subsequently colored and enriched his perception of nature; it was "true-to" nature.

Perhaps it should go without saying that when different painters deal with the same kind of object, their visions may all be "true"— they may all present a revealing aspect of trees which will enrich our future perception of trees in nature, and yet they may all be different—they may, so to speak, all capture different essences:

Thus, Theodore Rousseau is preoccupied in his careful drawings and paintings with the multiplicity of leaves and the intricacy of leaf, bark, and branch patterns. The oak is one of his favorite subjects as best exemplifying these arboreal characteristics. Corot, in his later style, emphasizes the softness of the foliage and the way in which it seems to melt into the surrounding atmosphere. Birches and willows are his favorite subjects. Henri Rousseau, unlike Corot, takes pains to delineate each individual leaf and delights in constructing patterns of leaves in which each leaf exists as a stiff, relatively self-contained, object. Tropical vegetation lends itself to such treatment, and this is one reason, though doubtless not the chief reason, for Rousseau's love of tropical forests. Cezanne, in his treatment of trees as of other perceptual objects, is interested in their three-dimensional solidity and, particularly in his later years, in the manner in which they contrast visually with their background. . . . Witness the strength of his tree trunks, the dynamic thrust of his branches, the manner in which his foliage relates itself to its supporting branches, and the way in which his trees exist as individual entities in three-dimensional space. He is also interested in the endless play of light and shadow, and of warm and cold color, which trees in the sunlight so clearly manifest. André Derain resembles Cézanne in many ways, but in the illustration here reproduced he emphasizes the sinewy, tensile, almost rubbery character of the twisting branches.

36. Edwyn Bevan, *Symbolism and Belief*, p. 278.

Matisse, to cite but one more example, is always primarily interested in the two-dimensional decorative character of perceptual objects. His trees clearly exhibit this interest. They are represented less for their own intrinsic character than as occasions for, and aids to, the creation of an interesting pictorial design. Yet even Matisse catches some of the flair and sweep of tree trunks and branches.[37]

We may not all agree with Professor Greene's analysis of the individual painters whom he mentions in this passage, but I think the quotation so admirably illustrates the point that no further comment is needed.

But it is not only physical objects of which painting can reveal to us "essences." Painting gives us these visual insights into objects of vision which are so general and all-pervasive that we would hardly be likely to think of them in this connection at all: phenomena such as light, space, volume, massiveness, solidity, depth. None of these, of course, are photographically presented—there is immense "distortion"; but, as in the El Greco example quoted above, the distortion is the *"necessary distortion"* required for the revelation of "inner truth." For example:

Monet . . . was primarily interested in the portrayal of light and luminous color. These qualities cannot be represented all by themselves. They can be depicted only in conjunction with colored objects which reflect light. Monet was therefore compelled to paint solid objects such as haystacks and buildings in sunlight, shadow, or fog. Yet it is clear that he was not interested in the stacks or the buildings as perceptual objects, but only in the luminous color which they exhibited at different times of day. The architectural structure of his buildings quite disintegrates under this treatment. They are structurally amorphous; his stone lacks lithic quality, and his solids are almost porous; as though the thick, luminous, color-saturated atmosphere not only bathed them but flowed through them without resistance. Here, then, the perceptual universal, "a stone architectural facade," is in large measure *sacrificed* in the effort to portray light and color for their own sakes; only enough of the solidity and structure of the perceptual object is introduced to achieve the desired effect. As a result, Monet's pictures are magnificent expressions of these adjectival universals.[38]

37. Greene, *op. cit.*, pp. 277-78.
38. *Ibid.*, p. 280. I have found it unnecessary (because, I think, unprofitable) to go into Professor Greene's distinctions between perceptual and spiritual universals, and his subdivisions, substantival and adjectival universals.

Here we have an attempt to present experienceable aspects of a pervasive phenomenon, light, in much the same way as universals of human character or landscape are portrayed. (The passage is also an excellent example of selection—how in the capturing of some "essence" others must be sacrificed.)

We come next to massiveness, solidity, spatial depth—in all of modern art we get a strong presentation of these aspects of our experience; our appreciation and perception of depth and line and solidity in all objects we experience is heightened and sharpened and intensified by seeing in paintings how the artist saw these aspects of his world. No one, for instance, can ever "be quite the same again" with regard to the perception of successive up-thrusts of massive volumes in receding space, after he has seen Cézanne's *House in Provence*. The revelations of various aspects of nature which one gets in paintings like these "grow on one" with growing perception and experience, and more and more one sees them to be true-to (not spatiality, depth, etc., in themselves, whatever that might mean, but) the *experienced* or *experienceable quality* of solid masses and spatial depth; and one's perception of the world is most intense, sensitive, and rewarding if one does see it "that way." (It seems difficult to say much more than this, for one either feels it or one doesn't.)

In many paintings the portrayal of these more pervasive universals is far more important than the values of human characterization or trees, etc. The latter must then be sacrificed, and the result is puzzling to those who go to the painting for familiar every-day human values (of which human character is perhaps the easiest to grasp), and who find on looking at the painting that the human figures are not characterized at all, and hence conclude that the artist "couldn't draw"; while in reality, though the observer probably does not see this, the human figures enter into the painting chiefly as excuses or means to something else, the accentuation of other values. For example, in Cézanne (who was many times accused of not being able to draw) the "human values" seldom enter the painting in their own right:

His figures or objects are static, but not inert or dead. The drama in which they take part is the interplay of abstract forces, not one of human

incident and personal emotion; they are active as a tower, a pier, or a buttress is active. His form is architectonic, its attributes are weight, equilibrium, and the balance of forces. . . .[39]

And much of contemporary painting is pervaded (quite justifiably, I think) by the doctrine that these universals can be communicated much more adequately without the use of any representational subject-matter at all: that the interplay of abstract forms to which there is no analogue in the outside world can better delineate these universals than can any group of people, trees, buildings, or other represented objects which, since they do appear in the world, are all too likely to distract the observer's attention by irrelevant associations.[40]

If this seems like an unwarranted extension of the notion of "true-to," I think this can only be because that which the painting is true-to is at a higher degree of abstraction from the photographic reality in the case of spatiality than in the case of human characterizations. But if a non-photographic presentation of a person (and some of Picasso's are violently non-photographic) can be true-to human nature or some aspect of it, then certainly a somewhat more non-photographic presentation can be true-to felt spatiality or volume or solidity. If El Greco distorts human forms

39. A. C. Barnes, *The Art in Painting*, p. 323.

40. We need not enter here into the details of the controversy on this issue. Mondrian, for one, takes the abstractionist position, declaring that painting, in order to be "expressive of" everything in visual experience, must not present anything in particular, but only those common attributes of spatiality, line, mass, volume, which are possessed by everything. Rhys Carpenter, on the other hand (in *The Esthetic Basis of Greek Art*), takes the view that the universals of tension, strength, grace, etc., can only become effectively presented when embodied in particular representational forms, for example, the speed of a railroad train, the strength of an ox. Which of the two methods is a more effective one is a psychological question which we need not go into here.

What we must do, here, however, is to distinguish this issue sharply from another one with which it is all too likely to be confused: the relevance of art to life. It is sometimes assumed that because Carpenter maintained the continuity of art with life and also was a champion of representational painting, while Bell maintained the separation of art from life, therefore Bell must necessarily champion abstract or non-representational painting. But this is not necessarily the case. Some representational painters, such as Chagall in the illustration in Chapter IV, use represented objects entirely as a means to abstract form (a rather circuitous means, it would surely seem); while many abstractionist painters, on the other hand, agree with Carpenter on the relevance of art to life, but believe that certain life-values can best be conveyed in the absence of particular represented objects in the painting. Carpenter and Mondrian, for example, disagree about the value of abstract painting, but they both agree, as over against Bell, about the continuity of art with life. These two issues must be kept clearly separated.

in order to "get at" the inner truth of human nature, why cannot Cézanne distort landscapes and spatial arrangements in order to present some experienceable essence of solidity or depth in space? The principle in both cases is the same; the difference is only one of degree.

And now for a final example, esthetic form itself. I have tried to describe in previous sections (so far as it can be described) what is meant by form in painting, in connection with Bell, Fry, and others. Now, may we not say that the forms created or discovered by the artist are true-to our feeling for form, just as we previously said that his treatment of space is true-to our experience of spatial distance?

We have already seen that the "significant form" of which Bell speaks cannot be entirely unrelated to the rest of our experience, that the forms of Bell's pure artist are a perfection, or shall we say a distillation, of the forms which occur in nature. Again, we depart from the photographic truth to get the "inner" truth. But more important still, the forms which the artist presents to us are forms which we see again in nature, which condition all our subsequent perception of the visual world. As T. E. Hulme says, "The artist dives into the inner flux, and comes back with a new shape which he endeavors to fix. He has not created it, he has *discovered* it, for *once expressed we recognize it as true.* His vision then becomes everybody's."[41] The artist's vision, when communicated to

41. Hulme, *Speculations,* p. 149. This passage follows: "Great painters are men in whom has originated a certain vision of things which has become or will become the vision of everybody. Once the painter has seen it, it becomes easy for all of us to see it. A mould has been made. But the creative activity came in the effort which was necessary to disentangle this particular type of vision from the general haze—the effort, that is, which is necessary to break moulds and to make new ones. For instance, the effect produced by Constable on the English and French schools of landscape painting. Nobody before Constable saw things, or at any rate painted them, in that particular way. This makes it easier to see clearly what one means by an individual way of looking at things. It does not mean something which is peculiar to an individual, for in that case it would be quite valueless. It means that a certain individual artist was able to break through the conventional ways of looking at things which veil reality from us at a certain point, was able to pick out one element which is really in all of us, but which before he had disentangled it we were unable to perceive. It is as if the surface of our mind was a sea in a continual state of motion, that there were so many waves on it, their existence was so transient, and they interfered so much with each other, that one was unable to perceive them. The artist by making a fixed model of one of these transient waves enables you to isolate it out and to perceive it in yourself."—(pp. 149-51.)

us through his painting, can make us see anew not only light and space and volume, but also *form*—I would say, *particularly* form; for form I am convinced, is by far the most important aspect of -visual art, the most important "essence" that painting can reveal to us (Bell and Fry go further and hold that it is the *only* one— the only one, that is, insofar as the painting is a work of art).[42] For it is not these other values, not even light, that we most *see* in nature after appreciating a painting; it is most of all the *forms,* the sense of unity and structures and balances and rhythms that we see in nature now that we never saw before; and we can see them everywhere, in everything, for form is all-pervasive. Without agreeing with Bell, it is quite permissible, I think, to say that he who does not grasp form simply does not appreciate painting.

Men and women who have been thrilled by the pure esthetic significance of a work of art go away into the outer world in a state of excitement and exaltation which makes them more sensitive to all that is going forward about them. . . . It is because art adds something new to our emotional experience, something that comes not from human life but from pure form, that it stirs us so deeply and so mysteriously. But that, for many, art not only adds something new, but seems to transmute and enrich the old, is certain. . . .[43]

There are those who hold that significant form is not merely true-to our perception of forms in the world, but is even true-to (a reflection or echo of) "divine forms," "cosmic rhythms," and the like. I have already mentioned the references of Chinese painters to "the life-movement of the spirit, or rhythmic vitality," and "the life-movement of the spirit through the rhythm of things." And in Cézanne:

It is possible to feel in many works of the Master of Aix some *completion* that is like the echoed rhythm of the universe. Indeed, those who link the achievement of the modern painters with the drift of modern

42. Form-values, when not merely those of two-dimensional design, are themselves bound up with spatial values, so that the two cannot be separated. Whenever, for example, El Greco's three-dimensional "plastic orchestration" comes into play, space-values are very much involved. This is another indication that form is not irrelevant to the rest of our experience, for space would certainly be agreed to be a life value; hence form, which is so inextricably bound up with it, must be so to some degree also.

43. Bell, *Art,* pp. 243, 244.

philosophy toward mysticism find in these pictures a warrant of the stability and poise of the cosmos, a hint of the sweet-running, rhythmic continuity of life.

The monumental rhythm, the serene poise, the mathematical grandeur of the *Mont Saint-Victoire Seen from Bellevue* mark Cézanne's "realization" as at one with that of the seer who has learned to quiet the voices of the clamorous outward world, to penetrate to the silent realm of the over-world. Nowhere else in modern art, or in any period of Western art, is there so moving a revelation of spiritual forces, and of the macroscopic splendors, as in Cézanne's series of landscapes of Mont Sainte-Victoire.[44]

Not all accounts are as metaphysical as this. For example, Professor Mather advances what he calls the "theory of correspondences of rhythm," rhythms not of the cosmos but of the countless manifestations of life which we see constantly around us and in us—the rhythms of growth, fructification, decline; our circulation, digestion, nervous vibration, etc.[45]

We now see how far Aristotle's principle of ideal-imitation (mimesis) which we took as a starting-point, can be extended. First we applied it to human characters only, then to situations and sequences of events, then to objects in the world, then to all-pervading phenomena like light and massiveness. And now we find that the very things we had previously included under esthetic form, design, structure, rhythm, balance, "plastic orchestration," can themselves be included under the principle. In each case we have departure from ("necessary distortion" of) the photographic reality, and the disclosure of an essence which is discoverable in experience and true-to that experience. And with this our discussion has swung full circle to its conclusion.

There are two remarks that I think should be made at this juncture, to avoid possible confusions:

1. The term "imitation" may be misleading here, since usually it denotes mere photographic transcription or copying. But Aristotle's "ideal-imitation" is far removed from photography. If it then be asked why the word "imitation" is retained, the answer, I think, is that there *is* something outside the work of art that the

44. Cheney, *The Story of Modern Art*, p. 236.
45. Frank Jewett Mather, *Concerning Beauty*, pp. 90-94.

work of art is true-to, and this something else is often lost sight of in theories of art as "expression" or "creation"; art thus conceived sounds too much like a whimsical flight of fancy with no roots in the world of common human experience (but of this more in a later section of this chapter). The notion of imitation recalls us back to earth, so to speak. At the same time, however, our notion of imitation involves creation; for the forms are not copied from the external world as it appears to the physical eye, but rather are intuited or discovered (we need not stop to discuss which) by the creative artist. To intuit these forms, to have the artist's vision, is as difficult an achievement as it is rare; few things could be harder than to be the first to look at the world with new eyes, to "dive into the flux" and return with a "new shape," which, once set down in some medium, can be communicated to others. Even to have an intuition of human character in a drama is a creative achievement; how much more difficult, then, is it in the case of something like significant form in painting, which is so much further abstracted from the naturalistic appearance of things! This kind of imitation *is* creation.

2. Is that which the artist is true-to something subjective or something "out there in the world"? Writers on art often say that art does not copy external reality but views it through the artist's temperament; art is "reality seen through a temperament." Or as Professor Greene often says, art is an *interpretation* of reality. If this is the case, what is it that the artist is true-to? Presumably his own vision, his own interpretation, the way *he* sees things.

But certainly this is not sufficient. For to say that an artist is true-to his own vision is to say no more or less than that he is sincere, that he puts down what he feels. And this presumably almost everybody will do who can express himself in any medium at all, including thousands who are not in any sense artists. One's own vision may conceivably be so freakish and eccentric as to be quite peculiar to oneself and unsharable; the works of a crackpot may not be true-to anybody's vision (actual or potential) except his own, and to say that they are true-to his own is not to say very much.

In order to get away from this subjectivity, some philosophers

have said that what the artist imitates or is true-to is an essence, an objective essence which, though it does not exist in the perceivable universe, exists (or perhaps subsists) in some metaphysical realm beyond the senses. But such an hypothesis is certainly not necessary to account for our esthetic experiences; indeed, it would be of no help at all, since that which is beyond the realm of the senses cannot, by definition, be sensed. Accordingly, when we say that the artist reveals an essence we need not be saying anything as metaphysical as this; we mean something *in* the realm of actual or possible experience which the artist captures, a new way of seeing or feeling things which we can share with him. Without this sharability it could not be universal. Perhaps the essence he captures is true-to his own vision—it probably is; but it is not the truth-to his own vision that is important; what is important is that his vision is and can be the vision of others—that he can "dive into the flux" and come back with a vision that we find "true," that stands the test of experience. The essence is verified by our being conditioned by it in our subsequent perceptions. And it is verified *in* experience: we need not hypostatize it to lend it dignity and importance.

It is true of course that we do recognize the individuality of an artist in his work; we can often identify the artist at once when we look at a painting, for example. But when a Cézanne canvas seems to disclose or reveal to us certain essential qualities of experience and ways of seeing things, the disclosure is not "true" for us simply because it is true-to Cézanne's temperament. If some revealed essence in a painting or poem "works upon" our temperaments, it is not because the painting is true-to the temperament which produced it, but because it reveals, *through* that temperament, something which both he and we can see. The fact that it is true-to Cézanne is incidental to the fact that it is true in the sense we have described.

6

The case of music is a particularly difficult one. Music does not condition our subsequent *hearing* in the way that painting conditions our subsequent *seeing;* it does not intensify or enrich or

sensitize our perceptions in the particular sense-modality in which it is presented. Music is not true-to "the way we hear things." What it is generally claimed to be true-to, when this claim is made for it, is our emotional or affective nature. For example, "The real power of music lies in the fact that it can be 'true to' the life of feeling in a way that language cannot."[46] And this is a different sense-modality entirely. The "true-to" in music, then, can never be as direct as it is in the case of painting.

And yet I think that in some sense or other the claim that music is true-to "the life of feeling" is not unjustified. When we detect some emotion in a work of music, or to be more exact, when the hearing of the music evokes in us a certain emotion, we can often recognize, even though we have not experienced just this emotion before, that it is a deep and human emotion, and true-to some feeling we have had or might have. I daresay that everyone who has listened with any attentiveness to the late Beethoven quartets has been transported by them into a world of emotions and a realm of experience that he has never before felt, except perhaps in embryo. Music, as we saw in Part I, evokes experiences which we could never have in any other way; but here we seem to have experiences of quite a different *kind*.

Beethoven's late music communicates experiences that very few people can normally possess. But we value these experiences bcause we feel they are not freakish. They correspond to a spiritual synthesis which the race has not achieved but which, we may suppose, is on the way to achieving. It is only the very greatest kind of artist who presents us with experiences that we recognize both as fundamental and as in advance of anything we have hitherto known. . . .[47]

I do not insist that all so-called great music is true-to human feeling, nor do I see how I could prove it even in the case of Beethoven; but certainly if it occurs anywhere, it occurs here. Listening to the five last quartets of Beethoven is an experience unparalleled by anything else either in music or outside it, and not the least important of the reasons why this music touches and stirs us so deeply is that when we hear it we seem to live in "sympa-

46. Langer, *Philosophy in a New Key*, p. 243.
47. Sullivan, *Beethoven*, p. 250.

thetic vibration" with emotions not our own and into which we yet can enter, emotions of a kind experienceable by us but of which, until hearing this music, we had as yet but little conception. Perhaps music can be true-to "the life of feeling" in the sense that it "truthfully expresses to us or adequately embodies a feeling which, because we can imaginatively realize it in ourselves, we recognize as a genuine human feeling."[48]

7

In none of what precedes has anything been said about the imagination. And yet it is often held that the imagination is the outstanding and distinguishing characteristic of artistic creation. Moreover, it is sometimes asserted that the truth which art presents is not "literal" truth but "imaginative" truth. What is this imaginative truth, and how is it related to the things I have been describing?

The most famous theory of poetry (in English, at any rate) as a product of the imagination is that of Coleridge, which in turn stems from Kant in many of its aspects. In our own century the chief theory of poetry as imagination is probably that of Santayana, particularly in his essay on "The Elements of Poetry" in *Poetry and Religion,* and some of his observations in *Three Philosophical Poets.* Santayana declares that poetry,

seizing hold of the reality of sensation and fancy beneath the surface of conventional ideas . . . out of that living but indefinite material (builds) new structures, richer, finer, fitter to the primary tendencies of our nature, truer to the ultimate possibilities of the soul. . . .[49]

But Santayana does not really develop his theory; aside from a few passages like the above, he leaves it to be inferred from the criticisms he makes of particular poets. Accordingly, we shall devote our entire attention while on this subject to one theory only, the most systematized and comprehensive of them all, which incorporates the essential points in Kant and Coleridge and Santayana all at the same time; I refer to the theory set forth by Professor D. G. James in his remarkable volume *Scepticism and Poetry.*

48. Carritt, *What Is Beauty?* p. 34.
49. Santayana, *Interpretations of Poetry and Religion,* p. 270.

Professor James's first thesis in this book is that the world of our common every-day experience is not equivalent to that which is *given* to us through the senses, but is an imaginative construction out of these given materials. All that is strictly *given* is sense-data, but what we really *see* are wholes, unities, objects; all that is given is a number of presentations in temporal succession, but we see not merely temporal succession but causal connection. In all these things we are going "beyond" the given data of sense, and yet they are a part of the every-day world of all of us. Physical objects and causal connection are not given, but are the result of the activity of the creative imagination upon given sense-data. This Professor James (after Coleridge) calls the "primary imagination"; and, continues Professor James, in the same way that the world of common experience is an imaginative synthesis of the given data of sense, the world of poetry is an imaginative synthesis or construction from the every-day world of common experience. The former is the product of the "primary imagination," the latter of the "secondary imagination."

Our ordinary knowledge of the world and the artistic prehension of reality are not two things, worlds apart, but . . . one thing enjoying in the artist a conscious extension of activity which is denied it in the ordinary business of life. . . . To deny poetry the right to be taken seriously is also and equally to deny the everyday perception the right to be taken seriously; for in both the imagination is creative. . . .[50]

50. D. G. James, *Scepticism and Poetry*, pp. 15-16. This notion Professor James traces back to Kant: "Kant's most distinctive contribution to the theory of knowledge was his doctrine that the mind is not entirely passive in the face of a world presenting itself to mind, but as essentially active in exercising certain powers which, he held, are a necessary condition of knowledge, and of knowledge of a world of objects. This activity of the mind is synthetic of what is given, and is creative in the sense that the world is not given as an ordered unity to the mind, and that the mind is not a mirror in which a world is reflected or a blank sheet upon which the world imprints itself. Instead, the mind actively grasps and operates upon what is presented in sensation. . . . The mind, he said, is presented with a 'manifold,' a plurality of sensation, and works creatively upon this bare, insignificant given, transforming it, by its power, into a system of ordered and interesting objects. There is all the difference in the world, he said, between a mass of barely given elements, unrelated colors, sounds, etc., and a world of enduring objects of which these sense qualities are known as qualities. And to account for the difference between the two, in the genesis and growth of human knowledge, it is necessary, Kant held, to assume that the mind is active in synthesis and in transcending what is merely presented to the mind in sensation. . . ."—(*Ibid.*, p. 19.)

Moreover, asserts Professor James, the world revealed to us by science is an imaginative construction out of the every-day world just as the world of poetry is. Both are based upon the every-day world, yet both transcend it; and in this they are alike—the oft-made distinction between science as "objective" and poetry as "subjective" is a fallacious one. Both are alike products of the creative imagination. Speaking of science, Professor James declares the following:

. . . . its reconstruction of a world as different from that present to perception places it nearer to art than everyday perception. For in the first place it has one of the marks which Coleridge, although no doubt he was writing only with regard to the artistic imagination, attributed to the secondary imagination—it is consciously exercised or it is "co-existent with the conscious will"; it is deliberately exerted in an effort to gather a mass of fact into a single coherent scheme. Also, in so far as this is so, it shares with the artistic imagination a destructive aspect; it destroys in the interests of further construction. The history of science is a sequence of construction and destruction, of rebuilding an imagined world. . . . Though the end and aim of science is not imaginative, there is involved in its process a re-creation of the world which makes of the scientific imagination a "secondary" process. . . .[51]

Now it seems to me that these two theses are open to a good deal of question. (1) That the world of common experience is properly called an *imaginative* construction out of the materials of sense (or a construction in any sense at all) is dubious indeed; if it is an imaginative construction, this construction is certainly of a rather inevitable sort. I think that an account of perceptual experiences of physical objects is not to be given in the way that Professor James does (by saying that we see wholes and unities even when the given data are not wholes), nor of causal experience as he does (by saying that we see—or feel?—causation even though the attribution of cause is "going beyond the given"). These views rest upon a great many confusions which it would require a lengthy excursus into epistemology to bring out, and for this reason I do not propose to go into them here. The analogy between the case of ordinary perception and that of poetic creation is in any case no more than an analogy, and Professor James's case for poetic imagi-

51. *Ibid.,* p. 45.

nation may very well hold even if the analogy with ordinary perception does not. Similarly, there is a sense in which the *theories* of science (not the observations) are on a level with poetry in that they are both products of the creative imagination; but here again the analogy does not extend far, since the purpose, nature, and manner of verification of scientific theories are far different from those of poetry. Accordingly, in both these cases I think we had best disregard the analogy and simply consider Professor James's theory of poetry on its own merits. This procedure will relieve us of the necessity of exploring large tracts of epistemology and philosophy of science which, however interesting, would scarcely be in line with the purpose of this book.

For Professor James the distinguishing quality of poetry is not that it gives us any facts or knowledge about the world, nor that it evokes emotion, but rather that it presents us with what he calls an *imaginative prehension* of the world.

The question of the abstract truth or otherwise of a play or poem simply does not occur in imaginative experience; for poetry is not a number of propositions, but the conveyance of imaginative prehension. The poet sees the world in a certain way; thus has his imagination created it, and thus is it real to him, the world in which he lives and to which in his life he responds. The world as it is represented is the poet's world; and in so far as his poem is successful, he will make it the reader's world by compelling his vision upon him. And this is so whether the poet be a Lucretius or a Wordsworth. In great poetry we at once receive and create an imaginative vision of the world; a new world becomes acutely present to us, or, as Coleridge says, the poet makes us creators, after him, of such a new world. And to ask is *Tintern Abbey* true or false is to put an impossible question from outside the imaginative experience, and, in any case, a question which surely no one can claim to have answered once and for all. . . However Christian a man may be, however much, that is to say, his life may be controlled by the Christian imagination of the world, he may yet enjoy the *De Rerum Natura* as the expression of an amazing vision of the world. It is surely not the business of the critic to make pronouncements upon the "truth" or otherwise of poems and plays; we do not want, say, a Christian critic to point out objections to Lucretius' scheme; we want him to help us enjoy an imaginative synthesis which is not Christian. And if he cannot do that he is no critic.[52]

52. *Ibid.*, pp. 63-64. Cf. also p. 51.

These last remarks reënforce the conclusion that we will do well to emphasize again, namely that *truth-about* is not the business of poetry to impart. We read *De Rerum Natura* as an imaginative synthesis, not as a document containing true or false statements. Professor James emphasizes this at various places. Against the "revelation theory" of art criticized by I. A. Richards, he says that "as we do not know 'for truth' (as Keats says) the ultimate nature of the universe, we must be content with a situation in which the poet is seen as conveying to us the world as it is for his imagination, which controls his life, and which is thus real to him."[53] Again, the language of poetry is used "to evoke an imaginative world; as we have seen, the question of ultimate truth remains unanswered."[54] And "the primary fact about poetry is that in and through it an imaginative object is conveyed."[55] And at the very end of the book, "I have argued that it is impossible to claim that the imagination can give us what can be known for truth, or what may, in all strictness, be called knowledge. Keats ... was careful, as I have tried to show, not to make this claim for it."[56]

It is not necessarily true that *all* poetry, even short lyrics, should present such an "imaginative synthesis"; these short poems do not have time to develop an inclusive imaginative pattern. But they do issue from imaginative vision:

... More frequently, and certainly in the case of the greater poets, a total imaginative pattern, originally perhaps vaguely felt, clarifies itself in the exploration of a situation or plot which has been felt to be relevant to that pattern. Such a unity, inclusive of the poet's imaginative universe, seeks to crystallize itself, with varying degrees of completeness, in lyric, narrative, and drama.[57]

Poetry does *not* exist in order to evoke emotions:

The aim of poetry is *never* to create emotion; its aim is to convey an imaginative idea or object. It may be that the conveyance is accompanied by the occurrence of emotion; but such emotion is incidental to the main end of poetry, which is the expression and communication of an object or objects as they are present to the imagination of the poet. Indeed, we may go so far as to say that, so far as its intention goes, poetic language is no more "emotive" than scientific language.[58]

53. *Ibid.*, p. 67. 54. *Ibid.*, p. 69. 55. *Ibid.*, p. 74. 56. *Ibid.*, p. 273.
57. *Ibid.*, pp. 49-50. 58. *Ibid.*, p. 30.

Professor James draws a distinction made famous by Coleridge, between the imagination and the fancy (a distinction of special interest for our purposes); although unlike Coleridge, James does not consider them to be two separate faculties, but rather a continuum, the one flowing into the other and the difference being only one of degree. The distinction is as follows:

The imagination is always a process of organizing and synthesizing experience, whether at the lower and rudimentary level of the primary imagination, or at the higher level of the secondary; and the secondary imagination is only an extension of the former. . . . It is an activitiy whereby the world is prehended, and, in that prehension, at once dissolved and remade. Its object, that is to say, is what is always present to the imagination as the real world; when the imagination withdraws itself from this conscious labor of creation into the contemplation of a world to the reality of which it is indifferent, and when it exercises its processes for their own sake, it is no longer *imagination,* but *fancy.* . . . It is true, of course, that we can imagine for the sake of imagining; and no doubt there is a natural pleasure to be found in playful indulgence of the imagination. But such is not the imagination of which Coleridge is speaking; on the contrary, such activity is productive of the artificial and is fancy, which is deliberately trivial, though of course it may be a source of great delight. What the imagination makes is the world to which the deepest and most strenuous life of personality responds, and to which it adapts itself in all its activities. It is only when it relaxes from this task that it becomes indifferent to reality, and enjoys itself in fancy. The works of fancy supply a release from the serious business of living, a playful enjoyment of that to the reality of which we are indifferent; the works of imagination, on the contrary, compel a strong sense of the real world, re-created at a new and unique level, and with a novel integrative and imaginative pattern. This comprehensive imaginative pattern may be but a background to the particular imaginative prehension which is conveyed in the lyric; in the play or novel, it finds a full expression, as a single prehension of the whole of life, within which the poet has sought to "balance or reconcile" all the opposite and discordant qualities which his experience has brought with it.[59]

59. *Ibid.,* pp. 48-49. Italics mine. This suggests a most interesting related question, namely, how relevant is anything outside the work when one is having an esthetic experience from a work of art? It is popular to assume that at the moment of esthetic ecstasy everything outside the art-object is entirely irrelevant. Professor Cheney, for example, speaks of the virtue of Chinese painting as being that it depends on an "inner vitality" for its effect, not on its relation with anything outside itself. Cf. also Reid, *A Study in Esthetics,* pp. 37-38; Abercrombie, *The Theory of Poetry,* pp. 153, 158; Fry, *Transformations,* pp. 37-41; DeWitt Parker, quotation in Rader, *A Modern Book of*

We might express the distinction metaphorically by saying that the imagination, no matter how high it may raise its head into the clouds, keeps its feet firmly on the ground. The fancy, on the other hand, sails into the cerulean with nothing to bind it to the world of common experience; and as Professor James says in the passage just quoted, it can be pleasant but hardly significant. All great poetry is a product of the imagination, not a whimsical flight of fancy.

The line between imagination and fancy may often be hard to draw in individual cases, and I know of no cut-and-dried rule for settling controversies about the issue.[60] Yet we all do feel, I believe, that the vision of a Dante or a Milton, even though it may not be a "true" one (in the sense of "truth" which Professor James says is inapplicable), is an *imaginative* vision, deeply rooted in common human experience, and full of insights into the experienced world, particularly that of human feeling, which are true-to in the sense I have described. When Shakespeare says,

Esthetics, p. 234. Croce too says that in art the reality of the object is indifferent; art is "the indistinction of reality and unreality."

But it seems to me that it does make a difference in the esthetic state whether or not there is anything outside the art-object during esthetic contemplation. What is more, I believe we can never forget entirely that there *is* an outside world; we can never see a painting of a human being without knowing it to be a human being, and without coming to it with a large apperception-mass of fused experiences and associations. Moreover, in most cases the artist *intended* us to know and feel these things, and our ability to appreciate his work depends upon this previous knowledge and experience. We do not care, of course, that this particular character in history existed, or that to this figure in the painting there corresponds an exact model in life, but that there *are* human beings in life outside the painting is something we can (and must) never forget during the esthetic state. Without life, art would lose its significance. In the esthetic state all these things do not suddenly become irrelevant. Even in perception of the thin sense (for example, form), we cannot forget that these are the forms *of* life.—(Cf. Carritt, *What Is Beauty,* p. 24; Fry, *Transformations,* p. 41.) We need not know that it is Honfleur that Corot is painting, but we must know that it is a woman rather than a man or a horse or simply a solid. A remark such as "How like Honfleur!" would, as Fry says, be out of place as distracting attention from the esthetic object itself, but a remark like "What a characterization!" would not. (I do not mean to imply that it is necessary in *every* painting to know that the figure is a woman rather than a man, or even a human being. Cf. the end of Section 3, above.) In every moment of esthetic contemplation, no matter how detached, there is a residue from previous experience outside the work; we cannot abstract ourselves suddenly from the rest of our experiences.

60. Indeed, we might say that the boundary between imagination and fancy is not clear and distinct; that the two are not separate and independent faculties as Coleridge said, but that they form a continuum, and shade into each other.

Freeze, freeze, thou bitter sky,
Thou dost not bite so nigh
 As benefits forgot;
Though thou the waters warp,
Thy sting is not so sharp
 As friend remembered not,

certainly here we have an imaginative picture of something we all find "true" in our experience. It presents a communicable essence, enhances our imaginative vision, is true-to experience. Whether the poet has given us knowledge about the world is, as Professor James says, irrelevant; it is the "truth" of the imaginative vision that matters. And here we see already, I think, that when we have been talking about imaginative truth we have really been talking about the same sort of thing we just finished discussing in the previous section—truth-to experience. This "truth-to" seems to me to be the criterion of whether a poem is a work of the imagination (as opposed to the fancy); the two are the same thing clothed in different words. I at least cannot see any difference between saying that a piece of poetry conveys certain communicable essences which "hold true" in experience, and saying that it is imaginatively true; they seem to come to the same thing.[61] The same holds true for painting, though Professor James, whose field is literature, does not extend his theory to include it; however, it seems to me that a painting could be said to convey imaginative truth when it is true-to experience in the way we have described. It holds also in the narrower field of human characterization; a portrayal that is true-to human nature in the sense of deserting the photographic reality for the inner essence may be said to be imaginatively true.

8

We may mention, in conclusion, several differences between the kind of truth we have been discussing in this chapter and the kind we dealt with in the preceding chapter.

1. These "imaginative truths" or "essences," not being propositions, do not contradict each other. Some of them are more valu-

61. Professor James, however, puts a little more emphasis on imaginative *structure*— an imaginative synthesis of the world, etc., which is most appropriate to long poems.

able than others, and some are more imaginatively fruitful; but if there is one which does not seem to "hold water" in our experience, another may be presented to us to supplant it; it does not invalidate the first, it simply replaces it. As a rule, however, when we have once had a "prehension" of spatial depth, our perception of it in another painter does not eradicate the first one from our perceptions, but merely conditions it, or combines with it in such a way as to form a new whole which then influences our further perceptions. Our vision will be colored by both of them acting together.

2. Once again it must be emphasized that the kind of "truth" which has been developed in this chapter does not refer to anything verifiable in the usual scientific sense involving, e.g., measurement. It refers to the kind of thing that people (presupposing a certain degree of esthetic sensitivity and in many cases some training or background in the arts) can verify in their subsequent experiences of the arts and of the world, in the form of enriched and renewed perception (or perception for the first time). It contributes to *Erlebnis,* not to *Erkenntnis.* The difference between these will be pursued in Chapter VIII. It may be that this difference is so considerable that the use of the common term "truth" to refer to them both may be unjustifiable, even after the meanings of the word in the two kinds of cases have been made clear. In this chapter I have started out with a fairly common-sense acceptation of "truth" and developed it; perhaps it has been developed too far, and the common-sense meaning has gradually been left behind in the process, so that to retain the term "truth" in referring to the sort of thing described in the last twenty pages would be confusing and dangerous. If this is so, I have no objection to a change in terminology.

There is, however, one justification for the use of the term in both cases, namely, common usage. We all do use the term in both senses. For example, we say that a statement is true and that a characterization is true, and even that a poem is true to life in some sense and we know quite well what we mean when we employ these locutions. I have no desire to recommend a change in the English language.

"But," it may be replied, "common usage is confused." And so it is, perhaps, on some points. For example, there are senses of the word "truth" (though it must be emphasized that they are not very common ones,) which were rejected outright at the beginning of Chapter V. Why not the same with the one we have been discussing in this chapter?

At present I can only reply that the use of the same term for both cases does not seem to me to be an accident. The usage of the word "true" in the sense of "true-to" seems to be fairly clear, and does not, I think, have to be learned after we have learned what the usage of the word in the other (truth-about) sense is. This in itself would seem to indicate that there is an underlying similarity between the usages. Perhaps it is simply that something is revealed or disclosed in both cases.

I must remark once again that I am not particular about the use of the word "true"; if a more satisfactory term can be found, then so much the better. But whatever other term be devised, it must refer to the same sort of thing that has been discussed in this chapter; and the same facts must be recognized, no matter under what names they may appear.

9

One final difficulty may be felt on reviewing the contents of this chapter. I have spoken of a characterization in a drama as being "true-to the human heart." Then I extended this notion to "the feel, look, taste of experience" in poetry and painting. But is there not a difference here? Can it not be said that the first is really truth-*about*? I have said that literature's function is not to give us truths about science or history or theology; but does it not give us truth about human character, truth which is really scientifically verifiable in a way that the "communication of the felt qualities of experience" in poetry and painting is not? For in the paintings we get "ways of seeing the world," verifiable in the experience of other observers and the same observer at other times (as is seen when a whole generation of art-lovers "catch on" to Cézanne's vision of space), but we *learn* nothing new about the world; yet

we do seem to in the case of the characterization. In a literal sense, may we not *know* something more about human nature from reading Dostoyevsky; but what do we *know* from seeing Cézanne or hearing Mozart? There are propositions about human nature which we may be able to assert after reading Dostoyevsky, which we never could in the other cases. Is there not a difference here? Do not *some* works of literature at least (certainly not all) give us "truth-about"?

I think there is a difference. Appreciation of painting gives us new "ways of seeing" but no knowledge, no facts, no propositions; so also with music and much literature, especially poetry. But there are things about human nature which we may well *learn* from literature—and may we not call this knowledge? It may be less than is often supposed—for example, Shakespeare was a master dramatist and an incomparable poet, but how much about human nature one learns from him has at least been disputed[62]—yet it often happens that we get more knowledge of human character from a novel or drama than we do from most books on psychology or observation of people around us. Literature can do this by presenting characters in various situations and showing their inner motives (either directly, in a novel, or through their actions, as in epic and drama). And these observations, though not true in the sense of describing the ways these characters did behave (most of them never existed at all), still often enable us, by a kind of transference, to know more about people around us than direct observation of the people themselves would afford.[63] The novel does not *state* truths about human nature; but it presents them indirectly by simply *being* true-to human nature, allowing us to see these (fictitious) characters revealed, and leaving us to draw the proper inferences and make the application to the people around us. And this is something that cannot be said of most poems and paintings—they "illuminate the world" for us in the sense of giving us enriched vision of it and affective responses to it—making us feel more intensely (once again) "the felt qualities of experi-

62. For example, by E. E. Stoll, *Art and Artifice in Shakespeare* and *Shakespeare and Other Masters*.

63. On the reasons for this, see E. M. Forster, *Aspects of the Novel*.

ence"—and are true-to experience in that sense, but they do not, I think, give us knowledge as the characters in a novel can be said to do, in the indirect manner just described.

The relation of art to knowledge, however, will be further developed in Chapter VIII, but not until we have first inquired briefly, in the next chapter, into the question of whether these truths—the facts discussed in the previous chapter, and the "truths" (either of human nature or "truth-to felt experience") discussed in this one—are, when they occur in a work of art, relevant to it *as* a work of art.

7

The Esthetic Relevance of Truth

WE HAVE NOW SPENT considerable time in considering the various senses in which what we call "truth" may be said to be presented in works of art. We discussed first of all "truth-about"—facts, data; and although we saw that it is no part of the function of art to present these truths, they do nevertheless occur in works of art: from Stendhal's *Le Rouge et Le Noir* we learn a good deal about the condition of France in the post-Napoleonic generation; in reading *Arrowsmith* we pick up a good many facts about medical techniques and practices. Next we discussed at some length the idea that works of art are *true-to* human character, human emotions, humanly felt experiences of objects and elements in nature such as trees, light, and space. And it cannot be denied that many persons, justifiably or not, come to art with the purpose in mind of acquainting themselves with more of this "truth," and that the apprehension of it is a considerable, if not the main, source of their enjoyment of works of art.

But the question that at once arises is, Is this truth important to art *as* art? or is it artistically "accidental"? All other things being equal, does the fact that a work of art is true-to something make it a better *work of art*?[1]

The obvious reply will be made at once: "That depends on how

1. I. A. Richards says, "The people who say 'How true!' at intervals while reading Shakespeare are misusing his work, and, comparatively speaking, wasting their time."—(*Principles of Literary Criticism,* pp. 272-73.) But what is meant here is, judging by the context, "truth-about." And on that matter I have already conceded the point, in discussing Eastman in Chapter V. But any other sense of "truth" than this Richards never seems to recognize at all.

you choose to define a work of art." The inclusiveness of our definition of a work of art will determine whether the things referred to will or will not fall within their scope. For example, someone might assert that any work exhibiting significant form in Bell's sense is a work of art, and that *only* such works are works of art. In that case all facts, truths, and indeed all life-values whatever will as such be artistically irrelevant and extraneous to the work of art as an esthetic object. But, on a different definition of a work of art, many of these life-values will become artistically relevant. It all depends on one's definition.

Is the question, then, of whether the truth and "reality" (of whatever sort) in a work of art is esthetically relevant or not merely a question of terminology? Is it merely a call for a definition of a work of art? If so, we shall simply have to formulate a definition and see whether, on that definition, this or that particular element appearing in a work of art is relevant to it as a work of art.

First of all, however, we must avoid a confusion into which it is dangerously easy to fall. It is sometimes held to be characteristic of works of art that anything presented in them can be presented only in just the way it is presented—the painting in just that combination of lines and colors, the poem in just those words and no others—that is, it is untranslatable into any other terms but just those in which it appears. And this is indeed characteristic of works of art. This might tempt us to say, "Whatever element or presentation in a work of art that cannot be taken out of that work without damaging the entire work, but can be presented *only* in this particular medium and in this particular context, is a truly artistic element." (For example, a given melody or poem would be damaged or destroyed if a single note or word were changed.) But on reflection I think we must see that this is not the case. For while the phenomenon of untranslatability just referred to is characteristic of works of art, it is characteristic also of works that no one would call a work of art. For example, we might say that in the line "The hill is ruffed with trees," the insight is completely bound up with the words and could not occur at all if different words such as "The hill is clothed with trees" were used; and we might say that

in Turner's landscapes every light and shadow and bit of luminosity has to be just as it is and where it is, and that the whole effect would be destroyed if any element in the painting were altered. And all this may be true enough, but this cannot be the criterion for determining the relevance of these elements to the works *as* works of art, for would not the same thing apply to compositions and paintings, etc., which are not generally considered art at all? For example, there are hundreds of portrait-painters of the eighteenth century whom no one would think to call artists (no one, that is, would call their works "artistic" or "fine art," although they are obviously art in the sense of being a "making"), in whom this is equally true: if one line in the face were changed, the whole character of the portrait would change; the line must be in just this place, fulfilling just this function. Or to take another example, just as the desired effect in a lovely line of poetry would be destroyed or at least changed if a single word were altered, so too in a bad poem: a single word might evoke a very different effect. Thus if an element in a work of art is *organically* connected with the rest of the work, it still need not be artistically relevant in the sense of being capable of appearing only in a work of art; for as we have now seen, there are many works, admittedly not works of art, of which this is equally true. An esthetically revolting work may possess this same untranslatability of its elements.

To return, then, to the main question: when is something—in this case, a truth in either of the main senses described in the two preceding chapters—relevant to a work of art *qua* work of art? does its presence make it a better or worse work of art? (We have just seen that "untranslatability of its elements" is unsatisfactory as a criterion of artistic relevance, since it is present also when no one would think of calling the work a work of art.) Again, this depends on how one chooses to conceive (I will not say define, since any verbal definition is likely to beg more questions than the term itself) a work of art. I propose, then, rather than arbitrarily to set up a conception of my own, to examine one or two prevalent conceptions and indicate whether, according to them, the presence of truth (of whatever kind) helps to make it a better work of art.

Let us take, to begin with, a requirement which I am sure most writers on art, as well as artists, would agree to: namely, that some *formal* criteria must be satisfied. Bell would hold that this is *all* that is necessary (life-values, he would say, are irrelevant); but many more would agree that this *at least* is necessary. Let us, then, see whether our truths are esthetically relevant in the conception of a work of art which Bell has set forth. If they are relevant on this *minimal* view of what art is, they will certainly be relevant according to more inclusive views.

To take purely factual truths first: There are statements in novels which are perfectly prosaic statements of fact, quite in place in a statistical report, which yet can *function* esthetically in a work of art, building up its structure, and contributing to formal effects such as unity, climax, conflict and resolution, development, balance, etc. Balzac's novels are filled with facts about Paris; we know more about Paris after reading them, though we might have gleaned most of the same information from historical documents. In *Le Père Goriot,* for example, these facts not only provide the setting, set the stage and help create the atmosphere, but they set the novel off into structural units, blocks of material that form the very principle of organization of the novel. This illustration, I think, will suffice, though others might be adduced. The prosiest facts which are of no esthetic value in themselves may function esthetically within a work of art as contributing to its formal organization.

And if this is the case with perfectly prosaic literal truths, it will certainly be the case with the various things described in Chapter VI under the heading of "artistic truth." For example, Bell would say that a strong characterization of a number of figures in a painting, no matter how true-to life, would be irrelevant to the painting as a work of art; but obviously the human figures can function esthetically in the painting (on his definition) in many ways, particularly in building up the design and pattern and introducing the kind of balance and unity, etc., required for the achievement of significant form. Human figures thus can contribute to the accomplishment of this form, even though *as* human figures Bell would say they are quite irrelevant to the form. And I take it that

it is in this role of means toward significant form that Bell has an admiration for the human figures that occur throughout Renaissance painting. Elements in a work of art that in themselves would be quite irrelevant can subserve an esthetic end *in* the work of art, even for Bell.

But most artists and critics would not be so stringent in their requirements of artistic relevance; most critics, I am sure, would say that the fact that a Rembrandt painting presents a strong, "true" characterization makes it a better painting, better *as* a painting, and they would give it a higher esthetic evaluation because of it. Again, if the lines and curves of a Ryder seascape capture a Romantic mood or flavor common to all of us at certain times, and are thus true-to this kind of sharable and fundamental human impulse, they will judge the work to be a better work of art (all other things being equal) because it does capture this feeling. And from the point of view of these critics, who are far in the majority, the truth-to this Romantic mood will be immensely relevant to the painting as a work of art; its presence will improve its worth in their eyes, as a painting. And the characterization in a drama will be an artistic achievement in its own right, not merely as a means of achieving "significant form." It will be important *as* art.

Usually, however, one kind of truth-value by itself will not suffice to make a critic call the work a work of art, or at any rate a "good" work of art. For example, characterization by itself is not enough; it must appear in conjunction with other elements. Many portraitists of the eighteenth century can present shrewd characterizations of human beings, as can certain cartoonists today, but if the pictures have only this leg to stand on they are not generally accepted as art. Many painters who have long since been forgotten could characterize strongly, just as strongly as Daumier; but Daumier had many other excellencies, particularly a wonderful sense for formal design, and as a result of this combination of virtues he is generally considered one of the great painters of the nineteenth century. (With an increasing number of critics of painting today, form is the most important thing; without it the painter cannot be an artist, and with it he is one; but this is not to say, as

Bell does, that it is the *only* relevant factor—that the addition of other things cannot make him a better artist.)

A common error in this connection is for connoisseurs to fix upon one type of "truth," and if the work does not have that, to dismiss all the others and then wonder why critics evaluate the work as they do. Two of the greatest of Western painters, Cézanne and Seurat, do not usually characterize their human figures strongly at all; we do not get many, if any, "human insights" from them, certainly not as many as we do from a large number of inferior painters. But it must always be remembered that Cézanne and Seurat were not aiming at human characterization—they were on the trail of other essences; and in the achievement of these, they had to neglect to a great extent the fulfillment of the other, more obvious ones.

I do not mean to say that every work of art must be true-to something or convey some "reality." On the contrary, many works of art—the most obvious examples are rugs, arabesque, pottery,—are probably not true-to anything at all. But (and this is the important point) it often happens that when these "truths" *do* appear, they *are* artistic relevant, and contribute to the esthetic value of the work (at least as most critics would conceive it). Thus when Turner is praised for "capturing the pristine freshness of the morning landscape," this is praise to him as an artist, and he is considered a better artist for having captured this than if he had not (though again, not on the pure formalist's criterion). Once again, a work may be esthetic in the thick sense as well as in the thin sense.

The argument of this section may be briefly summarized as follows:

1. The arts—literature at any rate—may contain statements about the world which *qua* information are not held by artists and critics to be relevant to it as art, although they may contribute in certain ways to its structural development or plan of organization.

2. The arts may also contain "truth" in the sense discussed at length in Chapter VI, anywhere from truths to human character to "viable essences" or ways of (actually or potentially) perceiving

our world. Whether these things, when they occur in works of art, are relevant to them *as* art depends on the degree of "isolation" which the critic in question considers proper to the work of art. On the "purist's" conception, they would not be; but to most critics, the fact that a work contains a true characterization (Tolstoy) or captures some essence (Cézanne) *is* an artistic virtue, and increases its value *as* a work of art—in fact, in the opinion of many, constitutes its chief virtue and aim.

3. But in any case a work of art *may* exist without them. At any rate there are acknowledged works of art, especially in the visual medium (it would be most difficult with literature, as we saw in Chapter IV), which exist entirely or almost entirely free of them.

2

One special application of the general thesis of this chapter is of special interest to connoisseurs of art: the relation of art to belief.

Objection has often been made to truth in art on the following grounds: In judging any matter, it is said, one should weigh the evidence impartially and without bias, and especially without being swayed by emotion. But a work of art is alive with emotion; it can present a case more vividly and intensely than any other medium—that is just what the writer is skilled in doing. Therefore it is to be avoided at all costs, for it keeps one from viewing the issue in question with impersonality of judgment. The sociologist, for example, a specialist in his field, can make statements in sociology and defend them. But now the artist invades the field of social relations; he has no detailed knowledge of the things whereof he speaks, but he has deep-felt convictions and, what is most dangerous, he has at his command a usage of the verbal medium whereby he can sway others to his point of view, no matter how ill-considered it may be. The artist is not a sociologist but he has a deeply emotional nature and the ability to fan his emotions into public flame by means of his writing. He can write a persuasive social drama without having investigated sufficiently that whereof he writes, and can win many others to his point of view; but the sociologist, meanwhile, realizes what the dramatist's

errors are but has not the command over language that is required to sway large numbers of people; and he realizes that to reach any well-founded truth on these matters would require a degree of patience and painstaking labor that the public, victims of easy slogans and all too prone to emotional persuasion, would never exert. And neither in most cases would the dramatist. In this matter the sociologist alone can speak the truth—but no one hears him, for the writer, with a golden pen, speaks foolishness and makes the people listen; hence the writer is dangerous, and the moment he tries to "speak truth" his voice should be stilled.

My reply to all this is that the criticism is perfectly justified— justified, that is, so long as what the writer is doing is to take some intellectual theme and bedeck it with literary and stylistic orna- ments in order to make it more persuasive. The writer in this case is not speaking as an artist but as a sociologist, since he is making statements in the sociological domain, and in order to do this he must know something about sociology. To make such statements, no matter how persuasive, and not know whereof one speaks is indeed extremely dangerous. His gift for style and diction, no matter how great, does not entitle him to speak *as a sociologist.* Much harm has come from this sort of prostitution of art. Lillian Hellman, for example, summons up all her talents as a writer, her ability at dramatic and compelling statement of issues and pre- sentation of conflicts, and the like, to make a stirring appeal in be- half of Russia in *The North Star.* But her persuasiveness and skill as a writer do not insure that she speaks the truth (though in this case I daresay she is doing so), although she has at her command the power to influence millions of people. Mastery of an artistic medium does not insure mastery of the subject-matter of which one speaks in that medium. Equally stirring appeals can be made on *both* sides of a question; the stirringness does not affect the merits of either side.

My point is, however, that the artist, *qua* artist, does not use his medium as a means of spreading social theory, or teaching more about China, or inculcating theological doctrines, or indeed dealing with *any other subject-matter* whatever. For as we have seen, what he is doing if he does so is to take some theme from life

and dress it up in artistic habiliments—the "layer" theory of art again.

Or to take a special case: Does the poet's philosophy, even that philosophy which appears in his work, qualify him to a position as a poet? Is his vision of the world relevant to the merits of his poem? Does it make him a better *poet*? And again the answer is that if the poet wants to speak any truths about the universe, he must enter into competition with the philosopher and the scientist, and the fact that he is a poet does not for a moment exonerate him from the necessity of passing the same rigid criteria of truth that they do, or excuse him for making false assertions, or mitigate his position in any way.

Sir Henry Newbolt appears to have involved himself in the old mistake that it is the philosophy of philosophical poetry that moves us. What moves us is the poetry; and, though it is difficult to separate the poetry of a philosophical poet from the intellectual argument which gives it form, the fact that we can and do continually refuse the philosophy and accept the poetry points to the likelihood that the philosophy merely serves the same office in philosophical poetry as the plot or myth in other kinds. We give to the one as to the other "that willing suspension of disbelief which constitutes poetic faith"; if the poet is great enough to create, by means of his philosophy or his story, a significant order in the chaos of human experience, we ask no more from the philosophy.[2]

But this is not to say that the artist is relegated to an ivory tower of "pure esthesis." When our perceptions are enriched by a Van Gogh or a Cézanne, we receive what only an artist can give us, because the very fact that they give us these things (the "essences" discussed in Chapter VI) entitles them to be called artists. That is to say, a part at least of the criteria which most critics would adopt in deciding whether a given work was to be called a work of art is precisely whether or not it does present us with the kind of thing described in Chapter VI. There are other criteria as well; and it

2. J. Middleton Murry, *The Countries of the Mind*, second series, p. 47. See also on this point James, *Scepticism and Poetry*, p. 272; George Boas, *Philosophy and Poetry*, p. 15; Brooks, *Modern Poetry and the Tradition*, entire volume, but especially, Chapter III; Carritt, *What Is Beauty*, p. 24; Abercrombie, *The Theory of Poetry*, pp. 238 f.; Richards, *Practical Criticism*, pp. 277 f.; William V. Evans, *Belief and Art*, pp. 40 ff.

may be (depending on the relative importance given to each criterion by the particular critic in question) that *some* work which presents these "truths" of perception or characterization may not be called a work of art because it is extremely shabby with respect to technique or form or esthetic surface, and the critic who holds these high will deny its right to be called a work of art because it lacks these essential things. On the other hand, another work may be low on insight and high on esthetic surface, and yet it may be called a work of art (some of Matisse) in spite of an almost complete lack of life-values. Whether a given work is called a work of art depends generally upon a *combination* of characteristics, of which "artistic truth" is only one; and unless in some given case it is considered the all-important one, a work may possess it and yet fail to be a work of art, and lack it and yet be one. Yet it is *one* of the factors which contributes (in the minds of most critics) toward its *being* a work of art. And in this respect it is unlike plain facts or literal (propositional) truths which may occur in a work of art; these are always "artistically accidental," except insofar as they contribute, as we saw earlier in this chapter, to the artistic structure of the whole. And in this capacity they are not functioning *as* facts.

The following is a most interesting example.

The Franciscan faith is present in Giotto, who expresses while he dominates it. As an atheist, I shall seek in it not reasons for believing, but the flavor of a particular state of mind. And so, for the space of a second, I, the unbeliever, must become like the man whose faith persuaded the beasts of the field, yet without ceasing to be the stranger who looks on, as Giotto doubtless never ceased, in the presence of the saint he loved, in the presence of his own soul, to be the stranger who looks on and paints. . . .

Men with very strong convictions will always regard it as an impious masquerade to put on, even for a moment, feelings other than their own. But after all, does not intellectual sincerity consist in being various where one should be various, single where one should be single? Active beliefs are meant for action. In practical life, if St. Francis becomes merely a label in the hands of a party, while Gorky is transferred into a weapon for the other party, then one must choose, and I do choose: I am for Gorky and against St. Francis. But neither Giotto nor the author of *Vagabonds,* as artists, require a choice from me. Both say:

"Look and appreciate." And I do look and appreciate; that is my integrity. It seems to me more difficult than a total abandonment to one idea.[3]

And in the same way, when Professor Abercrombie praises Homer for the wonderful way in which his "wide vision of life" saturates his poetry, he is praising him for poetic virtues; but when he goes on to praise Homer and Hardy for having certain views about Fate and Destiny,[4] he is certainly praising them as philosophers, not as poets, and his criticism is no longer poetic criticism. Homer and Hardy are great poets, but not because they entertained certain propositions about the nature of Fate or Destiny. The same remark may be made with regard to A. C. Bradley in his *Shakesperean Tragedy;* most of the time his criticism of Shakespeare is poetic criticism, as it is intended to be; but sometimes he criticizes (or praises) Shakespeare for certain implicit views on the nature of evil, and then certainly he is criticizing him as a philosopher. Shakespeare's superiority as a poet and dramatist does not make his implicit views (which other critics declare are not present even implicitly) on the subject of evil any more palatable than they were before, nor do the views make him a better dramatic artist. If Shakespeare is taken as a philosopher, he must pass the same bar of judgment that the non-literary philosophers must do.

Of course, the views of Fate which Homer may have made, and the propositions about evil to which Shakespeare may possibly have given his assent, may have been of great dramatic or epic significance, so that the development of their poetry would have been quite different without them. But then, of course, the views on Fate or evil would be of artistic importance only insofar as they did affect and mould the art-form, not insofar as they were true or false propositions about the universe.

3. Charles Mauron, *Esthetics and Psychology,* pp. 66-68. Cf. also the passage from D. G. James quoted above.

4. Abercrombie, *The Idea of Great Poetry,* in *The Theory of Poetry,* pp. 278-85, 294-96. Cf. also Pottle, *The Idiom of Poetry,* last half of Chapter 4.

"Reality" and Knowledge

THUS FAR I HAVE DISCUSSED only the first of the main concepts in this Part, and it now remains to make some comments on the others.

"Reality" is one of the greatest weasel-words in the language, and one most misused by philosophers. Indeed I feel tempted to say that "reality" is simply what one defines it as being, and that to ask simply, "Is this *real?*" is to utter a meaningless question unless one is specifying quite clearly at the same time just how he is using the word in this particular context. For example, is an optical illusion real? It is not real as a physical fact; there are no pink rats although the drunken man sees them, and in this sense pink rats are not real. But as a psychological phenomenon they are very real indeed. Nothing is absolutely real or unreal; reality or unreality can be predicated of something only with reference to a criterion which is specifically stated in advance. This, however, is not often done, and here all the confusion comes in.

Mr. Eastman, for example, is as insistent that poetry gives us "reality" as he is that it does not give us "truth." I have already examined in some detail his contentions with regard to truth in literature; and as for "reality," he combats the idea current among some contemporary writers that what is not scientific fact cannot be "real" (as if this statement as it stood could be a significant attribution).

The identification of poetic diction with unreality is a natural counterpart of the naive assumption of science that its function is to

tell us what reality "is." In proportion as science has grown mature, however—and grown even godlike in its power to perform miracles upon reality—the men of science have more and more clearly realized that their theories do not tell us what reality is, but only how we must conceive it if we wish to perform these miracles. This realization had gone so far in 1901 that the French mathematical physicist Henri Poincaré exactly reversed the grandiose declaration of Democritus in which his science began. "The void," he said—or to quote him more accurately, "our idea of space"—is nothing but "a convenient convention."[1]

Today more than ever physicists are aware that

> ... the relation of their formulae to "reality" is a complex and somewhat remote one, and that the sheer experiences—the sweets and bitters, hots and colds, with a knowledge of the relations between them and how they may be handled—*is about all the reality man will ever grasp. ...*[2]

Here the poet differs from the scientist, since "whereas science seeks convenience at the expense of reality, he seeks at the expense of convenience the most assured reality there is, the qualities that things have, or may have, in experience."[3]

Without attempting to criticize here Mr. Eastman's conception of science as a "convention," we may note that Mr. Eastman is using the word "reality" in such a way as to include the "immediately felt qualities of experience," but not to include constructions out of that experience, such as scientific world-pictures. And doubtless there is some justification in common usage for saying that these first-person experiences common to all of us are "more real."

Some writers, particularly in philosophy, have used the word "reality" to indicate some realm "beyond" space and time and "outside" the limits of sense-perception (though I do not see how one could make sense of such assertions but for the use of the spatial metaphors "beyond" and "outside") and have declared that the entire sensible world is "unreal." Some of these writers have used this notion as a kind of backdrop for the theory that the business of art is to "pierce the veil," to reveal this reality to us

1. Eastman, *The Literary Mind*, pp. 219-20.
2. *Ibid.*, pp. 220-21; italics mine.
3. *Ibid.*, p. 222.

which is hidden to all ordinary perception. What are we to say of such assertions? Even if the notion of a "transcendent reality" "beyond" the pale of experience made sense, how could it ever be experienced, through art or anything else? (Indeed, how could one know that there was such a "veil"? and what would it mean for there to be such a reality, since "being" and "existence" must be defined in terms of possible experience?) And if, on the other hand, we could experience it, then how could it be transcendent?

In any event, I do not see how any such "reality" could be of help to us in art. What art reveals is certainly something *within* the realm of (actual or possible) human experience, within our spatio-temporal universe—something relevant to the rest of our experience and illuminating that experience. But how a "transcendent reality" could do this is difficult to see.

What else can be meant by "real" and "reality"? Professor Reid lists four senses of the word which it may be worth our while to examine:

1. "Reality" may mean the solid world of facts and values of which we have convincing experience in our ordinary life. This reality is something which is regarded as opposed to mere fancy or fiction or figment of the imagination.

2. The term "reality" may include both solid fact *and* fancies, fictions and figments. In this sense everything is as real as everything else.

3. "Reality" may mean a vividness and intensity and vitality which is experienced directly. Anything experienced very vividly appears very "real" in this sense.

4. "Reality" may mean *importance* and *comprehensiveness* in the scheme of existence as apprehended by human experience. If "great" art is said to be "real," it is principally this kind of reality which is meant, though the others cannot be excluded.[4]

Let us examine these senses in turn. "Reality" in the first sense is the reality constituted by the physical universe, exemplified by scientific statements and statements of common fact (for example, "There are three people in this room")—except for the addition of the phrase "and values," which is very puzzling because one does not quite know what manner of bird or beast may be permitted to slip in under that head. Forgetting about the "values,"

4. Reid, *A Study in Esthetics*, p. 272-73.

however, one may safely say that this sense does not constitute the "reality" with which art is concerned.

In the second sense, as Professor Reid says, "everything is as real as everything else"; everything which in some sense *is,* is real. Obviously this sense of "reality" cannot apply any more to art than to anything else. Any word, no matter what, loses its significance when it can be predicated of everything. When philosophers say, "Everything is mind," or "Everything is matter," the words "mind" and "matter" lose all their force; in ordinary discourse they are applied only to *some* things, and now when such terms are applied to everything, they become impotent because within this all-inclusive class we must still make the same distinctions as before, that is, between physical and mental. Now, however, we must find a different term for at least one of them, since we have just used that term to apply to a class including both of them.

In the third sense—reality as intensity or vividness—many, if not most, works of art are real for those who enjoy them. And certainly this usage is not an uncommon one: "it's so real to me," people say, and the statement sounds perfectly natural. Vivid experiences are in this sense the most real, and there are many degrees of reality. But we should be careful, when we use "real" in this sense, not to talk as if we were using it in another sense in which that which is "real" is something objective and observable. Reality in the present sense is perfectly compatible with the seeing of an illusion, and an illusion is unreal in another sense of "real." Those who hold that "art reveals reality" must not do so simply on the basis of the observation that art is real in this third sense.

As for the fourth sense—reality as importance and comprehensiveness—this partly overlaps the third. The feeling of significance or importance which attaches to certain facts or sensory presentations may cause us to say, "it's real." This may be partly because the impression left is vivid, and hence real in the third sense; but even though it is not vivid, if it is sufficiently comprehensive or strikes us enough as being important, we may predicate "reality" of it. In both of these last two senses, "real" is a kind of honorific term which we apply when other words fail us, and which we can use to communicate to others how deeply we are impressed.

There is another sense of "real" which I would like to suggest which is of special relevance to art, namely the sense in which, when we say of a character in a drama that it is real, we mean that it is true-to life, or when we ascribe "reality" to a Cézanne canvas, we mean that it is true-to our experience of distance or spatial depth or form in the way we have described in the preceding chapter. In this sense, to say of a work of art that it is real is to say that it reveals these "essences" which are communicable to us and verifiable (in the way we have described) in our subsequent experience. "What Cézanne saw we too can see."[5] And in that sense what Cézanne saw is real. This is not to be confused with the statement that our experience of Cézanne is a real experience, since in the way in which "real" is used in that context, every experience is a real experience by virtue of the fact that it *is* an experience; but not every experience is an experience of reality in the sense of being an experience of some "essence," some "truth-to."

It will be seen at once that when we say something is real in this sense, we are talking about exactly the same sort of thing we discussed throughout Chapter VI. And since this, the most important sense of "reality" relevant to works of art, has been discussed in detail already, there is no point in going over it again. And thus the present discussion of "reality" is conveniently cut short by the fact that in the only sense which is highly relevant for our purpose, it has been discussed already.

One possible confusion, however, must be pointed out here. When we say that a character in a drama is "real," or that some presentation in a painting is "real," we *may* mean to use "reality" in the third sense listed by Professor Reid: we may mean no more than that it gives us a vivid "sense of reality," "the illusion of reality"—it *is* real (in the sense of being vivid), and it *seems* real (in the sense of creating the illusion of reality in another sense, namely something objective, "there"). But this is not to say that it *is* real in the sense we have applied to art; it may be vivid, it may evoke the "sense of reality" at the time, and yet it may not really communicate an essence or a perception of the world which is borne out in later experience. This perception may be *accompanied* as a

5. Greene, *The Arts and the Art of Criticism*, p. 454.

rule by an experience of vividness, but yet the vividness alone is not sufficient grounds for saying that it is real (in the sense of true-to, etc.). The most freakish flight of fancy may be vivid.

Thus, to say that art gives us a sense of reality, and to leave it at that, is assuredly to emaciate art: for anything whatever may give a *sense* of reality, depending on the person and the condition in which he finds himself. To say that art gives us a sense of reality is to state a psychological proposition about the quality of one's experience. But to say that art reveals to us reality in some sense which is not this subjective one, is quite different, since it is to say that art can call our attention to something in the world, or some possible way of seeing the world, which is publicly available. Experiences are involved, of course, but the reality is not a function of the experiences. Again, insights which are *of* reality in this sense may be accompanied by a *sense* of reality (vividness, and perhaps other psychological factors); but the reality logically precedes the sense-of-reality; the thing *seems* real because it *is* real. It is not just that the character the author presents gives us a sense or feeling of reality, that is, presents a tempting *illusion,* but that in a very important sense the character *is* real, is true-to experience, etc. One fallacy of the "illusion theory of art," it seems to me, is that it sounds as if the function of a work of art were to "put one over on us," to dupe us into feeling or believing something which we have no grounds for, to act like a propaganda machine in "pulling the wool over our eyes" and convincing us of something that really isn't so; in short, to give us a feeling of reality when there is no reality. This is what happens when "real" is interpreted merely as "vivid" or "intense" or in a similar manner.

2

I have now examined a number of senses of "reality." To decide among them, to say which is *the* correct sense, would be sheer dogma; they all have a perfectly legitimate usage, and confusion arises only when the writer does not specify what he means when he uses the term. "There is, in fact, no such thing as *the* form of the 'real' world; physics is one pattern which may be found in it, and 'appearance,' or the pattern of *things* with their qualities and

characters, is another. One construction may indeed preclude the other; but to maintain that the consistency and universality of the one brands the other as *false* is a mistake.[6]

Let us now examine a few examples of statements about "art and reality" to see how they are using the term and whether their claims are justified. Writers on painting seem to be particularly given to making such statements. And in many cases the usage seems so vague and obviously "emotive" that I for one cannot make much sense out of it. For example:

> Particularities of form and natural color evoke subjective states of feeling, which obscure *pure reality*. . . . *Time and subjective vision veil the true reality*. . . . The great plastic art of the past has made us feel true reality. . . . Despite cultural lags and breaks, there exists a continuous progression in the disclosure of true reality by means of the abstraction of reality's appearance. . . . Plastic expression of true reality is attained through dynamic movement in equilibrium. . . .[7]

It must be that Mondrian here is working with some special and unspecified use of the term, and until that usage *is* specified no more can be said.

In one place Clive Bell suggests that the significant form we find in art is significant of "reality" (although for him it remains as true as ever that the emotion evoked by art has nothing in common with any life-emotion): "In those moments of exaltation that art can give, it is easy to believe that we have been possessed by an emotion that comes from the world of reality," and "the peculiarity of the artist would seem to be that he possesses the power of surely and frequently seizing reality."[8]

> . . . Call it by what name you will, the thing that I am talking about is that which lies behind the appearance of all things—that which gives to all things their individual significance, the thing in itself, the ultimate reality. And if a more or less unconscious apprehension of this latent reality of material things be, indeed, the cause of that strange emotion, a passion to express which is the inspiration of many artists, it seems reasonable to suppose that those who, unaided by material objects, ex-

6. Langer, *Philosophy in a New Key*, p. 91.
7. Piet Mondrian, "Toward the True Vision of Reality," pamphlet published by Valentine Gallery, New York City.
8. Clive Bell, *Art*, pp. 56-57.

perience the same emotion have come by another road to the same country.[9]

To speak of that which underlies or motivates the artist's vision as "that which lies behind the appearance of all things" sounds suspiciously like the hypothesis of a transcendental reality to which we have already seen reason to object. Many critics, apparently, possessing unusual sensitivity, and feeling the emotion of "pure form" (or whatever emotion in connection with works of art which they most highly prize) with great intensity, feel inclined to give that emotion some cosmic status by saying that "reality" is its source, etc. They are apparently not satisfied, as we were in the preceding chapter, with saying that art conveys communicable essences, ways of perceiving the world which are fruitful in experience; they must add a metaphysics. But does it really give added stature to our esthetic experiences or to significant form to say that they are caused by "absolute reality"? Are not our esthetic experiences just as rich and rewarding without a transcendental metaphysics to bolster them up?

Dr. Barnes is much more guarded in his use of language. He says:

The artist illuminates the objective world for us, exactly as does the scientist, different as the terms are in which he envisages it; art is as little a plaything, a matter of caprice or uncontrolled subjectivity, as is physics or chemistry. What has made the study of science valuable and fruitful is method, and without a corresponding method of learning to see the study of art can lead only to futility. We must understand, in other words, what the distinctive aspects of reality are in which the artist is interested, how he organizes his work to reveal and organize these aspects. . . .[10]

In other words, as Dr. Barnes says very soon afterwards, art does give us "insight into reality." By "reality" he means something "objective," as is evident from the above quotation; on the other hand, he cannot mean the "reality" of science, which certainly would not include artistic insights. How one could establish that the artist's "reality" is objective in the sense of exhibiting *measur-*

9. *Ibid.,* pp. 69-70.
10. A. C. Barnes, *The Art in Painting,* p. 7.

able characteristics of objects as physics does is difficult to see. But if Dr. Barnes means to say that art is true-to various aspects of nature, nature as felt and experienced by human beings, then he is undoubtedly correct; and he is correct too in calling it objective in *some* sense, since as we have already seen, the artist's insights are not private and incommunicable, but are (potentially at least) publicly experienceable. They are not, or rather they do not remain, the private property of the artist. In this sense at least they are objective. (I do not think it would be fruitful at this point to quibble about the application of the term "objective." If the term is being used in such a way as to allow only scientific statements, then very well; art is at least objective in the sense we have stated, and if someone does not like the term he is welcome to use another.) The artist, Dr. Barnes says, does not merely invent or fabricate, he discovers: "The artist is primarily the discoverer, just as the scientist is; the scientist discovers abstract symbols which may be used for purposes of calculation and prediction; the artist, the qualities of things which heighten their human significance. . . ."[11] But whether and to what extent this "discovery" is of things or qualities which would be there even without the presence of human beings in the world, is a question which I do not think we need go into. Philosophy has never yet succeeded in settling the question of exactly what is "out there in the world" and what is "in our minds." And I doubt whether the relevance of my contentions about art depends upon the outcome of this controversy.

3

Another statement of the notion that art "reveals reality" is presented in a book we have already considered in another connection, J. W. N. Sullivan's *Beethoven*. Although Sullivan's remarks are made with special reference to music, he states his theory of "art and reality" so as to apply to all art.

Sullivan first spends a good deal of time arguing against scientific materialism, for, he says, if materialism is true, science is the only means of learning about "reality," and the artist's work can reveal nothing about "reality" but only (at most) the composer's

11. *Ibid.*, p. 13.

state of mind or nervous organization at the time of composition. Now it seems to me that this is a complete misapprehension. For not only does Sullivan never define "reality" or "materialism" (the latter is also, needless to say, an extremely vague word), but his thesis is quite mistaken: materialism, in whatever sense the word be taken, has never been, so far as I know, a theory of *how* we came to know anything, but rather a theory about the nature of the world, usually with "all is matter" or some such maxim as its fundamental postulate. Presumably we could come to know that "all is matter" by other means than scientific investigation; the philosophers promulgating the theory certainly came by it through high-flown speculation. And why could not the artist come to "know" and "reveal" it too? There is then no *a priori* reason why, in the world-view of materialism, art should be entirely excluded from revealing anything about the world. Accordingly I shall pass over the portion of Sullivan's discussion in which he is concerned with materialism as an obstacle to art.

Sullivan also advances as evidence against the notion that art cannot "reveal reality" a refutation of the "isolation theory" of art —the theory that music, or any other art, exploits one certain emotion, the esthetic emotion, a faculty quite separated from the rest of our nature. The difference between a late quartet of Beethoven and an early quartet of Haydn, says Sullivan, is not merely that the one evokes the esthetic emotion to a greater degree than the other, but rather that the Beethoven quartet evokes other emotions not isolated from life, and "illuminates and harmonizes" a large area of our experience.[12] Now, even if all this is admitted, and so much has already been said in the chapter discussing musical meaning, it does not even begin to prove that music or any other art "reveals reality." We might easily agree with Sullivan in repudiating the isolation theory of music and yet not agree with him about music's relation to "reality." And so I shall omit this portion of Sullivan's argument as well.

I shall pass directly, then, to the notion that art "reveals reality." Sullivan quotes the testimony of Beethoven on this point:

12. Sullivan, *Beethoven*, pp. 12-14.

Beethoven was a firm believer in what Mr. I. A. Richards calls the "revelation theory" of art. This is a theory which, if true, means that art has a significance very much more important than that usually attributed to it. Art must rank with science and philosophy as a way of communicating knowledge about reality.[13]

But according to Mr. Richards, art provides only a "superior organization of experience":

It is true, as Mr. Richards insists, that the artist gives us a superior organization of experience. But that experience includes perceptions which, although there is no place for them in the scientific scheme, may none the less be perceptions of factors in reality. Therefore a work of art may communicate knowledge. It may indeed be a "revelation." The higher consciousness of the great artist is evidenced not only by his capacity for ordering his experience, but also by having his experience. His world may differ from that of the ordinary man as the world of the ordinary man differs from that of a dog, in the extent of his contact with reality as well as in his superior organization of it. . . . The highest art has a transcendental function.[14]

And again:

It is characteristic of the greatest art that the attitude it communicates to us is felt by us to be valid, to be the reaction to a more subtle and comprehensive contact with reality than we can normally make. We no longer need dismiss this feeling or attempt to explain it away. The colossal and mastered experience which seems to be reflected in the Heilgesang of the A minor quartet, for instance, is, we may be confident, indicative of more than the peculiarities of Beethoven's neural organization. The perceptions which made that experience possible were in no sense illusory; they were perceptions of the nature of reality, even though they have no place in the scientific scheme. . . . He lived in a universe richer than ours, in some ways better than ours and in some ways more terrible. And yet we recognize his universe and find his attitudes towards it prophetic of our own. It is indeed our own universe, but as experienced by a consciousness which is aware of aspects of which we have but dim and transitory glimpses.[15]

We may be tempted to reply at once, "It may be true that Beethoven had certain experiences, valuable experiences, which to some extent he can communicate to us through his music; but to say that music gives us knowledge of 'reality,' that is something

13. *Ibid.*, p. 6. 14. *Ibid.*, pp. 22-23. 15. *Ibid.*, pp. 23-24.

else again. What is this 'reality,' and what is this 'knowledge' that art gives us?"

But then Sullivan modifies his position a little, and makes statements which are hard to reconcile with his previous assertion that art communicates knowledge:

We cannot say that art communicates knowledge, as science does, for we should be open to the objection made to the revelation theory of art that we cannot say what the revelation is of. But what art does do is to communicate to us an attitude, an attitude taken up by the artist consequent upon his perceptions, which perceptions may be perceptions of factors in reality....[16]

Beethoven does not communicate to us his perceptions or his experiences. He communicates to us the attitude based on them. We may share with him that unearthly state where the struggle ends and pain dissolves away, although we know but little of his struggle and have not experienced his pain.[17]

Music can no more express philosophic ideas than it can express scientific ideas. And nothing that Beethoven wanted to express can be called a philosophy. The states of consciousness he expresses, his reactions to perceptions and experiences, are not ideas. Belief in a Heavenly Father cannot be expressed in music; what can be expressed, and with unexampled power, is the state of soul that such a belief, sincerely held, may arouse. The music of the Credo of Beethoven's Mass in D is not the musical interpretation of certain Latin propositions. The Latin propositions express beliefs; the music expresses states of the soul that may, in some cases, be aroused by those beliefs.[18]

Thus the situation is now complicated: music conveys to us (1) "attitudes" or "states of soul" which are based upon (2) experiences or perceptions of (3) reality. Neither the reality nor the experience of it is directly "given" to us when we hear the music.

A bewildering array of questions presents itself at once: How does music convey attitudes or states of soul? How do we know whether we are experiencing the attitude or state of soul the composer intended? What is meant by "based upon"? When an attitude is based upon an experience, does that mean that the attitude would not have been possible, or at any rate would not have oc-

16. *Ibid.*, p. 23.　　17. *Ibid.*, p. 24.　　18. *Ibid.*, pp. 120-21.

curred, without the experience? What is the "reality" Sullivan speaks of? and how are we to know when our experiences or perceptions are of "reality" and when they are not? Are these "experiences of reality" experiences which could not be conveyed (or evoked) in any other way but through the medium of a work of art? or could they conceivably be put into statements? I find Sullivan's assertions so loose, so demanding of explanation and elucidation, that it is difficult to know where to begin in commenting on them.

Sullivan's qualification of his own statements, however, seems to me quite important: namely, when he says that art does not really "give knowledge" or "reveal reality," but that it rather conveys or communicates an "attitude" or "state of soul" based upon experiences which were experiences of reality. As long as the *attitude* is all we get from the music, the "reality" can be separately investigated; indeed, would not the attitude be the same even if there turned out to be no "reality" at all? For the "reality" is not what is experienced in the music, but only the attitude. Moreover, the "reality" in question might be a perfectly commonplace one: I can conceive of a work of music based upon the experience (that is, which could not have been written without the experience) of youthful romantic love, for example. A problem enters only when it is asserted that the "reality" which is the "basis" of the conveyed attitude could not have been presented except in the work of art; and this Sullivan has not even begun to establish. If all that Sullivan wants to say is that through music, through Beethoven's late quartets, for example, we may have experiences of a kind which we have never had before, and may be introduced into a realm or area of emotion whose existence we had never before been aware of, then all is well. This point has already been made in a preceding chapter; but if this is the substance of his remarks, then why these statements about "reality"?

All the further remarks which I could make with regard to Sullivan's contentions I could make much more clearly in the light of a clearer exposition of a somewhat similar position—that of Mrs. Langer in *Philosophy in a New Key*. I have already dealt with her theory of music as symbolism and her conception of music as "true-

to"; it remains now to examine her contention that music gives us "knowledge of reality."

Mrs. Langer is concerned with defending the thesis that music is an *exposition* of feelings, that it *tells* us "how feelings go." "Music," she says, "expresses primarily the composer's *knowledge of human feeling.*"[19] (How and in what sense knowledge can be "expressed" in sounds, and how we are to *know* anything as a result of hearing these sounds, she does not say.) "The content has been *symbolized* for us, and what it invites is not emotional response, but *insight.*"[20] Music articulates "forms" (the precise meaning of this term is not clear) which language cannot set forth, because "the classifications which language makes automatically preclude many relations, and many of those resting-points of thought which we call 'terms.' It is just because music has *not* the same terminology and pattern that it lends itself to the revelation of non-scientific concepts."[21] And "because the forms of human feeling are much more congruent with musical forms than with the forms of language, music can *reveal* the nature of feelings with a detail and truth that language cannot approach."[22] "Not communication but insight," she concludes, "is the gift of music; in very naive phrase, a knowledge of 'how feelings go'."[23]

A number of remarks may be made with regard to these assertions.

1. We might ask of this alleged knowledge, what it is that we know. Does one really have *knowledge* after listening to a piece of music that one did not have before? Are there any instances on record of persons who have more knowledge (other than simply "knowledge of the music itself," to be discussed below) after hearing the music than before?

2. Mrs. Langer declares that language is not well adapted to the communication of states of feeling. Words standing for emotions, as Sullivan says, are general portmanteau-words which cover up a million changes in emotional shade under one blanket term, for example, "joy." Now in part we might remove this difficulty by inventing more synonyms. But even a great wealth of synonyms

19. Langer, *op. cit.*, p. 221. 20. *Ibid.*, p. 223. 21. *Ibid.*, p. 233.
22. *Ibid.*, p. 235. 23. *Ibid.*, p. 244.

would not help us *feel* as the description intended us to. No words, no matter how precise, could infallibly tell us "how a certain feeling feels." But this defect is not peculiar to art, but is shared by everything else: *no* experience can be perfectly recorded in language. For example, the visual appearances of objects can no more adequately be expressed in language than can the sound of music or the emotions that music evokes. We must see the object in the one case, hear the music in the other.

But where in all this does knowledge come in? It seems to me that the most that can be said is "We know what the music sounds like, what its structure is, how it affected us, etc." If you want to know what a mango tastes like, the best thing to do is to let you taste one, to give you the experience, rather than describing it to you in propositions.

But are tasting the mango, hearing the music, really cases of knowing? If so, they are surely quite different from knowing *that* something is the case.[24] Are not the two, indeed, completely and irrevocably different? To call both these things knowledge—and thus to say that we get knowledge from hearing music—is extremely misleading, for the word "knowledge" in our language is confusingly ambiguous. Bertrand Russell has made the distinction between "knowledge by acquaintance" and "knowledge by description";[25] but Moritz Schlick has made approximately (not exactly) the same distinction in a manner which seems to me much more satisfactory by contrasting knowledge with something that is not knowledge at all. I know of no better way to conclude this volume than to put into a nutshell the principal theme of the last three chapters, and at the same time perhaps view it afresh from this new perspective, by presenting the distinction which Schlick makes:

When we have *knowledge* of something (whatever it is—let us call it *x*), we always know something *about x*. What we know consists of propositions—we know *that x* is white and granular,

24. I do not deny that from hearing the music one may know *that* something is the case, e.g., that the piece is in sonata form, or that it is a piece for the piano. But what fact, outside the music and its effect on us, we can be said to know, I am at a loss to see.

25. Bertrand Russell, *The Problems of Philosophy*, Chapter 5.

we know *that* it reacts chemically with *y*, etc. These are all facts *about x*, and constitute *knowledge* of *x*.

Now what of knowing *x* as opposed to knowing something about *x*?[26] Schlick says that this is not knowledge at all, but *acquaintance*. The difference is brought out in German by the distinction between *Erkenntnis* and *Erlebnis*, but is covered up in English by the application of the word "knowledge" to both of them.

> . . . But unfortunately there is another very common use of the word "knowledge" which we shall be very careful to avoid, for in my opinion it has given rise to the most terrible mistakes—I should even say, to *the* most fundamental mistake of the philosophy of all times. The misuse I am speaking of occurs when the word "knowledge" is applied to what is often called "immediate awareness". . . . When I hear a sound or see a color we often say that by these very acts of hearing or seeing I come to "know" what a sound is or what a color is—or it would be more cautious to say, I get knowledge of that particular sound I happen to be hearing, or the particular color I am seeing. . . .
>
> When we look at a leaf, we get an immediate acquaintance with a particular quality of "green." Is there any reason or justification to speak of this acquaintance as a kind of "knowledge"? The use of our words, i.e., our definitions, should be determined entirely from the practical point of view, and we ought not to employ the same word for two things which have nothing in common in their nature and purpose. Mr. Bertrand Russell distinguishes between "knowledge by acquaintance" and "knowledge by description" but why should the first be called "knowledge" at all? The word "acquaintance" alone seems to me sufficient, and then we can emphasize the distinction between *acquaintance* and *knowledge*.[27]

26. Cf. I. A. Richards, *Interpretation in Teaching*, p. 354: "Suppose someone asks, 'What is an apple?' Our answer might be, 'It is a fruit that grows on a tree.' To which he might reply, 'I was not asking you where it grew; I was asking you what it is.' We try again, 'It is a refreshing fruit.' He replies, 'I was not asking you what it was like or what it did; I was asking you what it is.' Suppose we say, 'It is an assemblage of cells, a system of molecules, atoms, etc.' He can always reply, 'I was not asking you what I should see if I took a microscope to it or what chemical hypothesis would explain what would happen to it if we did certain things to it, etc. I was asking you, quite simply, what it is?' In this way, he has us beaten from the start. We can only dispose of him by saying that his question is illegitimate, and that, if we define a question as something that theoretically can have an answer, his demand is not a question. It is only supposed to be one by having the same verbal form as some things which are questions and so, theoretically, can be answered."

27. Moritz Schlick, *Gesammelte Aufsätze*, p. 190.

The one is knowledge about things, the other is immediate acquaintance with them; the one is given *par excellence* by science, the other by art. When we hear music, we have deeper, richer acquaintance, not knowledge—it is not the function of music to give us that. When the arts give us knowledge, they do so only incidentally; but the enrichment of our perceptions, the deepening of our affective life, this is by no means incidental. But *Erkenntnis* is the task of the special sciences.[28]

But do we not gain some knowledge through acquaintance? If this means merely that when we are in the presence of a thing we are in a position to state some things *about* it just by looking at it, then this is true; this is knowledge. But it is more than mere awareness. Through mere awareness of the blue sky do we come to know what "blue" really is?

By no means! In order to give a name to the color I am seeing I have to go beyond the immediacy of pure intuition, I have to *think,* be it ever so little. I have to *recognize* the color as that particular one I was taught to call "blue." This involves an act of comparison, or association; to call a thing by its proper name is an intellectual act—the very simplest act

28. Cf. C. I. Lewis, *Mind and the World Order*, Appendix B. Also Schlick: "He who wants to know an object as completely as possible, wants an explanation of it, he does *not* want the object itself. He cannot possibly want it, because he *has* it already; for if he did not have it, if he were not acquainted with it (in the sense in which intuition is supposed to furnish acquaintance)—how could he wish for an explanation? . . . Thus Bergsonian intuition, so far from being the end and highest aim of all knowledge, is not even the beginning of it, it must precede all attempts to know anything. . . .

"I hope nobody will object here that the wish to 'know' a thing is often stimulated by a description and satisfied only by its actual presence; if, for example, we have heard a great deal about the Egyptian pyramids a vivid desire may be kindled in us to get acquainted with them personally, and we may not rest until we have travelled to Egypt and actually set eyes on them. But in a case of this kind it is obvious that what we are seeking is not knowledge at all (although we describe the result of our experience with the words 'Now at last I know the pyramids!') but it is *enjoyment*. We want a certain thrill which is quite different from genuine explanatory knowledge. Real knowledge about the pyramids consists of propositions about their nature and history, and in order to get these (which would also give us a thrill but of a different kind) we do not have to see the pyramids at all, we can read about them, or, if we want to find out facts about them which are not described in any books we can send another person to Egypt and have him make the necessary observations and communicate them to us. But the enjoyment we have when looking at the pyramids cannot be communicated and there is no substitute for it. And it remains true that it is neither the highest degree of knowledge nor even its lowest degree, but simply the indescribable datum that precedes everything else." (*Gesammelte Aufsätze*, pp. 192-93.)

of the intellect, to be sure—and its result is real knowledge. . . . The sentence "This is blue" expresses real knowledge.[29]

Hugo Münsterberg recognizes this distinction but, curiously enough, uses it to prove just the wrong thing, namely, that not through science but through esthetic contemplation only do we get "true knowledge" of the thing. Nevertheless the same distinction is very forcefully put:

The highest truth about the thing must be the knowledge of the thing itself, not of its causes and its effects; the thing itself with all its richness and all its meanings to the human mind, and not the substitution which the scientists proposes for the explanation of future events. . . . It is science which veils the real thing which we want to know, and turns our attention to that which the thing is not. . . . All that science can teach us about the object O is merely how it was caused by L and M and N and how it will bring about the effect P . . . but O itself remains always O: we cannot creep into it, we cannot get more of it than to know that it is O, and if we break it in pieces to show its parts, then it is a group of P's and R's but no longer the O. There is no escape: science does not care at all for O itself. . . .

That ocean yonder was my experience which I wanted to know in all its truth and reality. The scientist came and showed me the salt which was crystallized out of it, and the gases into which the galvanic current dissolved it, and the mathematical curves in which the drops were moving—most useful knowledge, indeed, for all my practical purposes—but in every one of his statements, that ocean itself with its waves and its surf and its radiant blueness had disappeared. But let us not ask what can be done with the water, how it can be used, what is its economic value, how it will carry my boat, what has caused its movements; but let us ask only once, what is it really that I see; the water itself must give the answer. Let it express itself, give to it, too, a chance to communicate to us all that it can bring to our mind, to show us to its best advantage every one of its features, to tell us its own story, to bring to the highest expression every hidden meaning of reality; let us only once give our whole attention to that one courageous, breezy wave, which thunders there against the rock; let us forget what there was and what there will be; let us live through one pulse-beat of experience in listening merely to that wave alone, seeing its foam alone, tasting its breeze alone—and in that one thrill we have grasped the thing itself as it really is in its fullest truth. The painter alone can succeed in holding

29. Schlick, *op. cit.,* p. 195.

that wave in its wonderful swing on the canvas, and his golden frame can separate that painted wave forever from the rest of the universe.[30]

Is it not plain that it is acquaintance and not knowledge that Münsterberg is speaking of? It is science that gives us knowledge about the thing, and esthetic experience, preëminently, that gives us acquaintance with it. It is only a confusing reversal of terminology which allows him to say that science does not give us true knowledge after all but only in esthetic experience do we know it "in its fullest truth." I suppose there is no harm in using this terminology, in denying that science gives knowledge and asserting that esthetic contemplation alone gives it, provided the distinction between the two is kept clear—the difference after all is one of whether to apply the word "knowledge" to a given kind of situation; but so well entrenched has the word "knowledge" become in the other context—that of facts, truth-about—that it is surely an abuse of terms, and at the very least a dangerous confusion, to call this "state of awareness" knowledge at all. It is *not* knowledge in the usual sense; and to call it so would be as confusing as it would be to use the term "tables" to apply to the things we now call "chairs" in addition to the objects we already call "tables." People have come to call it "knowledge" (or assent to its being called this) only through being misled by a vicious verbal ambiguity which they do not recognize, much less stop to analyze.

Surely to fail to attribute this noetic value to the arts is not to deprive them of signficance or value in any way. Does it make the arts, or our experiences of them, any the less precious? Must we always go on to make assertions about our experiences which later we cannot establish or justify? Many people appear to think there is a strict dichotomy: either music (for example) gives us knowledge, or it is a mere insignificant titillation of the sensibilities, like wine or snuff or peacock's-tongues. But certainly this is not the case; it is through music that we come to have some of our most treasured and valuable experiences; and they would not be one whit less valuable if some of the things that have been said about

30. Hugo Münsterberg, "Connection in Science and Isolation in Art," in *The Principles of Art Education;* reproduced in M. M. Rader, *A Modern Book of Esthetics.* The above passages are from pp. 365-370.

them should turn out not to be true. For music (and the other arts as well), as we saw in Part I, does evoke profound and "life-related" affective responses, responses which nothing else can evoke, which deepen and enrich our whole affective life, and which those who have had them would not exchange for gold.

The desire of so many lovers of the arts to exhibit the latter as possessing an important cognitive core is symptomatic of the supreme, though perhaps unwitting, value they place upon *knowledge*. But if that desire can be satisfied only by so radically altering the meaning of "cognitive" that in its new use the term has no recognizable continuity with its normal employment, has not the ideal of clarity been sacrificed, and has not a serious disservice been thereby rendered to that which is prized so highly?[31]

What art gives us—in a Cézanne canvas, a Shakespeare sonnet, a Beethoven quartet—is something which is not knowledge but perhaps more valuable than knowledge—the enrichment of experience itself. Writers so divergent as Eastman and Schlick in different ways testify to the same fact. When art gives us more, when it gives us knowledge as well, this is something "added unto it," not something integral to it, much as the emotional satisfaction of the observer is not integral but rather "added unto" a scientific observation. "Truth" in the other sense—"truth-to" felt ways of seeing and feeling, is generally agreed to be integral to it, but this is not knowledge.[32] The same is true of "reality": in the scientific sense, art does not give it except incidentally; in the sense of conveyance of the look, taste, feel of things, the enrichment of our affective life and the sensitizing of its perceptions (what Mr. Eastman calls "reality"), art gives it to us more than anything else. And who is to say, in an age when the consequences of *Erkenntnis* have brought our civilization almost to the brink of disaster, that a larger share of *Erlebnis,* as art gives it, might not help to give humanity the largeness of spirit and breadth of vision which alone can enable us to survive?

31. Ernest Nagel, review of Langer, *Philosophy in a New Key,* in *Journal of Philosophy,* XL, No. 12 (June 10, 1943), p. 329.

32. Truth-to character, as we saw at the very end of Chapter VI, may give us knowledge, in the manner there described, but while less incidental than mere presentation of facts, it is not so common to art as is the "truth to felt experience" which, in various ways, Eastman, James, Bennett, and many others describe and which for them constitutes the very core of art.

Bibliography
and
Index

Bibliography

The books referred to in the text are listed below. References to articles in periodicals are completely annotated in the footnotes to the text and consequently are not listed here. The items marked with an asterisk (*) are the books in English which are recommended to the non-technical reader as the most interesting and fruitful in the esthetics of one another of the specific arts; those marked with two asterisks (**) are recommended as general works in esthetics. Many excellent books are unstarred because they are primarily works of criticism rather than esthetic theory.

*Abell, Walter, *Representation and Form*. New York, C. Scribner's Sons, 1936.

Abercrombie, Lascelles, *The Idea of Great Poetry* (Included in the volume *The Theory of Poetry*). New York, Harcourt, Brace and Company, 1926.

——. *The Theory of Poetry*. New York, Harcourt, Brace and Company, 1926.

Alexander, Samuel. *Beauty and Other Forms of Value*. London, Macmillan and Co., Ltd., 1933.

——. *Philosophical and Literary Pieces*. London, Macmillan and Co., Ltd., 1939.

*Aristotle, *Poetics*.

*Barnes, Albert C. *The Art in Painting*. New York, Harcourt, Brace and Company, 1937. Revised.

*——, and De Mazia, Violette. *The Art of Renoir*. New York, Minton, Balch and Company, 1935.

Bartlett, E. M. *Types of Esthetic Judgment*. London, G. Allen & Unwin, 1937.

*Bell, Clive. *Art*. London, Chatto & Windus, 1914.

——. *Enjoying Pictures*. New York, Harcourt, Brace and Company, 1934.

——. *Landmarks in Nineteenth-Century Painting*. London, Chatto & Windus, 1927.

Bennett, Arnold. *Literary Taste and How to Form It.* . . . New York, Doubleday, Doran and Company, 1909.

Berenson, Bernhard. *The Central Italian Painters of the Renaissance.* New York, G. P. Putnam's Sons, 1909. 2nd edition.

Bernheimer, Richard, Carpenter, Rhys, Koffka, K., and Nahm, Milton C. *Art: A Bryn Mawr Symposium.* Bryn Mawr, Pa., Bryn Mawr Press, 1940.

Bevan, Edwyn. *Symbolism and Belief.* London, G. Allen & Unwin, Ltd., 1938.

Binyon, Laurence. *The Flight of the Dragon: an Essay on the Theory and Practice of Art in China and Japan.* London, J. Murray, 1911.

Boas, George. *Philosophy and Poetry.* Norton, Mass., Wheaton College Press, 1932.

Bradby, Anne, Editor. *Shakespeare Criticism, 1919–1935.* London, Oxford University Press, 1936. (Oxford World's Classics series.)

Bradley, Andrew Cecil. *Oxford Lectures on Poetry.* London, Macmillan and Co., Ltd., 1909.

——. *Shakespearean Tragedy.* London, New York, Macmillan and Co., Ltd., 1914. 2nd edition.

Britton, Karl. *Communication.* . . . London, K. Paul, Trench, Trubner & Co., Ltd., 1939.

Brooks, Cleanth. *Modern Poetry and the Tradition.* Chapel Hill, The University of North Carolina Press, 1939.

——. *Understanding Poetry.* New York, H. Holt and Company, 1938.

Brooks, Cleanth, and Warren, Robert Penn. *Understanding Fiction.* New York, F. S. Crofts and Co., 1943.

Buermeyer, Laurence. *The Esthetic Experience.* Merion, Pa., Barnes Foundation, 1924.

Burke, Kenneth. *Counter-Statement.* New York, Harcourt, Brace and Company, 1931.

Butcher, S. H. *Aristotle's Theory of Poetry and Fine Art.* . . . London, Macmillan and Co., Ltd., 1907. 4th edition.

Carpenter, Rhys. *The Esthetic Basis of Greek Art.* . . . New York, Longmans Green and Co., 1921.

**Carritt, E. F. *What is Beauty?* Oxford, The Clarendon Press, 1932.

——. *The Theory of Beauty.* New York, The Macmillan Co., 1914.

Cheney, Sheldon. *The Story of Modern Art.* New York, The Viking Press, 1941.

——. *A World History of Art.* New York, The Viking Press, 1937.

Cohen, Morris, and Nagel, Ernest. *An Introduction to Logic and Scientific Method.* New York, Harcourt, Brace and Company, 1934.

Collingwood, R. G. *Outlines of a Philosophy of Art.* London, Oxford University Press, 1925.

**——. *The Principles of Art.* Oxford, The Clarendon Press, 1938.

**Dewey, John. *Art as Experience.* New York, Minton, Balch & Company, 1934.

**Ducasse, Curt J. *The Philosophy of Art.* New York, L. MacVeagh, The Dial Press, 1929.

Duret, Theodore. *Courbet.* Paris, Bernheim-June & Cie, 1918.

*Eastman, Max. *The Literary Mind: Its Place in an Age of Science.* New York, C. Scribner's Sons, 1931.

Empson, William. *Seven Types of Ambiguity.* London, Chatto & Windus, 1930.

Evans, William V. *Belief and Art.* Chicago, privately printed, 1939.

Foerster, Norman. *American Criticism.* Boston and New York, Houghton Mifflin Company, 1928.

Foerster, Norman, Wellek, Rene, McGalliard, John C., Warren, Austin, and Schramm, Wilbur L. *Literary Scholarship.* Chapel Hill, The University of North Carolina Press, 1941.

Forster, E. M. *Aspects of the Novel.* New York, Harcourt, Brace and Company, 1927.

Fry, Roger. *The Artist and Psychoanalysis.* London, L. and V. Woolf, 1924.

*——. *Transformations.* London, Chatto & Windus, 1926.

——. *Vision and Design.* London, Chatto & Windus, 1924.

Gehring, Albert. *The Basis of Musical Pleasure.* . . . New York and London, G. P. Putnam's Sons, 1910.

Giles, Herbert Allen. *Introduction to the History of Chinese Pictorial Art.* Shanghai, Kelly & Walsh, Ltd., 1905.

**Greene, Theodore Meyer. *The Arts and the Art of Criticism.* Princeton, Princton University Press, 1940.

Gurney, Edmund. *The Power of Sound.* London, Smith, Elder, & Co., 1880.

*Hanslick, Eduard. *The Beautiful in Music.* . . . New York, Novello, Ewer and Co., 1891.

**Heyl, Bernard C. *New Bearings in Esthetics and Art Criticism.* New Haven, Yale University Press, 1943.

Hulme, T. E. *Speculations.* . . . Edited by Herbert Read. New York, Harcourt, Brace and Company, 1924.

*James, D. G. *Scepticism and Poetry.* . . . London, G. Allen & Unwin, Ltd., 1937.

James, Henry. *The Art of the Novel.* New York, C. Scribner's Sons, 1934.

**Kant, Immanuel. *Critique of Esthetic Judgment.* Translated by James Creed Meredith. Oxford, Clarendon Press, 1911.

Láng, Paul H. *Music in Western Civilization*. New York, W. W. Norton & Co., Inc., 1941.

*Langer, Susanne K. *Philosophy in a New Key*. . . . Cambridge, Mass., Harvard University Press, 1942.

Langfeld, Herbert Sidney. *The Esthetic Attitude*. New York, Harcourt, Brace and Howe, 1920.

Leichtentritt, Hugo. *Music, History and Ideas*. Cambridge, Mass., Harvard University Press, 1938.

Lewis, Clarence Irving. *Mind and the World Order*. . . . New York, C. Scribner's Sons, 1929.

Mather, Frank Jewett, Jr. *Concerning Beauty*. Princeton, Princeton University Press, 1935.

**Mauron, Charles. *Esthetics and Psychology*. London, The Hogarth Press, 1935.

Mill, John Stuart. *Dissertations and Discussions*. 2 vols. New York, E. P. Dutton & Co., 1905.

Moore, Douglas. *Listening to Music*. New York, W. W. Norton & Company, Inc., 1932. 2nd edition.

Moore, George, editor. *An Anthology of Pure Poetry*. New York, Boni and Liveright, 1925.

Münsterberg, Hugo. *The Principles of Art Education*. . . . New York, The Prang Educational Co., 1905.

Murry, John Middleton. *The Problem of Style*. London, Oxford University Press, 1922.

——. *Countries of the Mind*. . . . 2nd Series. London, Oxford University Press, 1937.

Mursell, James L. *The Psychology of Music*. New York, W. W. Norton & Company, Inc., 1937.

Newman, Ernest. *Musical Studies*. London & New York, J. Lane, 1910.

Parker, DeWitt. *The Analysis of Art*. New Haven, Yale University Press, 1926.

**——. *The Principles of Esthetics*. Boston, New York, Silver, Burdett and Company, 1920.

Pepper, Stephen. *Esthetic Quality*. . . . New York, C. Scribner's Sons, 1938.

Pollock, Thomas Clark. *The Nature of Literature*. . . . Princeton, Princeton University Press, 1942.

Pottle, Frederick Albert. *The Idiom of Poetry*. Ithaca, N. Y., Cornell University Press, 1941.

Prall, David W. *Esthetic Analysis*. New York, Thomas Y. Crowell Company, 1936.

**——. *Esthetic Judgment*. New York, Thomas Y. Crowell Company, 1929.

*Pratt, Carroll C. *The Meaning of Music.* . . . New York and London, McGraw Hill Book Company, Inc., 1931.

**Rader, Melvin M., Editor. *A Modern Book of Esthetics.* New York, H. Holt and Company, 1935.

Redfield, John. *Music: A Science and An Art.* New York, A. A. Knopf, 1930.

**Reid, L. A. *A Study in Esthetics.* New York, The Macmillan Company, 1931.

Richards, I. A. *Interpretation and Teaching.* New York, Harcourt, Brace and Company, Inc., 1938.

*——. *Practical Criticism.* New York, Harcourt, Brace and Company, Inc., 1929.

*——. *Principles of Literary Criticism.* New York, Harcourt, Brace and Company, Inc., 1926.

——. *The Philosophy of Rhetoric.* New York, London, Oxford University Press, 1936.

——. *Science and Poetry.* London, K. Paul, Trench, Trubner & Co., Ltd., 1926.

Richards, I. A., and Ogden, C. K. *The Meaning of Meaning.* New York, Harcourt, Brace and Company, Inc., 1923.

Roberts, Michael. *Critique of Poetry.* London, Jonathan Cape, 1934.

Routh, H. V. *God, Man, and Epic Poetry.* Cambridge, The University Press, 1927.

Russell, Bertrand. *The Problems of Philosophy.* New York, Henry Holt and Company (Home University Library Series).

**Santayana, George. *The Sense of Beauty.* New York, C. Scribner's Sons, 1896.

——. *Interpretations of Poetry and Religion.* New York, C. Scribner's Sons, 1900.

——. *Reason in Art.* New York, C. Scribner's Sons, 1905.

——. *The Realm of Truth.* New York, C. Scribner's Sons, 1938.

Schlick, Moritz. *Gesammelte Aufsätze.* Vienna, Gerold and Company, 1938.

Schoen, Max. *The Effects of Music.* New York, Harcourt, Brace and Company, Inc., 1927.

**Stace, W. T. *The Meaning of Beauty.* . . . London, G. Richards and H. Toulmin, 1929.

Stoll, Elmer Edgar. *Art and Artifice in Shakespeare.* Cambridge, Cambridge University Press, 1933.

——. *Shakespeare and Other Masters.* Cambridge, Harvard University Press, 1940.

*Sullivan, J. W. N. *Beethoven: His Spiritual Development.* New York, A. A. Knopf, 1927.

Urban, Wilbur M. *Language and Reality*. New York, The Macmillan Company, 1939.

Whistler, James MacNeill. *The Gentle Art of Making Enemies*. London, W. Heinemann, 1890.

Zola, Emile. *The Experimental Novel*. New York, The Cassell Publishing Co., 1894.

Index

First names are omitted in referring to well-known classical figures in their fields (e.g., Beethoven, Shakespeare, Cézanne).

References to specific works are generally indexed under the names of their authors.